KB179210

키키 스미스
Kiki Smith

자유낙하
Free Fall

키키 스미스
Kiki Smith

자유낙하
Free Fall

열화당
Youlhwadang

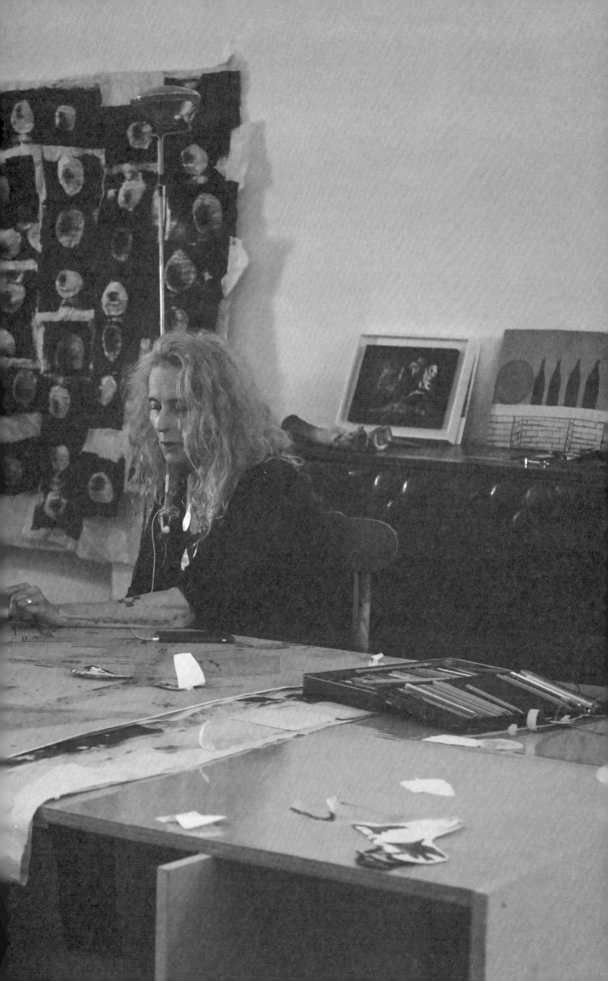

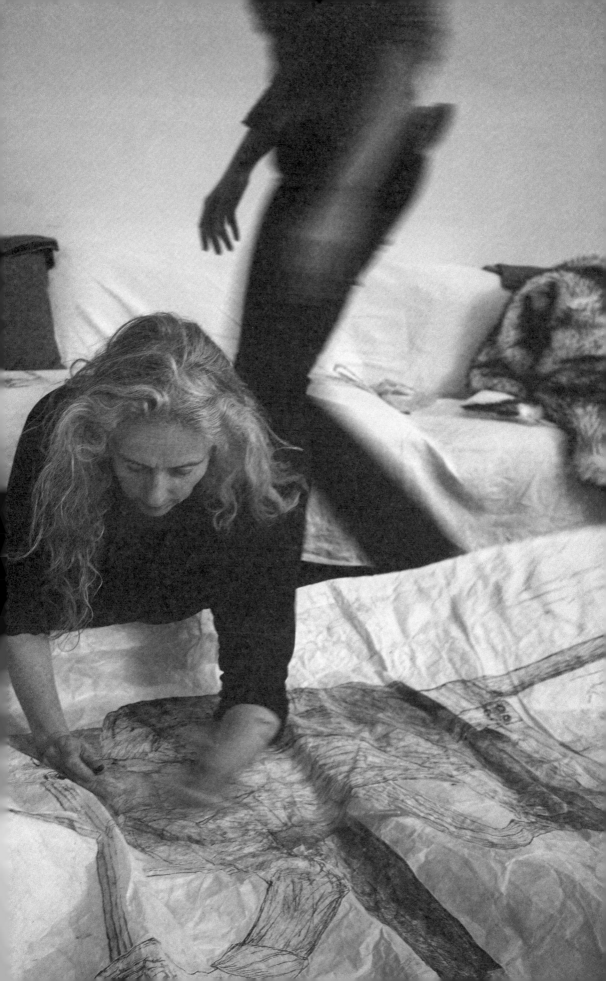

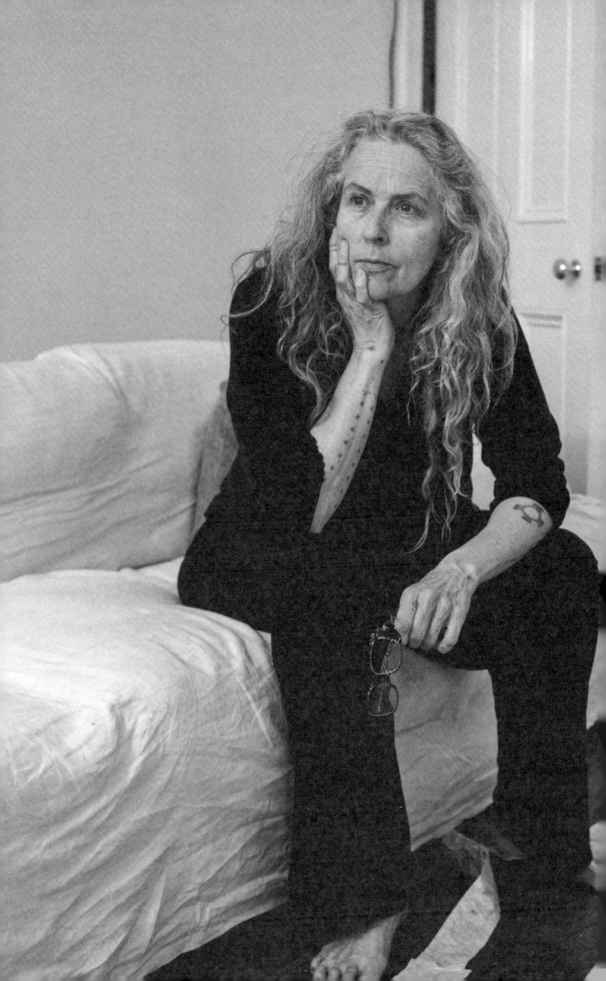

책머리에

1
Kiki Smith, *Kiki Smith—
Work!*, directed by Claudia
Müller, Phlox Films, 2015.

"하나의 문장을 말하는 것처럼."[1]

키키 스미스는 본인의 예술 활동에 대해 이렇게 술회한다.
이십세기 미국 현대미술사에서 독보적 위상을 갖는 그는 신체에
대한 해체적 표현으로 1980-1990년대에 개성과 다양성의
아이콘으로 자리매김한 이래 현재까지도 안주하지 않고 다매체
실험을 이어 오고 있는 작가이다. 스미스가 본격적으로 예술에
입문한 것은 스물네 살 무렵으로 소개되지만, 예술가 집안에서
성장한 그에게 예술은 이미 오래전부터 학교의 정규 미술수업을
통해야만 접할 수 있는 특별한 활동이라기보다는 숨 쉬는 것처럼
당연한 일상과도 같았다. 창작하는 일은 스미스가 애써 새롭게
익히고 습득해야 하는 것이 아니라 모국어만큼이나 자기표현의
가장 기본적인 방식이었을 터, 문장을 말하듯 자연스러웠다고
말하는 까닭이 여기에 있다.

　　　이는 작가의 작업방식에서도 잘 드러난다. 1980년대 미국의
시대상은 에이즈나 임신중절 등을 둘러싼 문제를 필두로 인권,
평등, 정체성, 젠더 담론으로 집약되는데, 이러한 물결 속 당시
미술 현장에서는 남성중심적 표현의 상징이던 미니멀리즘이나
추상미술에 맞서 신체를 예술의 소재이자 재료로 사용하는
움직임이 대두되었다. 특히 에바 헤세(Eva Hesse), 루이즈
부르주아(Louise Bourgeois), 주디 시카고(Judy Chicago)와 같은
여성주의 작가들은 여성 신체를 심미적 대상으로 간주하던 기존
관념을 전복시키고 이를 주체적 표현의 장으로 옮겨 왔다. 한편
이 시기 스미스는 아버지의 죽음, 에이즈에 의한 여동생의 죽음을
차례로 겪으면서 생명의 취약함과 불완전함에 대해 진지하게
들여다보게 되는데, 이로써 신체의 안과 밖을 맴돌며 경계선에서
사유하는 작가의 태도에는 정신성과 물질성이 함께 결부된다.
설치 작품〈생명은 살고 싶어 한다(Life Wants to Live)〉(1983) 또한
가정폭력을 겪은 한 여성의 사건에 기반을 두는데, (자신뿐 아니라)
타자의 치열한 삶의 현장을 작품으로 소환해내 영속시키려는
작가의 의지를 엿볼 수 있다. 이러한 일련의 사건들은 크게는
당시의 시대상, 작게는 해부학에 대한 개인적 관심사와 맞물리면서
스미스가 신체 탐구에 더욱 집요하게 파고드는 계기가 된다.

　　　1990년 뉴욕 현대미술관에서 열린「프로젝트 24: 키키
스미스(Projects 24: Kiki Smith)」는 그가 미술계에 본격적으로
이름을 알리기 시작한 전시로 회자된다. 우리에게 가장 널리

2
'자유낙하'는 스미스가
1994년에 제작한 작품의
제목이다. 판화이자
아티스트북 형식으로
제작된 이 작품은 평면
매체에 입체적으로 접근한
스미스의 조각가적 면모를
동시에 살펴볼 수 있는
대표작 중 하나이다. 전시
제목으로서의 '자유낙하'는
키키 스미스 작품에
내재된 분출하고 생동하는
에너지를 함의하며, 이는
작가의 지난 사십여 년에
걸친 방대한 매체와
작품 활동을 한데 묶는
연결점으로 기능한다.

3
Robin Winters, "An Interview
with Kiki Smith," *Kiki Smith*,
Amsterdam: Institute of
Contemporary Art; The
Hague: Sdu Publishers, 1990,
p.132.

인식된 스미스의 작품 유형은 애브젝트 아트(abject art)로 미술사
책에서 언급되는 파편화된 신체의 표현이 대부분일 것이다.
생리혈, 땀, 정액, 소변 등의 신체 분비물과 배설물까지 가감 없이
가시화한 파격적인 작품들은 단순히 심미적 대상으로서의 여성을
탈신비화하는 수준을 훌쩍 넘어, 극한의 수치심과 치욕을 일으키며
눈살을 찌푸리게 했다. 2000년대에 이르러서는 '빨간 망토' 우화,
『이상한 나라의 앨리스』와 같이 친근한 동화를 소재로 서정적인
서사를 전개하기도 하고, 자연, 우주 등의 주제로 작품의 반경을
확장해 나가기에 이른다.

이렇듯 시기별 작품의 변천 과정에서 심지어 다른 작가로
생각될 만큼 이질적인 스미스의 작품들은 어떻게 하나로 연결될
수 있을까. 서울시립미술관에서 아시아 첫 미술관 개인전으로
개최하는 「키키 스미스 — 자유낙하」는 작가의 다채로운
작품세계를 관통하는 키워드를 '자유낙하'[2]로 설정했다. 도달할
곳을 모른 채 끝없이 떨어지는 하강의 움직임, 시대에 순응하다가도
역행하면서 거슬러 오르는 움직임, 주변을 미시적 거시적 시선으로
살펴보면서 천천히 배회하는 움직임 등은 모두 스미스가 작품세계
안에서 언어와 문법을, 표현과 매체를, 주제와 도상을 달리하면서
실험해 온 '자유낙하'의 정신으로 귀결된다.

키키 스미스를 수식해 온 '여성', '신체' 등의 규정적
접근은 이번 전시에서 크게 두드러지지 않는다. 작가는 자신이
'신체'에 관심을 두게 된 이유가 단순히 여성성을 새로운 방식으로
부각시키기 위해서만이 아니라 신체야말로 "우리 모두가 공유하는
형태이자 각자의 경험을 담을 수 있는 그릇"[3]이기 때문이라고
말했는데, 이러한 다층적 해석에 닿는 지점이 이번 전시의 중요한
출발점이 되었다. 이것이 작가가 본인의 작품이 교훈적으로
비춰지지 않고 보는 이의 경험에 따라 각자의 이야기가 생성되기를
희망하는 이유다. 그동안 작가를 정의해 온 여러 수식어는
분명 유효한 관점이지만, 또 다른 해석으로의 접근을 제한하는
요소이기도 하다. 이러한 의식 아래, 이번 전시에서는 여성주의로
대표되는 작가의 면모만을 앞세우거나, 그의 활동을 단순히 연대기
순으로 나열하는 것이 아니라, 해체와 구성을 반복하며 복잡다단한
내러티브를 구축해 온 작가의 시각 어법에서 일관되게 발견되는
요소, 즉 '서사 구조', '반복적 요소', '에너지'와 같은 몇 가지 특징적
골자를 우선시했다. 이런 접근방식은 작가의 지난 사십여 년간의

궤적을 포괄하는 전시로, 또한 국내에 작가를 제대로 소개하는 첫 단행본으로 이어졌다.

　전시를 구성하는 세 가지 주제는 느슨한 얼개처럼 기능한다. 이는 보는 이에게 해석의 여러 층위를 열어 두는 동시에, 키키 스미스의 다채로운 조형언어와 그 문법의 메커니즘에 우선적으로 집중하기 위한 의도적 느슨함이다. 먼저 첫번째 축인 '이야기의 조건: 너머의 내러티브'에서는 스미스가 특유의 접근방식을 통해 직조해 나가는 서사 구조에 주목한다. 스미스는 민화, 설화, 신화, 고대 역사, 문학, 종교 등을 아우르면서 시공간을 초월한 모티프를 한 화면 안으로 소환해 새로운 서사를 구축해 왔다. 특히 가톨릭 배경에서 자란 스미스는 비가시적 요소를 시각적 재현의 영역으로 불러내는 움직임을 예술과 종교의 공통분모로 보고, 이를 작업의 단단한 토대이자 교차점으로 삼는다. 각각의 모티프는 스미스가 새로운 내러티브를 생성하는 데 중요한 축으로 기능한다. 이러한 서사는 주제나 도상뿐 아니라 매체에서도 나타나는데, 당시 미국과 유럽에서 비주류 매체로 인식되던 종이, 취약성을 품은 유리나 테라코타, 미술의 반경에서 도외시되는 공예와 그 장식적 요소를 전면에 내세운 것이 대표적 예이다. 두번째로 '배회하는 자아'는 작가의 창작 활동에서 반복성이 함의하는 층위를 살핀다. 성별을 배제하고 익명성을 강조했던 초기 신체 탐구의 유형과 달리 1990년대 이후 스미스는 판화나 사진 매체를 접하면서부터 자신을 작품에 본격적으로 등장시키기에 이른다. 의도적으로 작품에서 자신의 모습을 드러내지 않은 초기와는 매우 대조되는 행보로, 판화나 사진 매체가 지닌 반복적인 속성과 자아 탐구에 대한 실험은 서로 교차하면서 스미스의 작업 경향에 새로운 전환점을 가져오게 된다. 뉴욕의 판화 스튜디오 유니버설 리미티드 아트 에디션(Universal Limited Art Editions, ULAE)과의 협업으로 제작된 〈밴시 펄스(Banshee Pearls)〉(1991, pp.138-139), 〈무제(머리카락)〔Untitled(Hair)〕〉(1990, pp.123-125) 등에서도 이러한 모습을 직간접적으로 찾아볼 수 있다. 이는 작가가 본인의 예술 활동을 두고 일종의 '정원 거닐기'와도 같다고 한 표현처럼 반복적으로 배회하는 움직임으로 함축된다. 끝으로 '자유낙하: 생동하는 에너지'는 얼핏 대척점에 놓인 듯 보이는 다양한 작품 유형들을 관통하는 요소로서 그 안에 내재한 에너지에 주목한다. 쏟아지고 흐르는 유기적 움직임과 에너지는 신체 장기, 분비물,

13

배설물을 다룬 작품으로 익히 표현되었다. 이는 격동하는 이십세기와 히피 문화를 모티프 삼아 작품 안에 다채로운 색채를 불러들이는 계기가 된 태피스트리 연작에서도 동일하게 발견된다.

이 책에는 전시 출품작 외의 대표작들도 고르게 담아 작가에 대한 전반적인 이해를 돕고자 했다. 작품의 흐름도 전시의 구성을 참고하되 책에 맞는 호흡으로 재구성했다. 함께 수록된 세 편의 에세이 역시 전시의 세 가지 주제를 일대일로 조응하면서 씌어진 것은 아니다. 그보다는 전시의 기본적인 방향을 공유하면서 작가와 작품 연구에 깊이있는 시각을 제시하고자 했다. 미술사학자 이진숙은 「키키 스미스와 함께 거닐기」에서 스미스가 그간 다뤄 온 방대한 장르와 매체에 기초해 작가의 작품세계를 미술사적 맥락으로 읽어낸다. 십여 년 전 미국에서 작가의 전시를 직접 관람했을 때의 충격과 전율을 잊지 못하는 애호가로서, 스미스의 시기별 특성을 친절하고 편안하게 안내한다. 미학 연구자 신해경은 「확장하는 물질의 경계에 부치는 다섯 가지 주석」에서 초기 신체 중심의 작품을 시작으로 주변의 '크고 작은 모든 생명'에 대한 작가의 관심을 에코페미니즘의 시선에서 풀어 간다. 신체와 물질성이 갖는 층위를 다각도로 조망하려는 시도는 사람의 몸에만 국한되지 않고 동물의 몸, 그리고 자연과 우주가 품는 몸에까지 가닿는다. 소설가 최영건의 「태어나고, 다시 태어나는 신의 내러티브」는 스미스의 작업이 사적 체험에 머물지 않고 신화, 설화, 종교적 도상과 같은 보편적인 이야기를 거쳐 확장한다는 점에 주목한다. 특히 여러 문화권의 근원 서사를 '유년의 신'에 비유함으로써 그의 작품을 온갖 이야기들로 재탄생하고 변신하는 순환적 내러티브로 해석한다.

유기적인 관계망 속에 크고 작은, 가깝고도 먼, 그리고 소외되거나 아직 닿지 않은 모든 생명에 대한 경외를 담아 현재까지도 긴 순례의 여정을 이어 나가는 스미스는 "나는 여전히 자유낙하 중이다"[4]라고 말한다. 과거와 현재, 매체와 도상을 넘나드는 그의 작업은 그 안에서 스스로 맴돌고, 교차하면서 무수히 많은 서사를 생성해내고 있다. 조형 문법을 달리하며 꾸준히 문장을 직조하고 있는 현재진행형 작가의 면면을 하나의 전시, 한 권의 책에 모두 담아내기는 불가능하다. 키키 스미스의 작품세계를 이해하는 일은, 호흡하고 말하듯이 작업하는 그의 세밀한 시선을 따라, 타자를 이해하려는 노력에 동참해 한 걸음씩

4
Kiki Smith, interview by Christopher Lyon, "Free Fall: Kiki Smith on Her Art," *Kiki Smith*, ed. by Helaine Posner, New York: The Monacelli Press, 2005, p.37; "Anthology from Conversations 1990 to 2016," *Kiki Smith: Procession*, ed. by Petra Giloy-Hirtz, Munich: Haus der Kunst & Prestel, 2018. p.37.

나아가는 것에 가깝지 않을까. 이 책과 전시가 그 움직임의
의미있는 시작점이 되었으면 하는 바람이다.

2022년 12월
서울시립미술관 학예연구사
이보배(李寶培)

Preface

1

Kiki Smith, *Kiki Smith— Work!*, directed by Claudia Mülller, Phlox Films, 2015.

"It's just a language, like saying a sentence or something."[1]

This is how Kiki Smith describes her artistic practice. She is an artist who occupies a unique status in the history of twentieth-century American contemporary art—who, since the moment she was established as an icon of individuality and diversity in the 1980s and 1990s through her deconstructive expression of the body, refused to rest on her laurels and continues to conduct her multimedia experiments. It is often mentioned that Smith's earnest entry into art was around the age of 24, but for someone who was raised in an artists' family, art was like breathing, a part of everyday life, rather than a special activity only to be accessed through formal art courses in school. To create was not an activity to be learned and mastered—it was the most basic way of self-expression, as basic as using one's mother tongue, like saying a sentence, as Smith said.

This is also evident in the way Smith worked. America in the 1980s was focused on discourses on human rights, equality, identity, and gender surrounding issues like AIDS and abortion. Along this wave, art rose against minimalism or abstract art—regarded as symbols of androcentric—and instead started to incorporate the body as both its subject matter and material. Feminist artists like Eva Hesse, Louise Bourgeois, and Judy Chicago subverted the prevalent attitude that understood women's bodies as aesthetic objects and brought them into a place where expression happened with agency. Meanwhile, Smith, having lost her father and her sister who died from AIDS during this time, peered into life's frailty and imperfections. From this peering came her ways of thinking across the border between the inside and outside of the body, and with this attitude, spirituality and materiality were combined. *Life Wants to Live* (1983) is based on a story of a woman who suffered domestic violence, and here we get a glimpse of the artist's will to summon the fierceness of life—not only hers but also of the other—into her work and perpetuate it. Such series of events, combined with the spirit of the times and the artist's personal interest in anatomy, served as an opportunity for Smith to delve deeper into exploring the body.

Projects 24: Kiki Smith, held at the Museum of Modern Art, New York in 1990 is known to be the exhibition that made her name known in the art world in earnest. The most widely recognized type of Smith's work is abject art, which is mostly of expressions of the fragmented body mentioned in art history books. The unconventional works, which

visualized body secretions such as menstrual blood, sweat, semen, and urine, went beyond simply demystifying women as aesthetic objects and caused extreme embarrassment, shame, and many a grimace. In the 2000s, Smith took familiar fairy tales and developed them into lyrical narratives, such as the fable of "Little Red Riding Hood" and *Alice's Adventure in Wonderland*, while gradually expanding the radius of her work along the themes of nature and the universe.

How are we to connect Smith's oeuvre—whose works not only change through different phases but are also heterogeneous enough to pass as being created by different artists—with a common thread? *Kiki Smith—Free Fall*, held at the Seoul Museum of Art as Smith's first solo exhibition at a museum in Asia, chose "free fall"[2] as the keyword that pierces through her variegated art world. The endless descent that knows not where it lands, the movement that goes along with—then against—the current of the times, the slow wandering that allows the microscopic and macroscopic surveying of the surrounding—they all boil down to the spirit of "free fall" with which Smith has been experimenting by differing language and grammar, expressions and media, subjects and icons.

The prescriptive approaches—those of "woman" or "body"—that have decorated Kiki Smith are not made prominent in this exhibition. The artist said that the reason she became interested in the body was not simply to emphasize the feminine in a new way, but "because it is the one form that we all share; it's something that everybody has their own authentic experience with,"[3] and it is here, where multiple layers of interpretation meet, that we found the crucial starting point of this exhibition. This is also the reason why the artist hopes that her work will not come across as didactic, that it will allow each viewer to have their own story unfold according to their own experience. The many qualifiers that have defined the artist so far are certainly valid points of view, but they are also factors that limit access to other interpretations. With this awareness, rather than solely emphasizing the feminist aspects of Smith's work or displaying her works simply in chronological order, this exhibition prioritized certain characteristic features like "narrative structure," "recurring elements," and "energy" that consistently appear throughout the artist's visual grammar, one that has built an intricate narrative through repeated deconstruction and construction. This approach has led to an exhibition that covers the artist's trajectory over

2
"Free Fall" is the title of a work Smith created in 1994. The work, produced as both print work and artist's book, is representative of Smith's sculptural aspects that lean on a three-dimensional approach to flat media. As the title of the exhibition, "Free Fall" points to the bursting and vibrant energy inherent in Kiki Smith's work, and function as a connecting point that ties together the artist's extensive media and art practice over the past forty years.

3
Robin Winters, "An Interview with Kiki Smith," *Kiki Smith*, Amsterdam: Institute of Contemporary Art; The Hague: Sdu Publishers, 1990, p.132.

the past forty years, and also to the first book that properly introduces the artist to the Korean audience.

The three themes that make up the exhibition function like a loose framework. This looseness is an intentional one; for the viewer, it opens various layers of interpretation, while at the same time prioritizing the focus on Kiki Smith's variegated formative language and the mechanism of its grammar. The first of the three axes is "Beyond Unknown," and here we focus on the narrative structure Kiki Smith has woven with her characteristic approach. Smith has built a new narrative by traversing folk paintings, fables, myths, ancient history, literature, and religion, summoning onto one screen motifs that transcend time and space. With her Catholic background, Smith particularly sees the practice of bringing invisible elements into the realm of visual representation as a common denominator between art and religion, and uses it as a solid foundation and point of intersection for her art. Each motif serves as an important axis for Smith to create a new narrative. Such narratives appear not only in her themes or icons, but also in the media she uses. Some key instances include her use of paper (a non-mainstream medium in the United States and Europe at the time) and glass or terracotta (characterized by its fragility) as well as bringing to the fore aspects of crafts and decorative elements that were largely excluded from the radius of art. The second axis is "Wandering Self," which examines what repetition implies in Smith's artistic practice. Unlike her early works that studied the body, in which gender was excluded and anonymity was emphasized, Smith actively cast herself in her own works after the 1990s when she started to work with prints and photography. Standing in stark contrast to her early days when she deliberately excluded herself from her works, experimentation with the repetitive characteristics of printmaking or photographic media and with self-exploration brings about a new turning point in the trajectory of her work. Works like *Banshee Pearls* (1991, pp.138-139) and *Untitled (Hair)* (1990, pp.123-125)—made in collaboration with the New York-based fine print publisher Universal Limited Art Editions, ULAE—offer a glimpse into this aspect. This alludes to the repetitive wandering implied in the expression "walking around in the garden" that Smith used to describe her own art practice. Lastly, "Free Fall" focuses on the element that runs through various types of works—various enough to seem to be at odds with each other at first glance—and the energy inherent in it. The

organic movement and energy of gushing and flowing have been well expressed in works dealing with body organs, secretions and excrement. We find their recurrence in Smith's tapestry series which, inspired by the turbulence of the twentieth century and the hippie culture, channeled in a variety of colors into her work.

In this book, we have endeavored to include a balanced array of Smith's representative works, those from the exhibition as well as others that have not been included in the exhibition. The progression of the works takes its cue from the composition of the exhibition, while also being designed along a rhythm befitting the book. Likewise, the three essays included are not a one-to-one correspondence with the three themes of the exhibition. Rather, they intend to present in-depth perspectives on the artist and her work in tandem with the direction of the exhibition. In her "Walking Around with Kiki Smith," art historian Lee Jinsuk surveys the extensive ground of genres and media the artist has covered, and against this backdrop, examines the artist's oeuvre within the context of art history. A Kiki Smith enthusiast who cannot forget the shock and thrill of seeing the artist's exhibition in the United States more than a decade ago, Lee kindly and considerately guides the reader through the characteristics of Smith's work marked by different periods. A researcher in aesthetics, Shin Haekyong takes an ecofeminist point of view in her "Five Notes on the Boundary of Expanding Matter" to discuss Smith's early works on the body as well as her interest in "all creatures great and small." The attempt to examine the layers of the body and materiality from various angles is not limited to the human body but extends to bodies of animals and even to bodies that nature and the universe contain. Novelist Choi YeongKeon's "The Narrative of Gods, Born, Then Born Again" focuses on the aspect of Smith's practice that does not remain on the level of personal experience but expands into the realm of universal stories, such as myths, fables, and religious iconographies. Origin tales from various cultures are compared to "gods of childhood" from which a myriad of stories are reborn and transformed, and Choi interprets this as cyclical narrative.

Smith continues the long pilgrimage to this day, with reverence for all life—small and large, near and distant, marginalized or yet unreached—that exists within an organic network of relationships. "I am in a kind of free fall now,"[4] she says. Her work—traversing past and present, media and icons—meanders and mingles within, creating

4
Kiki Smith, interview by Christopher Lyon, "Free Fall: Kiki Smith on Her Art," *Kiki Smith*, ed. by Helaine Posner, New York: The Monacelli Press, 2005, p.37; "Anthology from Conversations 1990 to 2016," *Kiki Smith: Procession*, ed. by Petra Giloy-Hirtz, Munich: Haus der Kunst & Prestel, 2018. p.37.

countless narratives. It is an impossible task to capture in one exhibition, or in one book, all aspects of an artist who is in the present progressive tense, who is constantly weaving sentences by tweaking the grammars of form. To understand Kiki Smith's art world might mean taking each step forward while following her meticulous gaze that stems from a practice as natural as breathing or speaking—it might mean joining her in her endeavor to understand the other. Our hope is that this book and this exhibition would be a meaningful starting point in taking that first step.

December 2022
Curator, Seoul Museum of Art
Lee Bo Bae

차례

Contents

취약한 몸으로부터 시작된 예술

인류 최초의 서사시인 『길가메시 서사시』에는 미술이 탄생하는 순간이 흥미롭게 묘사되어 있다. 지금으로부터 오천여 년 전, 수메르 지역 우루크 왕국의 왕 길가메시는 친구 엔키두의 죽음을 목도하면서 '죽음'을 넘어서는 불멸에 대한 욕망을 갖게 된다. 그러나 불멸은 인간에게는 허용되지 않는 것. 죽은 친구를 위해서 그가 할 수 있었던 것은 몸이 사라지더라도 그 아름다웠던 모습이 기억되도록 대장장이, 보석세공인, 구리세공인, 금세공인들을 불러 모아 조각으로 남기는 일이었다. 그래서 프랑스 철학자이자 매개론자인 레지 드브레(Régis Debray)는 "죽음의 파괴에 맞서는 이미지라는 재생"[1]이 미술의 시작이라고 주장한다. 사실 박물관과 미술관을 가득 채우고 있는 고대의 미술품은 대부분 부장품들이다. 그리고 그것은 대리석을 포함한 돌, 나무, 청동, 금, 보석 등 인간의 평균 수명을 압도적으로 능가하는, 영원에 수렴하는 내구성 강한 재료들로 만들어졌다. 이런 예술작품들은 생로병사의 변화를 겪고 결국 덧없이 사라지는 몸이 아니라 비물질적이고 영원한 정신을 대변한다. 그 몸은 정신의 불멸성에 걸맞은 이상화된 몸이어야 했다. 이러한 예술관은 고대미술부터 르네상스와 신고전주의, 그리고 모더니즘까지 장구한 역사를 이루며 이어졌다.

그러나 현대미술의 거장 키키 스미스는 다르게 시작했다. 그의 사십 년 넘는 긴 창작의 궤적은 흥미롭고 특별하다. 1980년대에는 미술사에서 좀처럼 시도되지 않았던 파편화된 몸과 내장기관 등을 작품으로 다뤄 충격을 주었다. 1990년대에는 신체를 다루는 작업에 집중하면서 서구 문화 속에서의 여성을 둘러싼 기성 담론을 해체하는 페미니즘 미술 발전에 큰 기여를 했다. 2000년대에 들어서면서는 동물, 우주, 자연이라는 보다 넓은 영역으로 작품세계가 확장되었다. 이런 발전 과정이 연대기적으로 단선적이었던 것은 아니다. 이전 시대의 작품에 있던 요소가 후기 작품의 주요 모티프가 되기도 하고, 여러 모티프들의 작품들이 동시에 제작되기도 하면서 지금까지 이어지고 있다. 직관적으로 작품에서 작품으로 연결되는 이 과정을 스미스는 '정원 거닐기(walking around in the garden)' 혹은 '자유낙하(free fall)'[2], '어슬렁거리기(meandering)', '배회하기(wandering)'[3] 같은, 목적지가 정해져 있지 않은 자유로운 움직임으로 비유해서 표현하곤 했다.

'배회하기'라는 표현은 스미스가 편견 없이 다양한 문화적

1
레지스[레지] 드브레, 정진국 역, 『이미지의 삶과 죽음』, 글항아리, 2011, p.37.

2
Kiki Smith, interview by Christopher Lyon, "Free Fall: Kiki Smith on Her Art," *Kiki Smith*, ed. by Helaine Posner, New York: The Monacelli Press, 2005. p.37.

3
Anna Sansom, "'It's our intervention that causes the mayhem': Kiki Smith on Work, Wandering and the Wonders of Nature," *The Art Newspaper*, September 26, 2019. https://www.theartnewspaper.com/2019/09/26/its-our-intervention-that-causes-the-mayhem-kiki-smith-on-work-wandering-and-the-wonders-of-nature

4
Anna Sansom, "'It's our
intervention that causes
the mayhem': Kiki Smith on
Work, Wandering and the
Wonders of Nature."

소스를 받아들였다는 점을 강조할 때도 사용했다.[4] 실제로 가톨릭 미술, 서양 중세미술, 미국 민속미술, 멕시코 민속미술, 팝아트와 동시대 페미니즘 미술, 중국 명나라 시대의 예술, 불교조각, 앤티크 소품, 장식미술 등, 그가 참조하고 작품 속으로 끌어들이는 문화적 요소들은 일일이 다 나열할 수 없을 만큼 다양하다. 스미스가 다루는 매체와 재료 역시 그만큼 다채로워서 에칭, 석판, 리놀륨, 목판, 시아노타이프 등의 판화와, 드로잉, 사진, 도자기, 유리, 청동, 알루미늄, 비즈, 수예, 태피스트리를 아우른다. 하나의 형상이 성격이 다른 여러 재료로 만들어지기도 하는 흥미로운 창작의 과정을 보여준다. 이러한 방식으로 키키 스미스는, 이 짧은 글에서 감히 그 전부를 헤아릴 수 없을 만큼 광대하고 풍요로운 작품세계를 구축했다. 작가의 '배회하기'는 우리의 관람 방법이 되기도 할 것이다. 하나의 작품을 이해하기 위해서 연관된 여러 작품들을 두루 찾아 살펴보는 즐거운 '거닐기'를 이어 나가다 보면, 그 안에서 우리는 충격, 슬픔, 연민, 그리고 작가가 건네는 따뜻한 농담, 치유와 회복의 힘도 만날 수 있을 것이다.

　　잘 알려져 있다시피 키키 스미스의 아버지는 유명한 미니멀리스트 조각가 토니 스미스(Tony Smith)이고, 어머니는 오페라 가수 제인 로런스 스미스(Jane Lawrence Smith)다. 아버지는 집에서 작업을 했고, 키키 스미스는 두 쌍둥이 여동생 시턴과 베아트리스와 함께 거실에서 아버지의 작업을 돕곤 했다. 예술이 넘치는 분위기 속에서 성장했지만, 처음부터 예술가가 되려는 생각은 없었다. 전기 기술자 조수, 요리사 등 다양한 일을 경험하면서 젊은 시절을 보냈다. 1978년부터 언더그라운드 예술가들의 모임인 콜랩(Colab, Collaborative Projects, Inc.) 활동으로 미술계와 관련을 맺고 작업을 시작했지만, 그녀를 본격적인 예술 작업으로 등을 떠민 것은 가족의 죽음이었다. 오래된 물건이 쌓여 있는 집 안에는 묘한 죽음의 분위기가 감돌았다. 아버지 토니 스미스는 잔병치레를 하며 죽음이 늘 곁에 있다고 생각했고, 결국 1980년 세상을 떠났다. 해부학 책 『그레이 해부학(Gray's Anatomy)』을 읽고 드로잉을 했던 것도, 1985년에 베아트리스와 함께 응급구조사(EMT) 훈련을 받았던 것도 죽음과 몸에 대한 관심에서 비롯되었다. 그러던 베아트리스도 1987년 에이즈로 세상을 떠났다.

　　1960년대 후반 이후 퍼포먼스 아트와 페미니즘 미술가들의

활동으로 '몸'에 대한 관심이 꾸준히 증가하고 있었다. 특히 스미스가 작품 활동을 시작한 1980년대는 이러한 경향이 더욱 강화되었다. 몸은 소비사회, 정체성, 젠더, 에이즈, 동성애, 낙태권 투쟁, 페미니즘 등의 이슈와 결합하면서 활발하게 논의되었다. '몸'을 둘러싼 '살고 죽기'의 문제가 사회적이고 정치적인 일이라는 것이 본격적으로 인식되는 시기이기도 했다. 이러한 시대적 흐름과 더불어 키키 스미스는 개인적으로는 가족의 죽음을 안타깝게 지켜봐야 했다.

유한성을 가진 취약한 몸에서 키키 스미스의 예술이 시작되었다. 그것은 기존의 미술과 출발점이 근본적으로 다르다는 것을 의미한다. "죽음의 파괴에 맞서는 이미지라는 재생"을 전략으로 택한 예술은 불멸의 영웅상들을 만들어냈다. 레지 드브레가 지적했던 것처럼 이미지를 남기는 것은 심각한 권력의 문제였다. 그 자리를 차지한 것은 대부분 남성 권력자였다. 그리고 그 형상이 인간상의 기준으로 작동해 왔다.[5] 이것은 동시에 '불멸의 정신' 대 '필멸의 몸'이라는 이원론적인 관념이 이성/감성, 문화/자연, 인간/동물, 남성/여성, 서양/동양 등 다양한 개념쌍들을 만들어내면서 서구 문화 깊숙이 자리잡아 가는 과정이기도 했다. 가장 큰 문제는 개념쌍의 전자가 후자에 대해 지배적인 요소로 작동하면서 차별적인 위계질서를 구축한다는 점이다. 스미스 역시 우리가 직면한 여러 문제들이 정신과 몸을 나누고 몸을 경시하는 '위계적인 이원론(hierarchical dualism)'에서 기인한다고 여러 인터뷰에서 이야기한다.[6] 시작점이 다르니 당연히 도달점도 다르다. 앞서 지적한 대로 스미스는 재료의 사용에서도, 인간, 자연, 동물의 관계를 해석하는 데서도 이원론의 틀에 갇히지 않는다. 영원한 정신 대신 몸의 취약함을 받아들인 예술은 반드시 조형의 언어를 바꾸고, 그 과정에서 이원론의 틀에 다양한 균열들을 가져오게 된다. 취약한 몸에서 시작된 이야기는 삶에 대한 '다른' 이야기를 펼쳐낸다.

파편화된 몸이 말하는 것

키키 스미스는 1980년대 초반의 작품들을 아버지의 죽음과 관련해서 설명하곤 한다. 토니 스미스는 1980년 12월 26일 세상을 떠났다. 구세주의 탄생을 기념하는 크리스마스 휴가 기간에 가족은 죽음을 맞이했다. 그리고 그 무렵 작가는 길에서 우연히

5
고대 그리스 고전기의 조각가 폴리클레이토스는 이상적인 인체 비례에 대해 연구하기 위해 논문을 썼다. 그리고 그 이론을 적용해 '남자'의 형상을 작품으로 만들었다. 흔히 '도리포로스(Doryphoros, 창을 들고 걸어가는 남자)'라고 부르는 이 작품의 원래 제목은, 논문의 제목과 동일한 〈규범(Canon)〉이었다. 즉, 모두가 따라야 할 본보기라는 뜻이었고, 실제로 이 조각품은 후대의 미술에 큰 영향을 끼쳤다.

6
Kiki Smith, interview by Christian Lund, "Kiki Smith Interview: In a Wandering Way," Louisiana Channel, October, 2018. https://www.youtube.com/watch?v=RLeanMwWSs8; Kiki Smith, interview by Carlo McCormick, *Journal of Contemporary Art*, 2008. http://www.jca-online.com/ksmith.html

라텍스 손을 발견한다. 이 작은 손에서 작품은 시작되었다. 그것을
보존병에 넣고 수족관에서 쓰던 물을 넣었는데, 뜻하지 않게
그곳에서 조류(藻類)가 자라기 시작했다. 이후 1983년 자신의
손을 본떠서 만든 라텍스 손을 병에 넣어 작품 〈병 속의 손(Hand
in Jar)〉(p.151)을 완성했다. 같은 절단된 손이라 하더라도, 로댕의
작품처럼 직립해서 하늘로 솟구치는 형상은 구원의 가능성을
떠올리게 하지만, 하강하는 형태는 즉각적으로 상실감, 죽음을
떠올리게 한다. 거기에 조류까지 생겨나면서 부패의 느낌이
더해졌다. 그런데 조류가 자라나는 모습은 죽음에 대한 다른
해석을 가능하게 해 주었다. 스미스를 흥분하게 한 것은 바로 이
부분이었다. 한 개체의 죽음은 분명 슬픈 것이지만, 결코 세계의
종말은 아니다. 죽은 몸은 미생물에 의해 분해되어 다시 다른
생명으로 연결이 된다. 후에 그녀는 이 작품과 관련해서 우리
모두는 공생관계에 있는 '작은 생태계(small ecosystem)'라고
말한다.[7] 이러한 과정은 육체의 취약성에 대립되는 정신의
불멸성을 추구하는 기존의 예술적 관행과는 정반대되는 것이다.
키키 스미스가 인간의 몸을 죽음과 삶이 순환하는 생태계의 한
고리로 보는 것은 그가 이후 자연과의 관계를 다루는 미술로
넘어가는 중요한 단서가 된다.

　　1980년대 내내 키키 스미스는 파편화된 몸을 다루는 일련의
작품들을 발표했다. 위장, 동맥과 정맥, 남녀 생식기 등, 얼핏
들으면 도저히 예술이 될 수 없을 것 같은 인체의 내장기관들을
유리, 세라믹, 청동 등 다채로운 재료를 동원해서 작품으로
만들어 나갔다. 작품 〈내가 여기 있음을 아는 방법(How I Know
I'm Here)〉(1985-2000)은 이런 절단된 사지와 내장기관을 다루는
작품들의 의미를 보여준다. 아버지가 세상을 뜨고 몇 년 뒤 기일
무렵, 멕시코를 방문했던 스미스는 그곳 사람들 특유의 활기에 큰
감명을 받았고, 몸을 통해서 '여기 있음(being here)'[8]을 표현하는
작품을 구상했다. 현존의 감각을 표현하기 위해 그는 철학적
존재론의 장광설에 의존하지 않았다. 그 대신 심장과 허파, 남녀
생식기 한 쌍, 콩팥과 간, 위와 뇌를 보여주는 작품을 만들었다.
이것은 근대적 이원론을 체계화한 철학자 데카르트의 유명한 언명
'나는 생각한다, 고로 존재한다'에 대한 직접적인 반론처럼 보인다.
데카르트는 몸과 정신을 대립시키고 인간을 정신적인 존재로
상정했지만, 스미스는 반대로 내장기관들, 즉 몸을 통해서 현존을

7
Kiki Smith, interview by
David Frankel, "In Her Own
Words," *Kiki Smith*, ed. by
Helaine Posner, Boston;
New York; Toronto; London:
Bulfinch press, 1998. p.32.

8
Kiki Smith, "Kiki Smith,"
Aperture, no. 137, Fall, 1994,
p.34.

확인하고 있는 중이다. 절단된 사지와 내장기관을 다루는 작품들은 결코 죽음을 전시하기 위한 것이 아니라, 지금 이곳에서 살아 있음을 확인하기 위한 것이었다. 겉보기엔 충격적일 수 있는 이 작품들은 죽음으로부터 삶으로 돌아오는 과정이었고, 키키 스미스 자신을 위한 자기 치유(self-healing)의 과정이기도 했다.

1990년대에 접어들면서 키키 스미스는 본격적인 전신상 작업을 시작한다. 이때 그는 종이나 밀랍처럼 부드럽고 내구성이 떨어져 보이는 재료를 사용해 인간 몸의 취약성을 드러냈다. 파편화된 신체를 직접 다루지 않을 때도, 신체를 분절해서 바라보는 시선은 다른 방식으로 유지된다. 예를 들어, 완성된 조각 작품을 찍은 사진 작품에서 이러한 시선을 볼 수 있다. 조각이란 기본적으로 덩어리(양감)를 전체로 인식하는 것이니 각 사지와 몸통의 비율, 포즈, 동세 등을 보는 것이 우선이다. 그런데 키키 스미스가 이 조각품들을 찍을 때는, 파편화된 몸을 다룬 작품들의 계보를 잇는 것처럼 작품의 일부만을 찍는 경우가 대다수다.

사진 〈무제(허니 왁스)〔Untitled(Honey Wax)〕〉(1995, p.231)는 조각 작품 〈허니 왁스〉(1995, pp.156-157)의 일부분을 찍은 작품이다. 태아처럼 웅크리고 있는 여성의 몸은 양수에 떠 있는 것처럼 사지의 어느 부분에도 힘이 들어가 있지 않다. 왼팔은 무기력하게 뻗고 있지만 오른팔은 태아처럼 접고 있는 것 같기도 하고, 생각에 잠긴 듯 손을 턱 쪽에 괴고 있는 것 같기도 하다. 이 작품은 보통 오른쪽 어깨가 좌대 위에 닿도록 놓인다. 키키 스미스가 사진으로 포착한 부분은 공중에 떠 있는 왼쪽 손과 두 발이다. 사진과 같은 시점에서 보려면 작품의 아래쪽에 앉아서 봐야 하는데, 이는 전시장을 걸어 다니면서 보는 관람객들의 일반적인 시선이 아니다. 오히려 이것은 키키 스미스가 자신의 작품을 바라보는 시선에 가깝다. 사실 〈허니 왁스〉는 〈웅크린 몸(Curled Up Body)〉(1995)이라는 청동으로 만들어진 다른 버전의 작품이 존재한다. 굳이 청동이 아니라 밀랍으로 된 작품을 사진의 대상으로 삼은 것은 완전히 다른 효과를 가져온다. 사진은 왼손에 포커스가 맞춰져 있어서 앞의 두 발은 아웃포커싱되어 흐릿해졌다. 그 덕분에 조각의 재료인 밀랍의 부드럽고 약한 질감이 더 섬세하게 전해진다. 힘없는 손과 야윈 맨발은 애잔해 보인다. 단단한 재료인 청동을 찍었을 경우에는 느끼기 힘든 감정이다. 그것은 취약한 몸을 가진 존재를 바라보는 연민과 사랑의 시선이다.

29

수치심이 묻은 여자

키키 스미스가 보여준 내장기관과 파편화된 몸은 생물학적인
측면에서 보면 성별, 인종, 나이에 상관없이 모든 인간들이
공통적으로 소유하는 것이다. 이런 몸을 가졌기에 죽음 앞에서
우리는 모두 평등하다. 그러나 죽는 방식은 평등하지 않다. 몸은
생물학적인 존재인 동시에 사회, 문화, 정치적으로 규정되는
존재이기 때문이다. 1990년대에 키키 스미스는 여성의 몸을
주제로 한 과감한 작품들을 쏟아냈다. 오줌 누는 여자〈소변보는
몸(Pee Body)〉(1992, p.161), 온몸이 흥건한 피로 가득 찬 채
태아처럼 웅크리고 있는 여자〈피 웅덩이(Blood Pool)〉(1992, p.154),
피부를 벗겨내고 근육과 혈관으로 묘사된〈성모 마리아(Virgin
Mary)〉(1992, p.155), 생리혈을 흘리는 여자〈트레인(Train)〉(1993)
등 충격적인 작품들을 발표했다. 이 작품들은 여성의 몸과 인간의
몸에 흐르는 액체들에 대한 우리의 태도가 결코 중성적이지 않음을
보여준다. 사실 살아 있는 사람의 몸에는 여러 종류의 액체가
흐르고, 이들 없이는 삶을 유지할 수 없다. 그럼에도 이 액체들은
밖으로 나오는 순간, 공포와 혐오를 유발한다. 이 액체를 통제하고
적절하게 배출하는 것은 문화적으로 중요한 일이었다. 영원한
정신을 대변하는 조각들은 완벽한 표면으로 마무리되면서 마치
이런 액체, 분비물이 없는 존재처럼 인간을 묘사해 왔다. 반면 눈물,
월경, 젖 등 액체를 흘리는 여성의 몸은 고결한 정신과 거리가 먼
동물적인 몸이라고 여겨졌다.

〈테일(Tale)〉(1992, p.158)이라는 제목이 달린 작품의 여성은
인간의 직립 보행의 역사를 부정하듯, 네 발로 기어 전시장에
등장했다. 이 작품은 작가가 암스테르담의 고문박물관에서 보았던
중세의 고문 기구에서 영감을 받았다. 형벌을 받는다는 것은
육체적 고통뿐 아니라 인격 말살의 고통을 함께 경험하게 되는
일이다. 여인의 엉덩이는 배설물에 의해 더럽혀졌고, 그 더러운
배설물은 벗어날 수 없는 치욕처럼 끝없이 길게 이어져 있다.
'꼬리(tail)'처럼 긴 배설물을 달고 있지만, 작품의 제목은 영어로
동음이의어인 '이야기(tale)'이다. 여성들이 결코 원하지 않은 긴
이야기, 수치심을 불러일으키고 모멸감을 느끼게 하는 긴 이야기가
마치 꼬리처럼 붙어 있다. 인간의 동물성과 취약성을 배제하는
논리는 여성, 타 인종, 성소수자를 배척하고 혐오하는 논리로
이어지곤 했다. 미국의 철학자이자 법학자인 마사 누스바움(Martha

9
마사 누스바움, 조계원 역,
『혐오와 수치심』, 민음사,
2015, p.319.

C. Nussbaum)에 따르면 이런 혐오는 앞서 지적했던 것처럼 정신
우위에 입각한 위계적 이원론에 기반하는 생각으로, 불완전한
인간의 동물성과 취약성을 약자에게 투사함으로써 생겨난다.
혐오의 대상이 된 존재는 자신의 부족함을 부끄러워해야 한다고
끊임없이 사회적으로 학습된다.[9] 이 작품처럼 여성들은 수치심을
강요하는 이야기를 꼬리처럼 달고 굴욕적인 자세로 수천 년을
살아왔다.

가부장제적 관계 속에서 여성의 몸은 오해되고 부정된다.
여성의 몸에 부여된 특정한 포즈와 신체의 형태는 사회문화적으로
규정되어 왔다. 흔히 미술사에서 말하는 도상(iconography)이라는
것은 이런 규정들을 시각적으로 확인해 주는 시스템이다. 키키
스미스는 성모 마리아, 마리아 막달레나, 릴리스 등 성경과 외경에
등장하는 여인들의 도상들을 재해석했다. 전통적인 도상에
도전하는 일은 여성의 몸을 규정하는 사회문화적 가치를 해체하는
일이다. 이런 맥락에서 꽤 추웠던 어느 날 뉴욕에서 내가 마주친
조각은 가장 충격적인 작품이었다. 휘트니 미술관에서 진행 중이던
키키 스미스의 개인전 「키키 스미스: 모임, 1980-2005(Kiki Smith:
A Gathering, 1980-2005)」(2005)에서 이 작품을 보았을 때를 나는
잊지 못한다. 시신처럼 축 늘어져 있는 두 남녀, 늑대의 배를 가르고
나오는 여자 등 충격적인 작품들이 연이었는데, 그중에서도 압권은
거꾸로 매달린 것도 아니고 공중제비를 도는 것도 아닌 기괴한
포즈로 벽에 붙어 있는 여자였다. 〈무제(Untitled)〉(1995, p.165)라는
제목이었고, 흔히 '절하는 여자(Bowed Woman)'라고 별칭되는
작품이었다. 내 인생에서 가장 파격적이고 과격한 절이었다.
'절하는 여자'의 깊이 숙인 몸은 화살표처럼 보였다. 그것은
다른 생각의 방향을 암시하는 듯했다. 나는 예술작품들이 주는
이런 충격의 순간들을 사랑한다. 여러 생각과 감각이 보글보글
끓어오르고, 마침내 새살이 돋는 듯한 순간 말이다. 시간이 지남에
따라 조금 더 어두워진 듯한 색깔은 이 작품이 종이로 만들어졌기
때문이다. 스미스는 1980년대부터 종이로 조각을 만들어 왔다.
인간의 피부가 나이가 들면서 노화되듯이 숨 쉬는 재료인 종이도
역시 시간과 함께 변해 갈 것이다. 더불어 작품을 바라보는
사람들의 생각도 함께 변해 갈 것이다.

이 작품은 실제 인물들의 몸을 캐스팅해서 제작했다. 이웃집
남자의 몸을 본뜨던 중 하체 작업이 끝났을 무렵 그가 바쁘다며

10
Kiki Smith, interview with
France 24, "When fantasy
meets popular folklore: Artist
Kiki Smith's work on display
in Paris," November 14, 2019.
https://www.france24.com/
en/culture/20191114-when-
fantasy-meets-popular-
folklore-artist-kiki-smith-s-
work-on-display-in-paris

가 버려서, 상체는 작가 자신의 몸을 본떠 연결했다. 조각품은
뜻하지 않은 자웅동체의 몸을 가지게 되었다. 작가는 이 의도치
않음을 수용했다. 십자가 책형(crucifixion)은 전통적으로 남성적인
도상이다. 여기에 여성이 등장했다는 것만으로도 작품은 전복적인
성격을 갖게 되었다. 키키 스미스의 주제가 자연과 우주로 확장된
후에도 여성의 몸은 작품의 중심을 차지한다. 이것은 작가가
여성의 몸을 가지고 있기 때문만은 아니다. 한때 남성의 몸이
인간 전체를 대변했던 것처럼 여성의 몸도, 트랜스젠더의 몸도
인간 전체를 대변할 수 있다고 작가는 말한다.[10] 인간은 몸을 가진
존재이고, 그 몸은 언제나 개별성을 가진 구체적인 현존일 뿐,
몸들 사이에는 위계가 존재하지 않는다. 살아 있는 사람들의 어떤
몸이든 의미가 있다. 또 여성의 몸이 등장함에 따라 이 작품에는
흥미로운 점이 배가되었다. 바로 폭포처럼 쏟아지는 머리카락이다.
그것은 지금 여기가 중력의 법칙이 작동하고 있는 지구임을
강력하게 웅변하고 있다.

　　원래 언덕 위에 솟구치듯 서 있는 십자가의 형상은 강력한
상승과 초월에의 의지, 정신을 통한 육체의 극복을 의미한다.
마찬가지로 높은 좌대에 올라가 우뚝 서 있는 조각상들 역시
중력의 법칙을 이겨내는 초자연적인 팔루스적 형상을 하고
있다. 이십세기 초반 모더니즘 미술 운동을 주도하던 몇몇
예술가들도 자연의 법칙인 중력의 법칙을 초월하고자 분투했다.
예컨대 말레비치 같은 아방가르드 작가는 지금까지 인류의
자유를 구속하던 중력의 법칙을 초월할 것을 주장했다. 그가
주창한 절대주의 추상화는 중력의 법칙에서 벗어난 사차원의
공간에서 전개되는 순수한 정신성의 표현이었다. 이것은 자연의
정복, 자유로운 비행, 마천루의 건설, 무한한 생산력의 증대로
이어지는 현대 사회의 욕망과도 일맥상통한다. 이 작품 외에도
⟨자유낙하(Free Fall)⟩(1994, p.241), '폭포(The Falls)' 연작(2013,
pp.224-225), ⟨타락(Fallen)⟩(2018) 등의 다른 작품들에서도
떨어지는 여러 형상을 볼 수 있다. 떨어짐을 받아들인다는 것,
상승을 포기한다는 것은 정신/몸, 상승/하강, 초월/타락이라는
이원론의 프레임에 포섭되기를 거부하는 일이다. 더 나아가,
불멸의 정신을 추구하는 대신 유한하고 취약한 몸을 인정하는
것과 마찬가지로, 낙하를 받아들이는 것은 중력의 법칙이 작용하는
지구에서 살아가는 인간의 조건을 그대로 수용하는 것이다.

다시 쓰는 이야기들

1990년대 초반 여성의 몸에 관한 작품들을 쏟아낸 후 키키
스미스의 관심은 서서히 인간과 동물/우주/자연과의 연관성으로
옮겨 가고 있었다. 오래된 신화, 종교적 설화, 민담, 동화는 인간과
동물이 어떤 관계를 갖고 있었는지를 전해 준다. 그런데 여성과
동물의 만남은 대부분 유혹과 타락, 죽음 같은 불길한 이야기의
맥락 속에 놓여 있었다. 스미스는 이런 여성과 동물 이야기를
다시 들여다본다. 그러나 이 경우도 특정 방향, 좋은 관계의
모범을 직접적으로 제시하지는 않는다. 드로잉 작품〈늑대와 함께
누워(Lying with the Wolf)〉(2001, pp.56-57)도 마찬가지다. 이
그림에서는 배경이 생략되어 있기 때문에, 그림 속 인물이 어디에
있는 누구인지를 특정하기 어렵다. 키키 스미스가 다른 작품에서
다뤘던 파리의 수호 성녀 준비에브, 빨간 망토 소녀, 라 로바(La
Loba) 등 관람자들은 늑대와 여성이 등장하는 여러 이야기들을
연상할 수 있다. 그러나 특정한 이야기를 떠올리게 하는 결정적인
단서가 어떤 포즈나 상징물로 함께 그려지지는 않았다. 제목에
쓰인 '눕다'라는 동사는 함께 취하는 휴식이나 성적인 관계를
연상시키는 말이지만, 둘의 표정은 어느 쪽으로도 쉽게 해석하기
힘들다. 심지어 여인과 늑대가 취하고 있는 자세도 공간적으로
쉽게 설명되지 않는다. 이야기를 특정하기 힘든 모호한 상황은
청동 조각〈황홀(Rapture)〉(2001, pp.168-169)과〈탄생(Born)〉(2002,
pp.170-171)이나, 공작, 뱀, 새, 양 등, 중세의 우화집, 전래동화,
기독교 성화에 등장하는 동물들과 여성을 함께 형상화한 여러 다른
작품들에서도 마찬가지다.

이런 모호함은 거꾸로 여성과 동물의 이야기가 다시 씌어져야
함을 요구하는 것은 아닐까?〈초원(꿈꾸기, 배회하기, 잠자기,
둘러보기, 기대기)〔Pasture(Sleeping, Wandering, Slumber, Looking
About, Rest Upon)〕〉(2009, p.180)은 작가가 루이스 캐럴의『이상한
나라의 앨리스』를 모티프로 2003년부터 시작한 작업이다. 이
작품에 등장하는 여인의 비례는 초기 작품과는 상당히 다르다.
2000년대 초반부터 스미스는 더 이상 실제 인간의 몸을 캐스팅하지
않았다. 초상화처럼 특별한 모델이 있는 경우가 아닌 가공의
이야기 속 인물들은 새로운 모습으로 표현되었다. 이 인물들의
몸은 작가가 좋아했던 브레드 앤드 퍼핏 극장(Bread and Puppet
Theater)의 거대한 인형들에서 큰 영향을 받았다. 작가가 상상한

33

작품의 배경은 전원이었다. 놀이터의 놀이기구처럼 누워 있는 여인의 주위를 아이들이 뛰어다니기도 하고 올라가기도 하는 평온한 풍경을 상상하며 만들었다고 한다. 실제로 설치되었던 모습을 보면 그 상상이 틀리지 않았음을 알 수 있다. 이제 작품은 미술관 안에 머물지 않고, 자연 속에서 즐겁게 유희하는 삶의 일부가 된다. 그리고 여기서도 잠든 여인들과 양들의 관계는 특정되지 않은, 세 가지 모습으로 제시되어 있다. 이야기를 만드는 것은 작품을 즐기는 관람객들의 몫이기도 하다.

여러 옛 이야기 속 여성의 모습을 형상화하는 과정은 우주라는 주제로 연결되기도 했다. 고대 이집트 여신 뉴트를 형상화한 〈뉴트(Nuit)〉(1993)는 우주와 관련된 주제가 등장하는 첫 작품이다. 뉴트는 매일 해를 삼켰다 다음 날 해를 낳는 여신이다. 여성의 몸을 먹는 일과 출산이라는 동물적인 기능으로 설명한 것이다. 스미스는 뉴트의 특별한 몸에 대한 궁금증은 재치있게 공백으로 남겨 두고, 여기서는 팔다리로만 표현했다. 여신이 우주적인 존재임을 암시하는 장식적인 별은 2000년대부터 중요한 주제로 발전해 나간다. 흥미로운 것은 이 별들은 레이스 모양의 컵받침 도일리(doily)에서 영감을 받았다는 점이다. 우주, 광대함, 무한 추구 같은 거창한 말이 나올 법한 순간에 아기자기한 일상용품인 도일리가 언급되면서 우주와 일상, 거대함과 미소함 사이에 존재할 수 있는 위계 관계를 위트있게 뒤틀고 있다.

또 인류는 하늘의 별을 보면서도 친근한 동물의 이야기들을 떠올렸다. 별과 관련된 초기작인 〈별자리(Constellation)〉(1996, pp.96-97)는 밤하늘처럼 깊은 인디고 블루로 염색한 네팔 종이 위에, 별 모양과, 토끼, 개, 뱀, 곰, 황소, 전갈, 숫양, 새, 염소 등 동물 모양의 유리 조각들을 펼쳐 놓은 작품이다. 이 동물들 중 몇몇은 큰곰자리와 작은곰자리, 전갈자리, 까마귀자리같이 우리가 흔히 밤하늘에서 보는 별자리와 관련이 있다. 그런데 이들이 깨지기 쉬운 유리로 만들어졌다는 것은 어떤 위기감의 표현으로 보인다. 실제 이 동물들의 일부 하위 종은 멸종 위기에 처했다. 작가는 동물의 위기는 인간 위기의 신호이며 "자연이 사라지면 우리의 개념이나 정체성 혹은 인간이 어떤 존재인가에 대한 생각도 사라질 것"[11]이라 말한다. 위계적인 이원론 시스템에서 자연은 그저 정복의 대상이었다. 그리고 지금 우리는 무분별한 정복의 참혹한 결과가 초래한 위기에 직면해 있다. 기존의 이야기로는 이 위기를 헤쳐 나갈 수 없다.

11
Kiki Smith, "Mini Documentary—Kiki Smith: I am a Wanderer," Modern Art Oxford, October 31, 2019. https://www.youtube.com/watch?v=G73lQ5NGV9k

지구 위에서 살아가는 존재들의 소중함

부드러운 촉감의 태피스트리는 키키 스미스에게 새로운 대안적인
생각이 자라나는 따뜻한 바탕이 된다. 작가는 2011년부터
태피스트리 작품들을 시작했다. 여기에는 이전 작품에 등장했던
사람, 동물, 우주 그리고 식물 등 모든 것이 함께 어우러지고 있어
그간의 작업을 종합하는 느낌을 준다. 그중 〈회합(Congregation)〉
(2014, p.185)이라는 묘한 제목의 작업을 살펴보자. 화면에는 젊은
여인이 아직 새로운 잎이 나지 않은 쓰러진 나무에 앉아 있다.
여인과 주변에 있는 박쥐, 청솔모 두 마리, 부엉이, 사슴의 눈에서
선이 나와서 서로 부딪히기도 하고 비껴가기도 한다. 이 선들은
키키 스미스가 조심스럽게 제안하는 대안적 세계로의 가이드라인이
될지 모르겠다. 이 선들은 반향위치측정(反響位置測定)이라
번역하는 에콜로케이션(echolocation)[12]을 도해한 듯한 모습이다.
이미 2009년 작품 〈나의 눈으로 너를 듣는다(Hearing You with
My Eyes)〉에서 에콜로케이션하는 대표적인 동물인 박쥐 두 마리를
그렸다. 박쥐는 초음파를 방출하고, 이것이 근처 물체에 부딪혀
되돌아오는 것을 내이(內耳)로 분석해서 방향을 찾고 세상에 대한
정보를 얻는다. 이 작품에서는 방출하는 기관이 귀가 아니라
눈으로 되어 있어 박쥐가 의인화되고 있음을 알 수 있다. 근대
사회에서 시각은 이성적 판단과 관련있는 가장 중요한 감각으로,
청각, 촉각, 후각, 미각보다 우위에 있다고 여겨져 왔다. 동시에
시각은 주체/대상의 이원론적인 사고에서 가장 중요한 감각이기에
일방적인 시각우위론은 지속적인 비판을 받아 왔다. '나의 눈으로
너를 듣는다'라는 말은 시각을 포함한 다른 감각으로 세상을
종합적으로 수용하고 있는 상태를 의미한다.

　　〈회합〉에서 여인과 동물들 눈에서 나오는 색색의 선들은
반짝이는 비즈 장식이 달린 것처럼 화려하고, 일부는 태슬(tassel)로
끝나기도 한다. 드로잉 작품 〈메시지(Message)〉(2010)는 선들의
또 다른 의미를 구체적으로 보여준다. 밝은 톤으로 그려진 여성의
눈에서 나오는 두 개의 선이 어둡게 그려진 다른 여성을 향하고
있다. 부드러운 태슬 모양의 시선은 상대를 소중하게 쓰다듬는 듯
바라본다. 같은 해에 그려진 〈홈(Home)〉(p.105)에서는 두 여인의
눈에서 나오는 태슬 모양의 선이 아래로 흐르고 있다. 그것은 키키
스미스의 아픈 가족사를 떠올리게도 하고, 동시에 죽음을 맞이할
수밖에 없는 모든 취약한 존재를 향한 연민의 눈물처럼도 보인다.

12
에콜로케이션이란,
동물이 자신의 입이나
콧구멍으로부터 음파를
발사해, 그 음파가 물체에
부딪쳐 되돌아오는
메아리를 듣고, 물체와
자기와의 거리를
측정하거나 그 물체의 형태
등을 구별하는 것을 말한다.

13
Kiki Smith, interview by
Christian Lund, "Kiki Smith
Interview: In a Wandering
Way."

14
최유미, 『해러웨이, 공-산의
사유』, 도서출판b, 2020,
p.203.

15
도나 해러웨이, 최유미
역, 『트러블과 함께하기』,
마농지, 2021, p.10.

앞서 지적했던 것처럼 취약한 몸을 받아들이면서 시작되었던 예술작품은 인간과 세계, 주체와 대상과의 관계를 다르게 정립한다. 사진을 바탕으로 드로잉을 한 '폭포' 연작에서 우리는 키키 스미스의 얼굴을 직접 볼 수 있다. 〈폭포 I〉에서는 작가의 눈과 귀로부터, 더 나아가 〈폭포 II〉〈폭포 III〉에서는 코, 입으로도 흰 선이 쏟아지고 있다. 흰 선은 형상적으로는 폭포를 암시하면서 동시에 '나의 눈으로 너를 듣는' 상태에 있다는 것을 의미한다. 더 나아가 문신이 있는 어깨와 팔은 별이 총총히 박힌 하늘이 되고, 쏟아지는 머리카락은 거대한 폭포가 된다. 이 작품에서 키키 스미스는 하나의 자연이 되어 세상과 감응(affect)하고 있다. 2018년 자신의 작품세계를 돌이켜 보는 자리에서 스미스는 "나는 자연이다(I am nature)"[13]라고 선언한다. 지금 인간이 처한 위기의 해법은 또 다시 자연을 구제의 대상으로 바라보는 것이 아니라 위기를 초래한 위계적 이원론에 근거한 사유의 틀을 거둬내고, 결국 우리 자신도 자연임을 깊이 자각하고 감응하는 것이다. 이런 모티프는 〈보내다(Send)〉(2016, p.103), 〈벅차오르다(Surge)〉(2016), 〈전송(Transmission)〉(2016), 〈날씨(The Weather)〉(2019, p.102) 등 이후의 여러 작품들에서도 반복해서 등장할 정도로 키키 스미스의 작업에서 큰 비중을 차지하고 있다. 1983년 작품 〈병 속의 손〉에 내재되어 있던, 우리 모두는 공생관계에 있는 '작은 생태계'라는 생각은, 작품들 속에서 이처럼 다양하게 발전했다.

다시 〈회합〉으로 돌아가 보자. 여기서는 복수종(multispecies)의 존재들이 주체가 되는 공생의 장이 펼쳐질 가능성에 대해서 언급하는 것처럼 보인다. 여인과 동물들의 눈에서 나오는 색색의 선들은 모두 조금씩 다른 방식으로 형상화되어 누구의 시선이 더 옳다거나 아름답다거나 하는 정오 판단, 미추 판단을 넘어선다. 유한한 몸을 가진 존재들은 자기의 위치에서만 보게 된다. 모두 상대적인 입장에서 이야기할 수밖에 없기 때문에 시선의 다양성은 당연한 것이다. 이를 인정하고 서로에게 귀 기울이고 바라보고 반응해 주는 '응답능력(response-ability)'[14]은 새로운 이야기들을 만들어낼 수 있는 근거가 된다. 모든 존재로부터 나오는 선들은 새롭게 연결되며 다른 이야기를 써 나가는 시작점이 될 수 있다. 그리고 그 연결은 도나 해러웨이(Donna J. Haraway)가 복수의 생명체들이 함께 살아가며 새로운 관계 속에서 새롭게 세상을 만들어 가는 방식으로 제안한 '실뜨기(string figure)'[15]를

연상시킨다. 실뜨기는 이원론적인 주체가 행하는 것처럼 상대방을 타자화하는 일방적 실천이 아니다. 말 그대로 실뜨기 놀이처럼 상대방이 어떤 방식으로 응대하느냐에 따라 결과와 그 이후의 실천이 달라지는 과정이다. 여기엔 정해진 답도 없고, 상황을 주도하는 우월적인 존재도 없다. 이원론의 진정한 극복은 그 프레임 자체를 무화하는 것이다. 그것은 어떤 위계도 없이 모든 "지구 위에서 살아가는 존재들의 소중함(the preciousness of being on earth)"16을 깨닫는 일이다. 새로운 관계 맺음은 새로운 이야기의 출발점이 된다. 지금 우리가 키키 스미스라는 세계를 배회하면서 놀라고 감탄하고, 아름다움을 느끼고, 의미를 찾고 의견을 나누는 이 모든 과정도 새로운 이야기를 만드는 일에 함께하는 것이다.

16
Kiki Smith, conversation with Petra Giloy-Hirtz, "Kiki Smith: Procession: 'A Wonder Version of Life,'" *Kiki Smith: Procession*, ed. by Petra Giloy-Hirtz, Munich: Haus der Kunst & Prestel, 2018. p.22.

이진숙(李眞淑)은 서울대학교 독어독문학과를 졸업하고 동대학원에서 석사학위를 받은 뒤, 러시아 국립인문대학교에서 미술사 석사학위를 받았다. 지은 책으로 『위대한 고독의 순간들』(2021), 『인간다움의 순간들』(2020), 『롤리타는 없다』(2016), 『시대를 훔친 미술』(2015), 『위대한 미술책』(2014), 『미술의 빅뱅』(2010), 『러시아 미술사』(2007) 등이 있다.

Art that began with a vulnerable body

In the *Epic of Gilgamesh*, the oldest written epic on Earth, the moment when art was born is described in an interesting way. More than five thousand years ago, Gilgamesh, king of the Sumerian kingdom of Uruk, witnessed the death of his friend Enkidu. This stirred in him the desire for what was beyond death, the immortal. However, immortality is not available for humans. What he could do for his friend was to gather blacksmiths, jewelers, coppersmiths, and goldsmiths and preserve his beauty in sculpted form so that it would be remembered even after the body was gone. This is why French philosopher and mediologist Régis Debray argues that the "regeneration that is the image against the destruction of death"[1] is the beginning of art. In fact, most of the ancient artifacts that fill up the rooms of museums and art galleries are burial goods. The materials used for these goods are durable, such as marble, stone, wood, bronze, gold, and gemstones—materials that outlast the average human lifespan. These art works are meant to represent the immaterial and eternal spirit, not the ephemeral body that eventually disappears after the oscillations of life. The represented body had to be an idealized body commensurate with the immortality of the spirit. This view of art have continued through a long history, from ancient art to the Renaissance, Neoclassicism, and modernism.

But Kiki Smith, a master of contemporary art, starts from a different point. The long trajectory of her creative practice that spans over 40 years is interesting and unique. In the 1980s, her practice shocked the art world by dealing with fragmented bodies and internal organs, subjects rarely treated in art history. In the 1990s, as her practice continued to focus on the body, Smith made great contributions to furthering feminist art that attempted to deconstruct the existing discourses around women. Coming into the 2000s, her works expanded to include animals, the universe, and nature. This line of development was not chronologically linear. Elements in past works would later recur as motifs for future works, and sometimes different motifs would appear across various works created around the same time. This process, in which there is an intuitive connection from work to work, Smith describes as "walking around in the garden," "free fall,"[2] "meandering," or "wandering,"[3] free movement that has no set destination.

The term "wandering" was used also when she emphasized that she adopted diverse cultural sources without prejudice.[4] From Catholic

1
Régis Debray, trans. by Jung Jinguk, *Imijiui samgwa jugeum*, Paju: Geulhangari, 2011, p.37; *Vie et mort de l'image*, Paris: Gallimard, 1995.

2
Kiki Smith, interview by Christopher Lyon, "Free Fall: Kiki Smith on Her Art," *Kiki Smith*, ed. by Helaine Posner, New York: The Monacelli Press, 2005. p.37.

3
Anna Sansom, "'It's our intervention that causes the mayhem': Kiki Smith on Work, Wandering and the Wonders of Nature," *The Art Newspaper*, September 26, 2019. https://www.theartnewspaper.com/2019/09/26/its-our-intervention-that-causes-the-mayhem-kiki-smith-on-work-wandering-and-the-wonders-of-nature

4
Anna Sansom, "'It's our intervention that causes the mayhem': Kiki Smith on Work, Wandering and the Wonders of Nature."

art to Western medieval art, American folk art, Mexican folk art, pop art, contemporary feminist art, Chinese Ming Dynasty art, Buddhist sculptures, antique props, and decorative art, the gamut of cultural elements she refers to and brings into her work is too wide to list them all. The media and materials Smith employs are also as diverse, ranging from various print methods—etching, lithography, linoleum, woodblocks, cyanotype prints—to drawings, photography, ceramics, glass, bronze, aluminum, beads, handicrafts, and tapestry. We see here an interesting creative process, where a single form is often made with different materials of different characteristics. In this way, Kiki Smith has built a world of art so vast and rich that it would be impossible to do justice to it in this short essay. Smith's "wandering" will also be our way of viewing. To understand one work, we will pleasantly "walk around" to search and look into several other related works, and in this process we will encounter shock, sadness, compassion, as well as warm jokes and the power to heal and restore that the artist offers.

As is well known, Kiki Smith's father was the renowned American minimalist sculptor Tony Smith, and her mother was actress and opera singer Jane Lawrence Smith. Her father worked at home, and Kiki Smith would help him along with her two twin sisters Seton and Beatrice. She grew up in an atmosphere filled with art, but the desire to become an artist did not come until later. She spent her youth doing various kinds of work—like working as an electrician's assistant and as a cook. She started working as an artist in 1978 when she became involved with an underground artist collective called Collaborative Projects, Inc. (Colab), but it was not until the deaths of family members that she was thrust into the art world. There was an eerie atmosphere of death in the house where old things piled up. Her father Tony Smith—frequently sick with minor ailments—thought death was always around him and passed away in 1980. The reason she made sketches after reading the anatomy book *Gray's Anatomy* as well as the reason she was trained as an emergency medical technician (EMT) with her sister Beatrice was because of her interest in death and the body. In 1987, Beatrice died of AIDS.

From the late 1960s, there was a steady increase in the interest in the "body" due to the practices of performance art and feminist artists. This tendency gained strength in the 1980s, which was when Smith started her practice. "Body" was rigorously discussed as it combined with other issues such as consumer society, identity, gender, AIDS,

homosexuality, abortion rights, and feminism. It was also a time when there was an earnest recognition that the idea of "life and death" surrounding the "body" was indeed social and political. Against the backdrop of this trend of the times, Kiki Smith mourned the death of her family.

Kiki Smith's art began with the vulnerable and mortal body. This means that the very starting point of her practice was fundamentally different from the existing art world. Art that chose "regeneration that is the image against the destruction of death" as its strategy created immortal images of heroes. As Régis Debray pointed out, making an image was a serious power issue. Most of those spaces were occupied by men in power. And that image has been operating as the standard for the human image.[5] This is simultaneously the process by which paired concepts such as reason/emotion, culture/nature, human/animal, male/female, West/East that stemmed from the binary notion of "immortal spirit" versus "mortal body" were taking deep root in Western culture. The biggest problem is that a discriminatory hierarchy is established as the former of the paired concept exerts dominance over the latter. Kiki Smith also said in several interviews that many of the problems we face stem from "hierarchical dualism," which divides the mind and the body, and subsequently downplays the body.[6] Because the starting point is different, so is the ending point. As pointed out earlier, whether it is in her use of materials or interpreting the relations between humans, nature, and animals, Kiki Smith is not confined to the framework of dualism. Art that accepted the vulnerability of the body instead of the eternal spirit changes the language of giving form to something, and in the process brings about various fissures in the framework of dualism. The story that starts from the vulnerable body unfolds a "different" story about life.

What the fragmented body speaks

Kiki Smith often speaks of her works from the early 1980s in relation to her father's death. Tony Smith died on December 26, 1980. It was during the Christmas season, a time when the birth of a Savior was celebrated. Around this time, Kiki Smith stumbles upon a latex hand on the street, and a work was started from this little hand. She put the hand in a preservation bottle, added water from the aquarium, and unexpectedly saw algae starting to grow. In 1983, she put a latex hand—this time

5
Polykleitos, a sculptor of ancient classical Greece, wrote a treatise to study the ideal proportions of the human body. And he applied his theory to make a "male" body shape. Commonly known as the *Doryphoros* ("Spear-bearer"), this sculpture was originally titled *Canon*, the same title as his treatise. In other words, it was meant to be an example for all to follow. In fact, this sculpture was to have a great influence on later art.

6
Kiki Smith, interview by Christian Lund, "Kiki Smith Interview: In a Wandering Way," Louisiana Channel, October, 2018. https://www.youtube.com/watch?v=RLeanMwWSs8; Kiki Smith, interview by Carlo McCormick, *Journal of Contemporary Art*, 2008. http://www.jca-online.com/ksmith.html

molded from her own hand—into a mason jar to complete her *Hand in Jar* (p.151). The same severed hand, when directed upward in a soaring manner, like in Rodin's work, evokes the possibility of salvation, but when it is directed downward in a descending manner, it immediately evokes a sense of loss and death. The algae add to the sense of decay. But the way in which the algae grew allowed for a different interpretation of death. What excited Smith was precisely this aspect. The death of an individual is certainly sad, yet it is by no means the end of the world. The dead body is decomposed by microorganisms only to be connected to another life. Later, in speaking about this work, Kiki Smith commented that we are all "small ecosystems"[7] that are in symbiotic relationships. That stands in stark contrast to the existing practices of art where the immortality of the spirit is pursued instead of the vulnerability of the body. Kiki Smith's view of the human body—as a link in an ecosystem in which death and life are in a cycle—is an important key in her transition to dealing with our relationship with nature.

Throughout the 1980s, Kiki Smith released a series of works dealing with the fragmented body. The internal organs of the human body, such as the stomach, arteries and veins, male and female genitalia—things that at first glance seem utterly unsuitable for art—were made with a variety of materials such as glass, ceramics, and bronze. *How I Know I'm Here* (1985-2000) shows the significance of works of severed limbs and organs. A few years after her father's passing, around the anniversary of his death, Smith visited Mexico and was deeply impressed by the unique vitality of its people, prompting her to create a work that expressed through the body the sense of "being here."[8] To express this sense of existence, she did not rely on the lengthy philosophical theories on ontology. Instead, she created works that showed the heart and lungs, a pair of male and female genitalia, kidneys and the liver, the stomach and the brain. This seems like a direct objection to "I think, therefore I am," the famous statement by Descartes who systematized modern dualism. Descartes pit the body against the mind, positing humans as spiritual beings, but Smith, by contrast, is confirming existence through internal organs—that is, the body. Works that deal with severed limbs and organs were never meant to be displays of death—they were always about confirming that we are living here, now. Seemingly shocking, these works were a process of returning from death to life, a process of self-healing for Kiki Smith herself.

7
Kiki Smith, interview by David Frankel, "In Her Own Words," *Kiki Smith*, ed. by Helaine Posner, Boston; New York; Toronto; London: Bulfinch Press, 1998. p.32.

8
Kiki Smith, "Kiki Smith," *Aperture*, no. 137, Fall, 1994, p.34.

Entering the 1990s, Kiki Smith adopted the life-size human figure as her subject. She used soft or less durable materials such as paper or wax to expose the vulnerability of the human body. Even when not directly working with fragmented bodies, the perspective that sees the body as fragmented continues in different ways. We identify this in her photographic works of her own sculpture. Sculptures usually involve perceiving mass as a whole, so the priority is to look at proportions, postures, and movements of the limbs and torso. But when Kiki Smith photographs her sculpture, the images are mostly of the parts of the sculpture, a process that is in keeping with her other works that deal with fragmented bodies.

Untitled (Honey Wax) (1995, p.231) is a photographic work based on parts of her sculpture Honey Wax (1995, pp.156-157). A woman's body is curled up like a fetus, and the limbs are loosened as if she is floating in amniotic fluid. The left hand is outstretched but only lethargically, and the right arm seems either folded like a fetus, or put under the chin, as if immersed in thought. This work is usually displayed with the right shoulder touching the pedestal. What Kiki Smith captured in her photographs is the left hand and two feet suspended in the air. To get a view similar to what is in the photos, the audience has to look at the sculpture from below, which is not the usual point of view the audience has when walking around the exhibition hall. This would be closer to how Kiki Smith sees her own work. There is in fact a bronze version of Honey Wax titled Curled Up Body (1995). Taking photos of a beeswax sculpture and not a bronze sculpture brings about a completely different effect. The photo's focal point is on the left hand, thus blurring the two feet. This composition more delicately delivers the soft and fragile texture of beeswax. The feeble hands and bare emaciated feet look altogether vulnerable. It is an impression that is difficult to convey when photographing hard material like bronze. This is the gaze of compassion and love toward beings with vulnerable bodies.

Woman with a stain of shame

From a biological point of view, the internal organs and fragmented bodies that Kiki Smith shows are common to all human beings regardless of gender, race, or age. Because of this shared body, we are all equal in the face of death. But the ways in which we die are not equal. This is because the body is not only a biologically entity—it is also an entity that

is socially, culturally, and politically defined. In the 1990s, Kiki Smith released a stream of daring—and shocking—works on the female body: a woman urinating in *Pee Body* (1992, p.161); a woman covered in blood crouching in fetal position in *Blood Pool* (1992, p.154); a woman stripped of skin and expressed only through musculature and veins in *Virgin Mary* (1992, p.155); and a woman dripping menstrual blood in *Train* (1993). These works reveal that our attitude towards the female body and bodily fluids is by no means neutral. There are different kinds of bodily fluids within a living human body, and without them life cannot be sustained. Yet, once these fluids leak out of the body, they elicit horror and disgust. Managing and regulating their adequate excretion was an important cultural task. Sculptures standing in for the eternal spirit would represent humans in unblemished surfaces, as if we are beings without such fluids or secretions. Women's bodies that secreted fluids, such as tears, menstrual blood or milk were considered animalistic, far removed from the noble spirit.

The woman in *Tale* (1992, p.158) showed up in the exhibition hall on four legs, as if to deny humans' bipedal history. This work was inspired by a medieval torture apparatus the artist saw at the Torture Museum in Amsterdam. To be punished is to experience not only physical pain but also the annihilation of character. The woman's buttocks are stained by her excrement, trailing behind her like a long-extended mark of shame that cannot be escaped. The excrement is extended like a "tail," yet the title of the work is "tale," its homonym. It seems to stand in for long stories that women never wanted, stories that brought labels of shame and humiliation that always tagged along. The logic that excludes humans' animality and vulnerability often led to the logic of rejecting and hating women, other races, and sexual minorities. According to American philosopher and legal scholar Martha C. Nussbaum, this aversion stems from a hierarchical dualism based on giving precedence to the mind, and it is a function of projecting imperfect human animality and vulnerability onto the weak. The being that has become the object of this aversion is constantly trained to believe to be ashamed of their shortcomings.[9] Like *Tale*, women have passed through thousands of years in humiliating postures with tales that affix shame like long extended tails.

In the patriarchal relation, the female body was misunderstood and denied. The specific postures and body shapes given to women's bodies

9
Martha C. Nussbaum, trans. by Cho Gyewon, *Hyeomowa suchisim*, Seoul: Minumsa, 2015, p.319; *Hiding from Humanity: Disgust, Shame, and the Law*, New Jersey: Princeton University Press, 2006.

have been socially and culturally prescribed. What is often referred to as iconography within art history is a system that gives visual confirmation to those prescriptions. Kiki Smith reinterpreted the iconographies of women from the Bible and the Apocrypha—like the Virgin Mary, Mary Magdalene, or Lilith. To defy traditional iconography is to deconstruct the sociocultural values that prescribe the female body. In this context, the sculpture I encountered in New York on a fairly cold day was the most shocking experience. I will never forget the day I saw this work at Kiki Smith's solo exhibition *Kiki Smith: A Gathering, 1980-2005* (2005) that was happening at the Whitney Museum of Art during that time. There was a series of disquieting works—a man and a woman drooping like corpses, or a woman tearing open and walking out of a wolf's belly— but the most intense of them all was a woman hanging on the wall in a bizarre fashion that was neither upside down nor in the middle of a somersault. The work is *Untitled* (1995, p.165) but is often known as "Bowed Woman." It was the most radical and aggressive bow I have seen in my life. The body of the deeply bowing woman looked like an arrow. It seemed to imply a different direction of thinking. I cherish these mind-blowing moments that art affords—moments where a myriad of thoughts and sense percolate and then finally result in new skin being formed. The reason the work looks darker overtime is because it is made of paper. From the 1980s, Smith has sculpted her works with paper. Just as human skin ages over time, paper—a breathable material—also changes over time. And along with it, people's thoughts change.

This work was made by casting the bodies of actual people. In the middle of the casting process of the man next door, he left saying he was busy when only the lower body was done, so the upper body was cast after the artist's own body. The work became unintentionally hermaphroditic. Smith embraced this accident. The crucifixion is traditionally a male iconography. The mere presence of a woman here gave the work a subversive character. Even when Kiki Smith's interest expanded into nature and the universe, the female body remained a central focus. This is not just because the artist has a female body. Smith once mentioned that if a male can represent all of humanity, a female or a transgendered body can represent all of humanity as well.[10] Humans are beings that have bodies, and those bodies are always concrete, individuated existences—there are no hierarchies between these bodies. Any body of a living person has meaning. The presence of the female

10
Kiki Smith, interview with France 24, "When fantasy meets popular folklore: Artist Kiki Smith's work on display in Paris," November 14, 2019. https://www.france24.com/en/culture/20191114-when-fantasy-meets-popular-folklore-artist-kiki-smith-s-work-on-display-in-paris

body doubled the fascinating aspect of this work. It is particularly the hair that does this job—hair that falls like a waterfall. It is a powerful, eloquent pronouncement that the here and now is the Earth where the law of gravity is at work.

Originally, the shape of the cross soaring from the hill signifies a powerful ascension, the will to transcend, and the overcoming of the body through the spirit. Likewise, the statues standing upright on elevated pedestals take on supernatural phallic forms that overcome the law of gravity. Some artists who were at the forefront of the modernist movement in the early twentieth century also labored to transcend the law of gravity which is the law of nature. Malevich, for instance, was an avant-garde artist who insisted on transcending the law of gravity, which has hitherto constrained human freedom. The abstract painting of Suprematism he advocated was an expression of pure spirit unraveling in a four-dimensional space that lies beyond the confines of the law of gravity. This is in line with the ambitions of modern society that lead to the conquest of nature, free flight, construction of skyscrapers, and the infinite increase of productivity. In addition to this work, Smith's other works also include images and forms of falling—like *Free Fall* (1994, p.241), *The Falls I, II, III* (2013, pp.224-225), and *Fallen* (2018). To accept falling—and to relinquish ascension—is to reject the restraints of the dualistic framework of mind/body, ascend/descend, transcendence/ decadence. Furthermore, just as it is with accepting the finitude and vulnerability of the body instead of pursuing the immortality of the spirit, embracing falling is to accept the human condition as it is on Earth where the law of gravity operates.

Tales rewritten

After releasing a series of works on the female body during the early 1990s, Kiki Smith's interest was slowly making its shift to the interrelation between humans and animals/the universe/nature. Age-old myths, religious tales, folklore and fairy tales tell us about the relationship between humans and animals. But encounters between women and animals are mostly told in the context of sinister stories that speak of temptation, corruption, and death. Smith re-examines these stories about women and animals. But even in this process, she does not directly suggest a certain direction or model for a good relationship. We can see this in her drawing *Lying with the Wolf* (2001, pp.56-57). Here, the

background is omitted, making it difficult to make out exactly who the figure is and where they are. The audience may think of the many tales with wolves and women, even the ones that Kiki Smith herself dealt with in her other works, like St. Geneviève (the patron saint of Paris), Little Red Riding Hood, and La Loba. But no posture or symbol is presented as a decisive clue to link to a specific story. The word "lying" used in the title elicits the image of rest or sexual intercourse, yet the expression on either of the two faces is difficult to make out. The posture of the woman and the wolf is also spatially inexplicable. This ambiguous situation in which no specific story can be ascertained can also be found in *Rapture* (2001, pp.168–169) and *Born* (2002, pp.170–171). The same goes with many of her other works that portray animals—like peacocks, snakes, birds, and sheep found in medieval fables, fairy tales, and Christian iconography— and women together.

One wonders whether this ambiguity is demanding that the story of women and animals be rewritten. Kiki Smith started working on *Pasture (Sleeping, Wandering, Slumber, Looking About, Rest Upon)* (2009, p.180) in 2003, taking Lewis Carroll's *Alice's Adventures in Wonderland* as the motif. The proportions of the woman in this work are quite different from those of her earlier works. Starting in the early 2000s, Smith no longer cast real human bodies. Except in the case of portraits where specific models are involved, characters from fictional stories were given new expression. The bodies of these characters are akin to the large-scale puppets used in the Bread and Puppet Theater that highly influenced her work. The background she imagined was a pastoral place. Smith mentioned that the work was created with a peaceful scene in mind, where children prance around the women who are lying down, like they would in the playground around the playground equipment. If you look at the actual installation, you can see that her vision was not wrong. The work does not stay in the museum but becomes a part of a life that takes joy in nature.

The process of representing women from different tales of old also connected to the subject of the universe. *Nuit* (1993) is her first work to feature a universe-related theme. Nuit is an ancient Egyptian goddess that swallowed the sun every evening and gave birth to it every morning. It was about explaining the female body in terms of the animal function of eating and giving birth. Tactfully leaving the curiosity over Nuit's body aside, Smith portrays her only with arms and legs. The decorative stars,

suggesting that the goddess is a cosmic being, develop into an important theme from the 2000s on. What is interesting here is that these stars were inspired by doilies, which are lace-shaped coasters. At a moment when grandiose words like space, vastness, and infinite pursuit are about to take center stage, in comes a mention about doilies, a small, dainty everyday item. The hierarchy that could exist between the universe and the quotidian, the infinite and the infinitesimal is given a witty twist.

Even while looking up at the stars, humans thought of stories of familiar animals. *Constellation* (1996, pp.96–97), an early work related to stars, consists of hot-sculpted glass stars and glass animals—a hare, a dog, a snake, bears, a bull, a scorpion, a ram, birds, and a goat—placed on Nepalese paper dyed in indigo as deep as the night sky. Many of the animals are related to well-known star patterns as Ursa Major and Minor, Scorpius, and Corvus. That they are made of fragile glass seems to be an expression of a certain sense of crisis. In fact, some subspecies of these animals are on the verge of extinction. Smith said that the animal crisis is a human crisis, and "if nature disappears our concepts or identity or anything about what humans are disappears."[11] Within the hierarchical dualistic system, nature is none more than an object to be conquered. And now we find ourselves in a disastrous crisis brought about by a reckless drive to conquer. Previous stories are not suitable to strive through the waves of this crisis.

The preciousness of being on earth

The soft texture of tapestry provides a warm backdrop for Kiki Smith's new alternative ideas to germinate. Smith started to work with tapestry in 2011, and here, the people, animals, the universe, and plants that appeared in her previous works come together to mingle, giving the impression of synthesizing her past works. Among them is one with a curious title, *Congregation* (2014, p.185). In this work, a young woman is sitting on a fallen tree that has not yet sprouted its leaves. Lines come out from the eyes of the woman, the bat, the two squirrels, the owl, and the deer around her, colliding into and steering away from each other. These lines may serve as a guide to an alternative world that Kiki Smith carefully suggests. They seem like illustrations of echolocation.[12] Already in 2009, two bats—animals well-known to use echolocation—were depicted in *Hearing You with My Eyes*. Bats emit ultrasonic pulses and process the echoes of those pulses in their inner ears to navigate and

11
Kiki Smith, "Mini Documentary—Kiki Smith: I am a Wanderer," Modern Art Oxford, October 31, 2019. https://www.youtube.com/watch?v=G73lQ5NGV9k

12
Echolocation occurs when an animal emits its own sound wave—through its mouth or nostrils—and bounces off an object, returning an echo that provides information about the object's distance, size, and/or form.

gather information about their world. In this work, the organ that does the emission is not the ears but the eyes, thereby personifying the bats. In modern society, sight was regarded as related to rational judgment, and was regarded as the most important of the five senses. Yet, because sight is also the most important sense in the binary thought of subject/object, a unilateral superiority theory of sight has been continuously criticized. The phrase "hearing you with my eyes" signifies a holistic embracing of the world by employing other senses in addition to sight.

In *Congregation*, the colorful lines coming out of the eyes of the woman and the animals are as splendid as glittering beads, and some end with tassels. *Message* (2010) is a drawing that specifically shows another meaning of lines. From the eyes of the woman drawn in lighter shade are two lines that are directed towards another woman drawn in darker shade. The gaze, softly tufted at the end, seems to stroke the other with care. In *Home* (2010, p.105), tassel-shaped lines coming out of the two women are flowing downwards. They recall Kiki Smith's painful family history, but they also seem like tears of compassion for all vulnerable beings who are bound to encounter death.

As pointed out earlier, works of art whose premise was to embrace the body's vulnerability establish the relationship between humans and the world, the subject and the object in a different manner. In *The Falls I, II, III*, drawings on photographic images, we see the actual face of Kiki Smith. White lines gush out—from her eyes and ears in *The Falls I*, and additionally from her nose and mouth in *The Falls II* and *The Falls III*. In form, they represent waterfalls, but they also signify the state of "hearing you with my eyes." Her tattooed shoulders and arms become a star-studded sky, and her cascading hair becomes a huge waterfall. In this work, Kiki Smith becomes a kind of nature—and she is also sympathizing with nature. In 2018, while recounting her oeuvre, the artist pronounced, "I am nature."[13] The solution to the crisis we are facing now is not to look at nature as an object to be saved again, but to do away with the frame of thought that stems from hierarchical dualism and recognize that we, too, are nature and move with it. This motif recurs in works like *Send* (2016, p.103), *Surge* (2016), *Transmission* (2016), and *The Weather* (2019, p.102), occupying a significant portion in Kiki Smith's practice. The idea that we are all a "small ecosystem" in symbiotic relationships—an idea that was inherent in the 1983 *Hand in Jar*—evolved in various ways through multiple works.

13
Kiki Smith, "Kiki Smith Interview: In a Wandering Way."

14
Choi Yumi, *Haereowei, gong-sanui sayu* [Haraway: Thoughts of Sympoiesis], Seoul: Bbooks, 2020, p.203.

15
Donna J. Haraway, trans. by Choi Yumi, *Teureobeulgwa hamkke hagi*, Seoul: Manongji, 2021, p.10; *Staying with the Trouble*, Durham: Duke University Press, 2016.

16
Kiki Smith, conversation with Petra Giloy-Hirtz, "Kiki Smith: Procession: 'A Wonder Version of Life'," *Kiki Smith: Procession*, ed. by Petra Giloy-Hirtz, Munich; Haus der Kunst & Prestel, 2018, p.22.

Let's return to *Congregation*. It seems to be referring to the possibility of a field of symbiosis in which beings of multispecies become subjects. The variegated lines coming out of the eyes of the women and the animals are each depicted in slightly different ways, transcending the judgment of right and wrong, or of beauty and ugliness. Beings with finite bodies can only see from where they stand. Because there is no other choice but to speak from relative points of view, the diversity of perspectives is only natural. The "response-ability"[14] to affirm this and lend one's ears to each other, to look at and respond to each other is the basis for creating new stories. Lines coming out of all beings make new connections, becoming starting points for writing another story. And these connections recall Donna J. Haraway's suggestion of "string figures"[15] as a way of creating a new world in a new relationship formed by a multiplicity of beings. String figures are not a unilateral practice in which there is a dualistic subject and its other. It is a process by which the result and the subsequent action change based on how the other responds. There is no fixed set of answers here, no superior position from which to dominate the situation. To truly overcome dualism, the frame itself should be neutralized. It is a practice of realizing "the preciousness of being on earth."[16] Newly formed relationships become starting points for new stories. The process of being surprised and awed, feeling beauty, finding meaning and sharing our thoughts while walking around in the world of Kiki Smith—all of this is also part of creating a new story.

Lee Jinsuk graduated from the Department of German Language and Literature at Seoul National University, and received her master's degree from the same department. She went on to earn a second master's degree in Art History from the State Academic University for Humanities, Russia. Her books include *The Moments of Great Solitude* (2021), *The Moments of Humanity* (2020), *Literature in the Arts* (2016), *Memories of Art: World History behind Famous Paintings* (2015), *The Books on Art* (2014), *The Big Bang of Korean Contemporary Art* (2010), and *Story of Russian Art: The Dream of Great Utopia* (2007).

작품 Works

은빛 새. 2006. 네팔 종이에 잉크, 은색 과슈, 운모, 글리터, 흑연. 183.5×148cm.
Silver Bird. ink on Nepalese paper with silver gouache, mica, glitter and graphite.

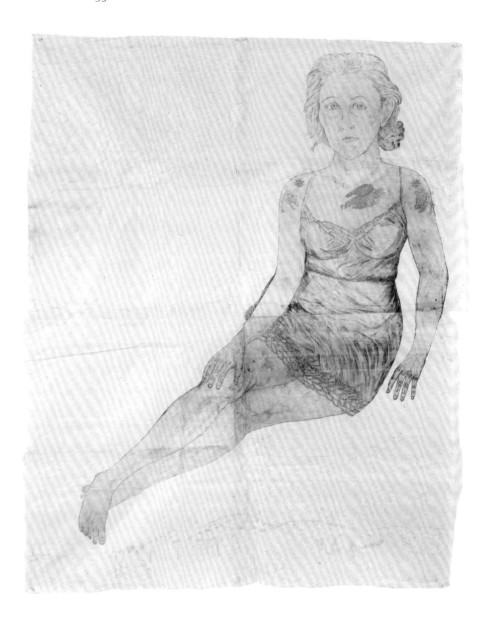

모임 Ⅲ. 2008-2019. 네팔 종이에 잉크, 색연필, 흑연, 석판용 크레용, 콜라주. 213.4×254cm.
Assembly Ⅲ. ink on Nepalese paper with colored pencil, graphite and lithographic crayon, collage.

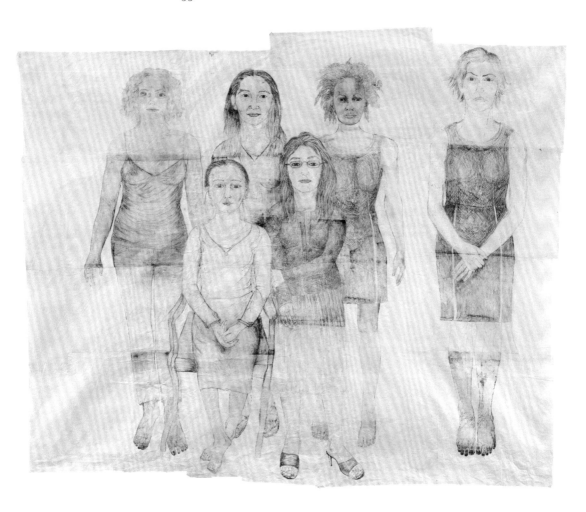

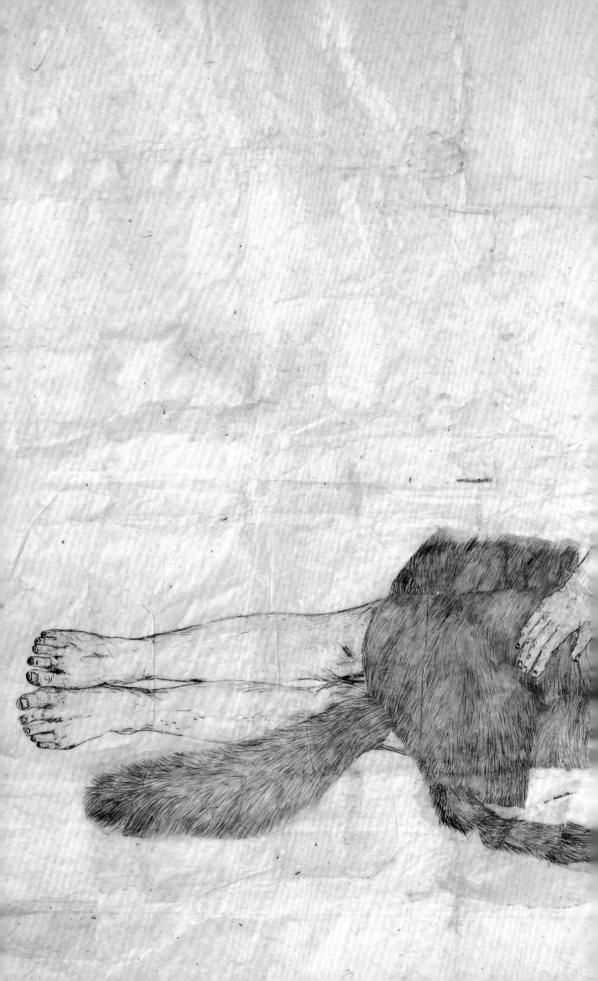

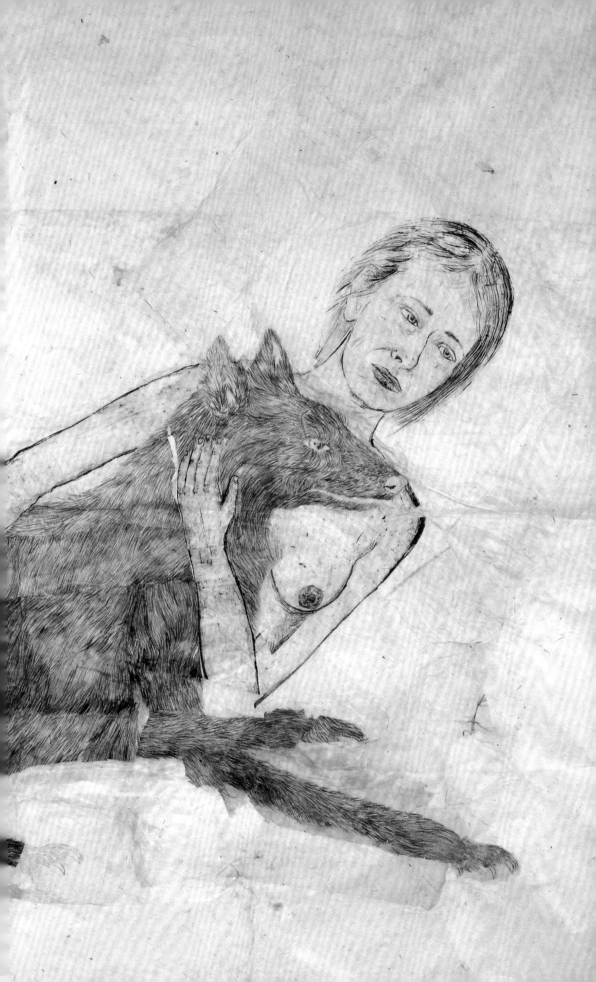

늑대와 함께 누워. 2001. 네팔 종이에 잉크, 흑연. 183.5×223.5cm. (pp.56-57)
Lying with the Wolf. ink and graphite on Nepalese paper.

모든 곳(두 토끼). 2010. 네팔 종이에 색연필, 잉크, 98.4×76.2cm.
Everywhere (double rabbit). colored pencil and ink on Nepalese paper.

나는 들어갈 공간이 충분히 있도록 나 자신을 비워 뒀다. 2009. 네팔 종이에 잉크, 색연필.
188×257.8cm.
I Put Aside Myself That There Was Room Enough to Enter. ink and colored pencil on Nepalese
paper.

황혼. 2009. 네팔 종이에 잉크, 글리터, 팔라듐박. 198.1×127cm. (p.62)
Dusk. ink on Nepalese paper with glitter and palladium.

전환. 2010. 네팔 종이에 잉크, 색연필. 175.3×208.3cm.
Shift. ink on Nepalese paper with colored pencil.

64

방문 Ⅲ. 2007. 네팔 종이에 잉크, 흑연, 색연필, 운모, 콜라주. 223.8×216.5cm.
Visitation Ⅲ. ink, graphite, colored pencil, mica and collage on Nepalese paper.

약속. 2012. 네팔 종이에 잉크, 콜라주. 155.6×205.7cm.
Promise. ink and collage on Nepalese paper.

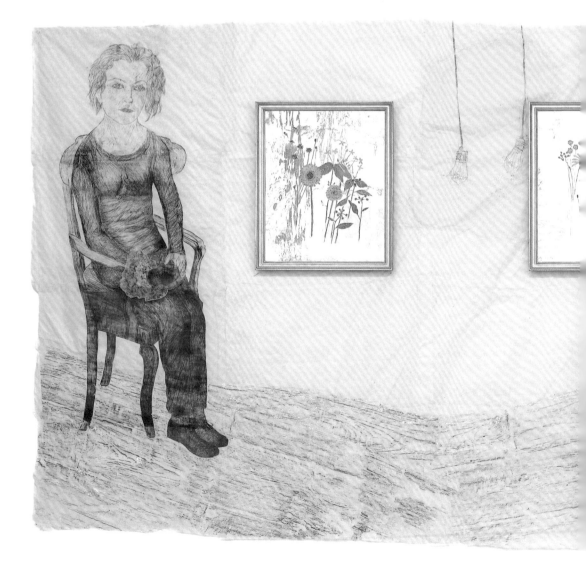

그녀의 부케. 2007–2008. 네팔 종이에 잉크, 유리 글리터, 석판용 크레용, 실크; 마우스 블로운 유리에 유채, 백금박 및 황금박. 종이 186.7×217.2cm, 190.5×218.4cm, 유리 패널 각 60×50.2cm.

Her Bouquet. ink on Nepalese paper with glass glitter, lithographic crayon and silk tissue; oil paint on mouth-blown clear antique glass with white and yellow gold leaf.

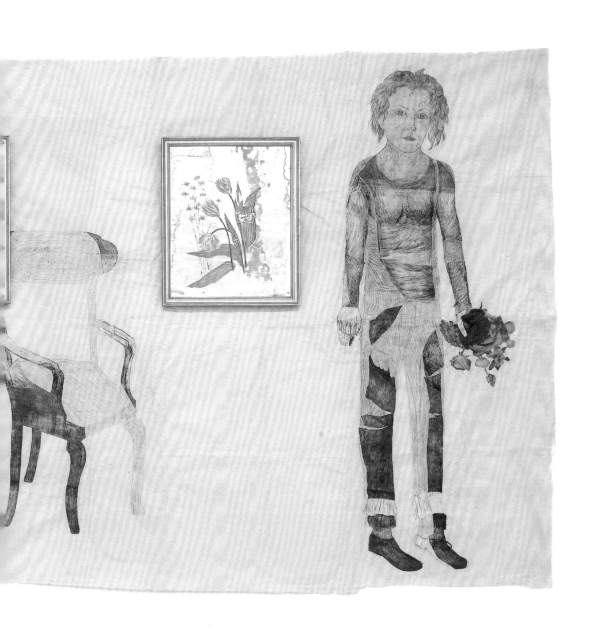

검은 꽃 IV. 2008. 흑백 유리 판화, 마우스 블로운 유리. 49.5×39.4cm.
Black Flowers IV. black and white cliché verre with mouth blown reamy glass.

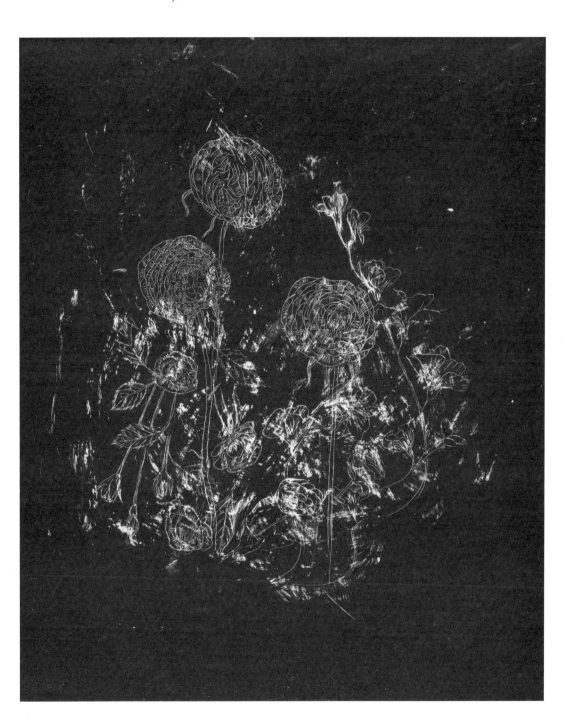

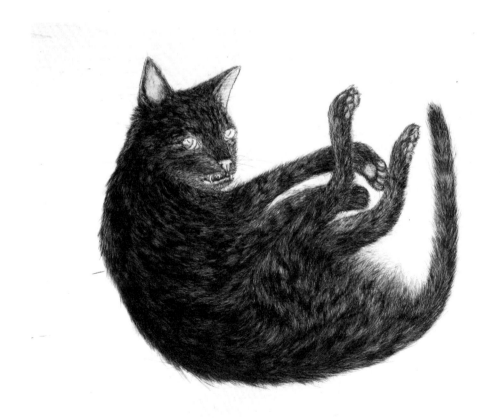

진저. 2000. 하네뮐레 밝은 흰색 종이에 아쿼틴트, 에칭, 드라이포인트. 57.2×78.7cm.
Ginzer. aquatint, etching and drypoint on Hahnemühle bright white paper.

별자리. 1996. 네팔 종이에 4색 석판, 털 장식. 146×78.7cm.
Constellations. lithograph in 4 colors with flocking on Nepalese paper.

노래 부르는 사람. 2008. 알루미늄. 165.1×68.6×61cm
Singer. cast aluminum.

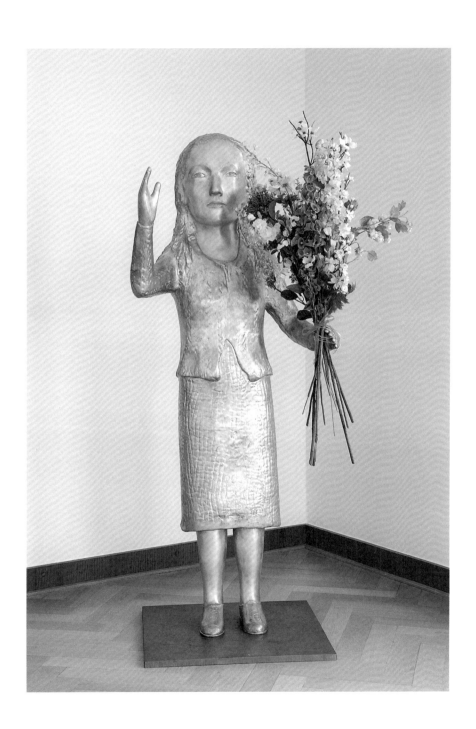

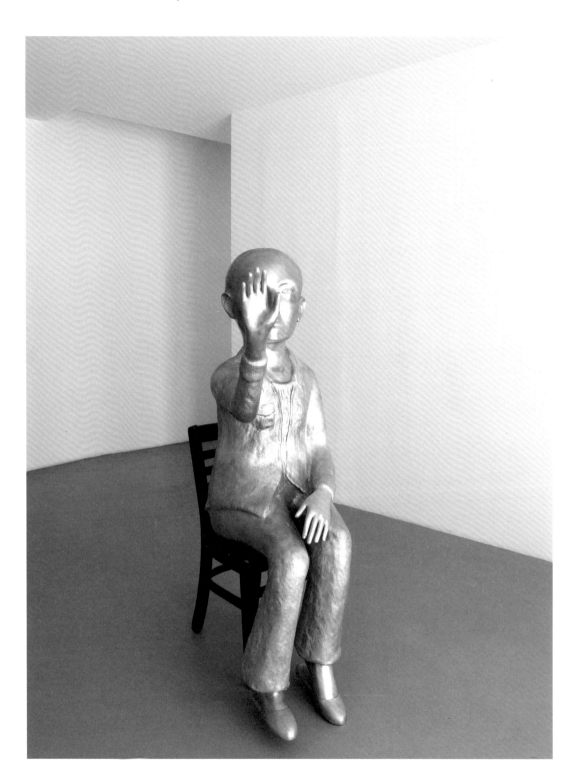

수태고지. 2008. 알루미늄, 나무. 156.2×81.3×48.3cm. (p.78)
Annunciation. cast aluminum, wood.

소녀. 2014. 순은. 54.6×30.5×14cm.
Girl. fine silver.

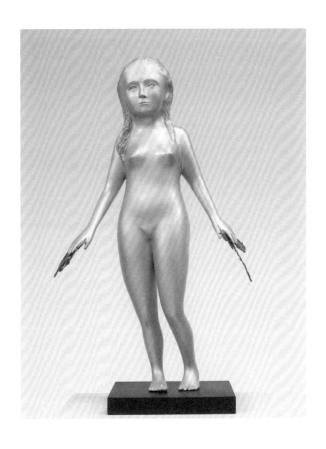

큰 나선 성운. 2017. 알루미늄. 83.8×64.1×5.7cm.
Spiral Nebula (Large) aluminum.

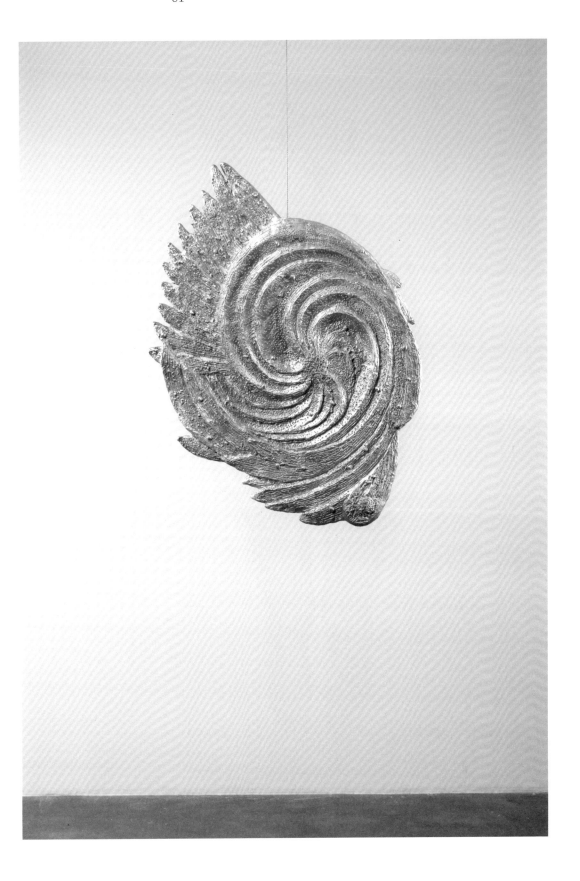

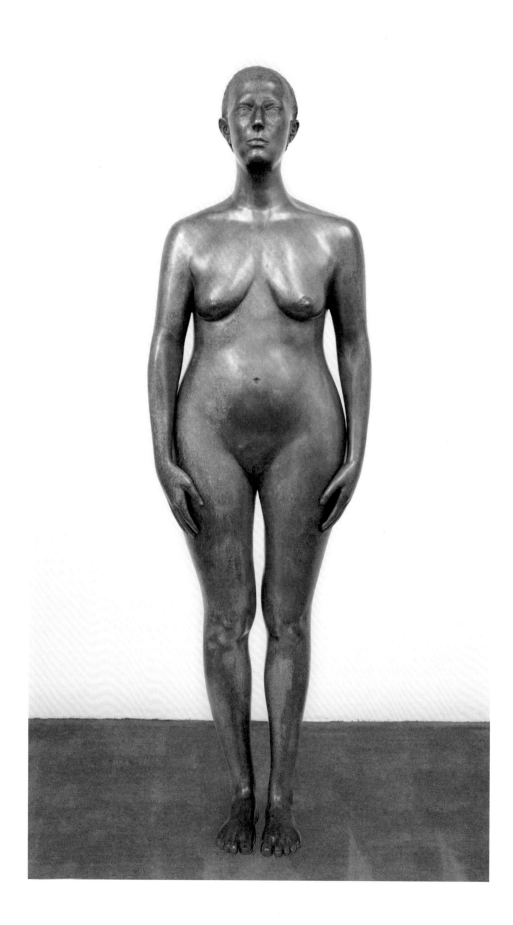

메두사. 2004. 청동, 다이아몬드 조각. 172.7×50.8×30.5cm.
Medusa. bronze with diamond chips.

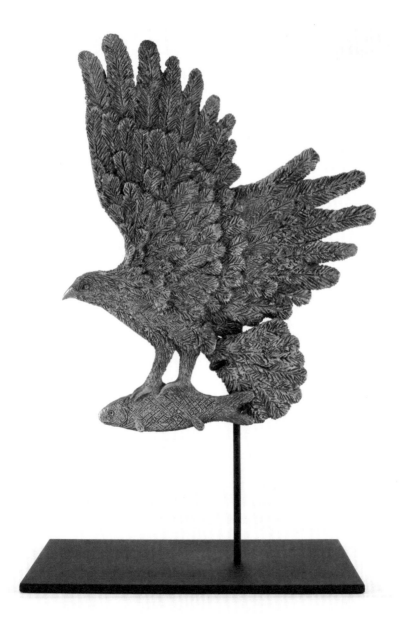

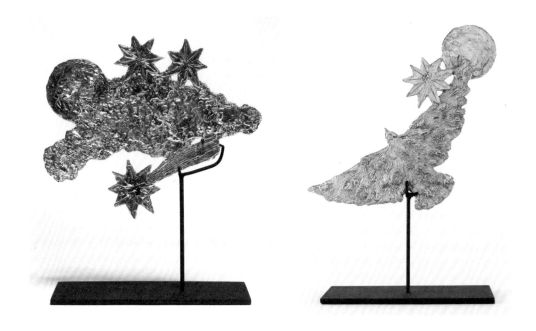

물고기를 잡고 있는 물수리. 2017. 청동, 질산은 파티나. 47.6×29.2×17.8cm. (p.84)
Osprey with Fish. bronze with silver nitrate patina.

별똥별. 2015. 순은. 25.7×21.6×7.6cm. (왼쪽)
Shooting Star. fine silver. (left)

초승달 모양의 새. 2015. 순은. 29.2×20×7.6cm. (오른쪽)
Crescent Bird. fine silver. (right)

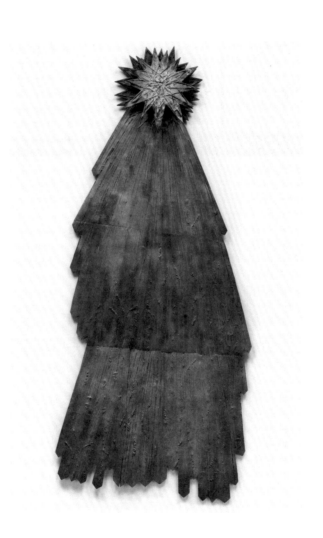

혜성 VI. 2019. 청동. 236.2×101.6×7cm.
Sungrazer VI. bronze.

p.86의 세부. (p.87)
Detail of p.86.

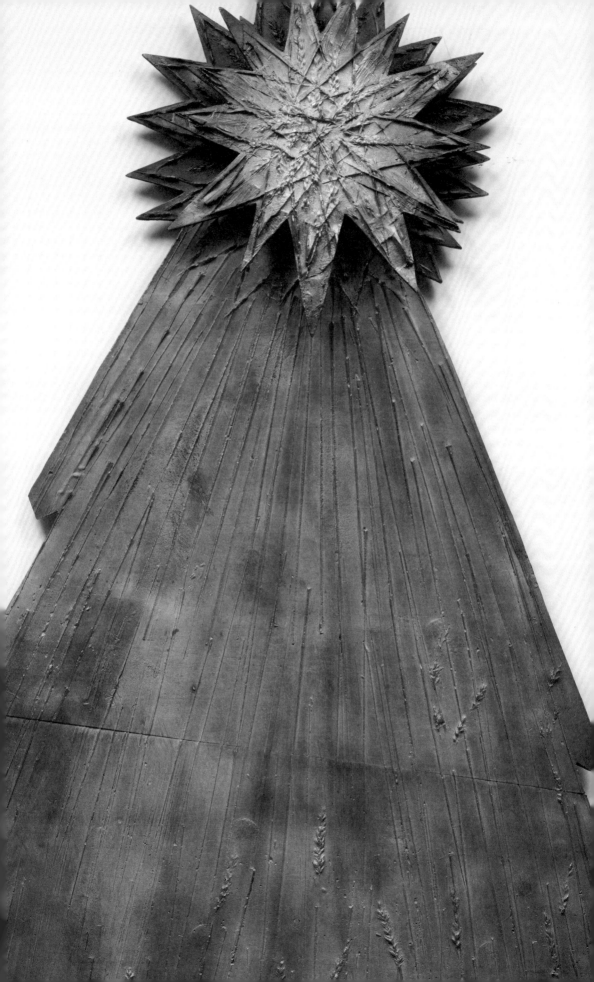

작은 파도. 2016. 청동, 백금박 및 황금박. 15.2×33×12.7cm.
Small Wave. bronze with white and yellow gold leaf.

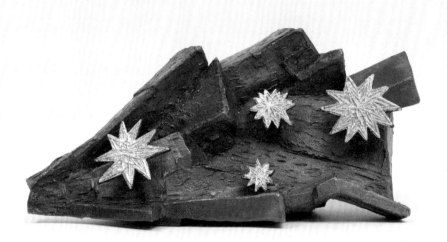

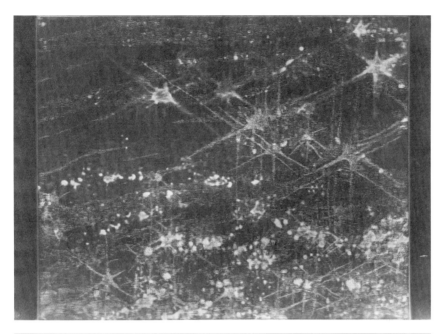

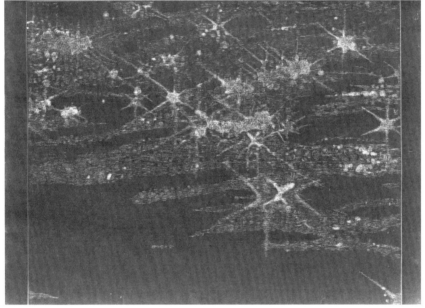

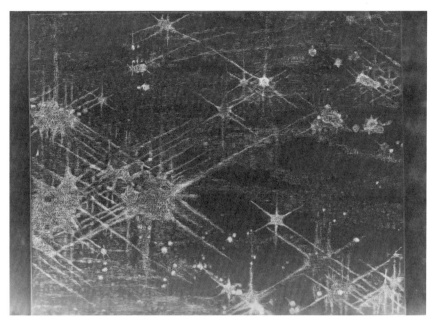

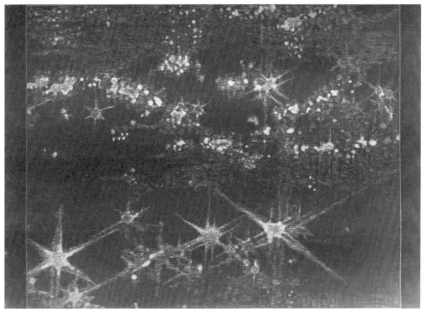

세상의 빛. 2017. 로신 프라하 종이에 시아노타이프. 각 41.3×57.2cm. (pp.90-95)
the light of the world. cyanotype on Losin Prague paper.

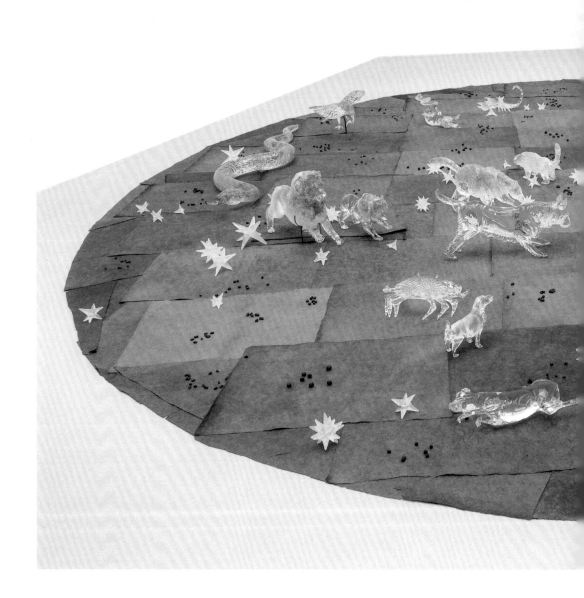

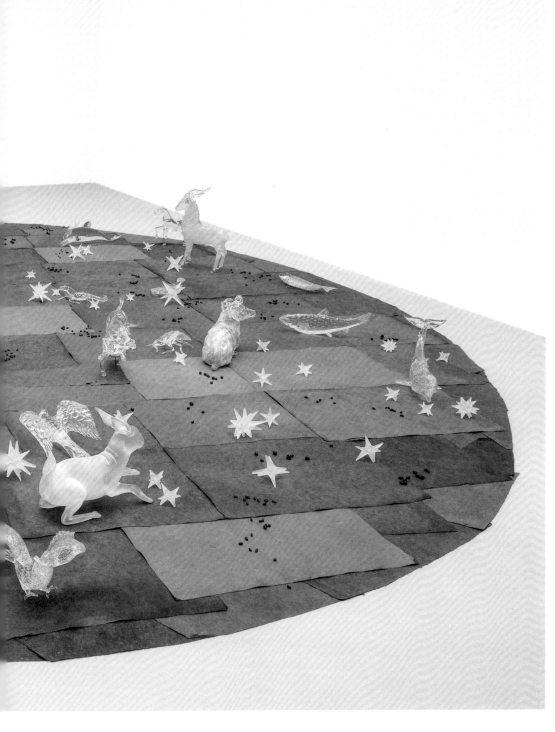

별자리. 1996. 납유리, 청동, 종이, 소다석회유리. 가변 설치.
Constellation. lead glass, bronze, paper, soda lime glass.

세포-달. 1996. 청동. 200.7×182.9×6.4cm.
The Cells - The Moon. bronze.

푸른 나무 위 푸른 별. 2006. 네팔 종이에 잉크, 은박. 233.7×177.8cm.
Blue Stars on Blue Tree ink and silver leaf on Nepalese paper.

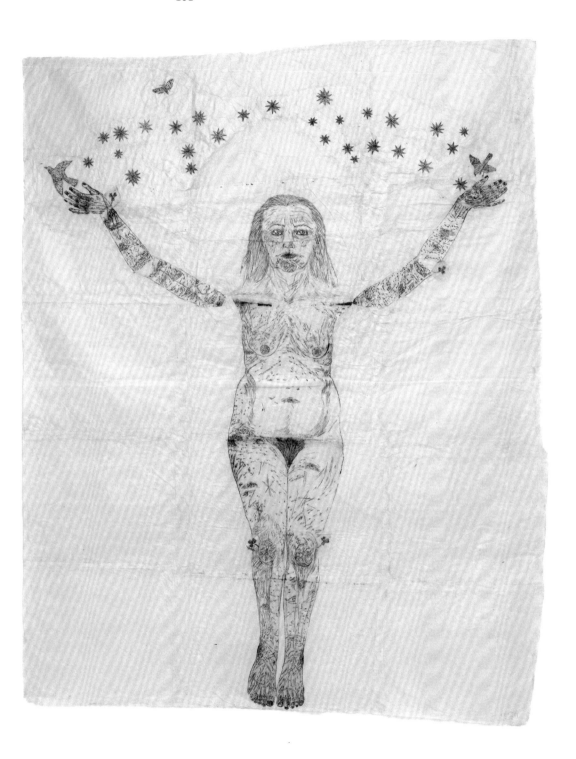

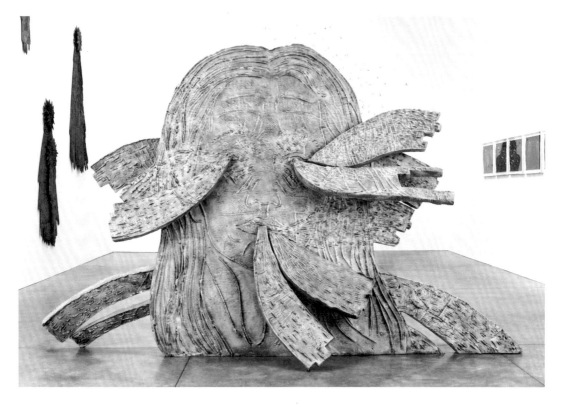

날씨. 2019. 청동. 208.3×339.1×92.7cm.
The Weather. bronze.

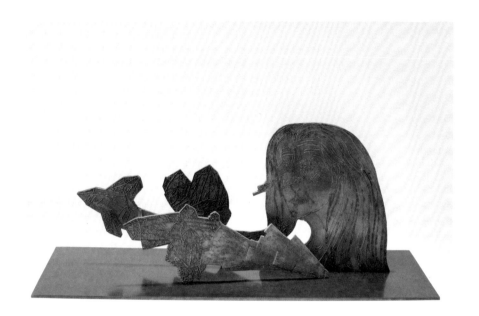

보내다. 2016. 청동, 질산은 파티나. 36.2×91.4×30.5cm.
Send. bronze with silver nitrate patina.

훈. 2010. 네팔 종이에 잉그, 색연필. 49.5×74.9cm.
Home. ink on Nepalese paper with colored pencil.

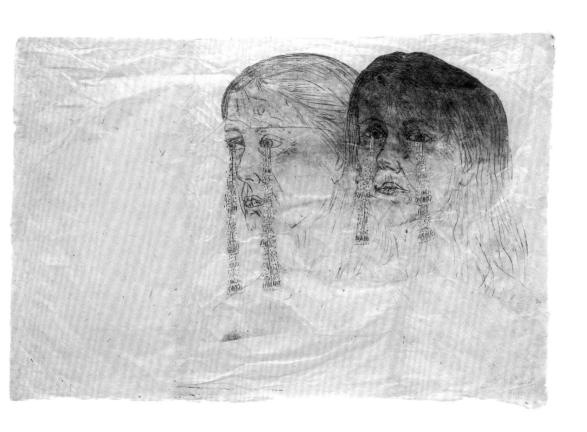

나뭇가지. 2009. 청동, 파티나. 243.8×596.9cm.
Bough. bronze with patina.

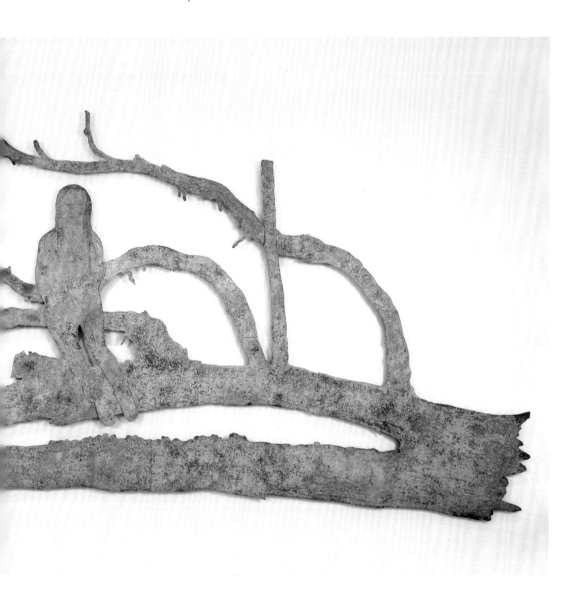

서곡. 2014. 6개의 패널, 스테인드글라스, 마우스 블로운 유리에 검은색 페인트,
에나멜 채색. 252.9×485.8×1.6cm.
Prelude. 6 framed panels, stained glass, mouth-blown clear antique glass, black paint
and enamel colors, fired and leaded.

방송. 2012. 3개의 패널, 유리에 채색, 은박 후면에 황동 프레임. 200.7×243.8cm.
Broadcast. 3 panels, clear antic glass, painted and fired, silver leaf on backside, leaded and framed in brass frame.

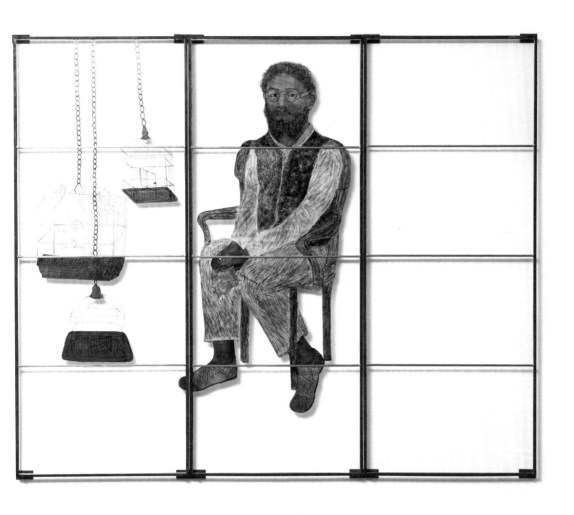

<u>태두</u>. 2012. 3개의 패널, 유리에 채색, 은박 후면에 황동 프레임. 200.7×243.8cm.
Luminary. 3 panels, clear antic glass, painted and fired, silver leaf on backside, leaded and
framed in brass frame.

<u>무제(지구 프린트)</u>. 1997. 감피 종이에 석판. 65.4×143.5cm.
Untitled (Earth Print). lithograph on gampi paper.

무리 해-1월 초. 2018. 일퍼드 다계조 인화지에 유리 판화. 50.5×40.3cm. (왼쪽)
Sundog - First January. cliché verre on Ilford Multigrade Contrast paper. (left)

무리 해-1월 말. 2018. 일퍼드 다계조 인화지에 유리 판화. 50.8×40.6cm. (오른쪽)
Sundog - Last January. cliché verre on Ilford Multigrade Contrast paper. (right)

무리 해 - 4월 초. 2018. 일퍼드 다계조 인화지에 유리 판화. 50.5×40.3cm. (왼쪽)
Sundog - First April. cliché verre on Ilford Multigrade Contrast paper. (left)

무리 해 - 4월 말. 2018. 일퍼드 다계조 인화지에 유리 판화. 50.5×40.3cm. (오른쪽)
Sundog - Last April. cliché verre on Ilford Multigrade Contrast paper. (right)

 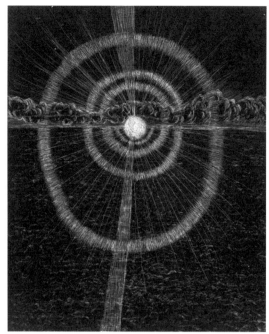

무리 해-8월 초. 2018. 일퍼드 다계조 인화지에 유리 판화. 50.8×40.6cm. (왼쪽)
Sundog - First August. cliché verre on Ilford Multigrade Contrast paper. (left)

무리 해-8월 말. 2018. 일퍼드 다계조 인화지에 유리 판화. 50.8×40.6cm. (오른쪽)
Sundog - Last August. cliché verre on Ilford Multigrade Contrast paper. (right)

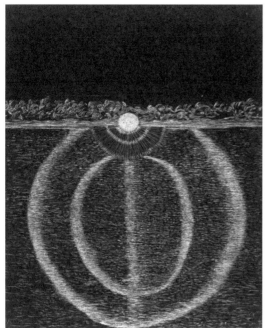 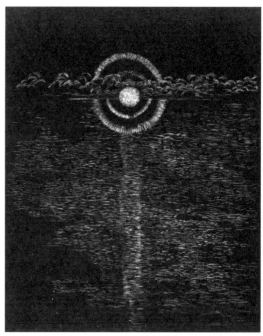

<u>무리 해-10월 초</u>. 2018. 일퍼드 다계조 인화지에 유리 판화. 50.5×40.3cm. (왼쪽)
Sundog - First October. cliché verre on Ilford Multigrade Contrast paper. (left)

<u>무리 해-10월 말</u>. 2018. 일퍼드 다계조 인화지에 유리 판화. 50.5×40.3cm. (오른쪽)
Sundog - Last October. cliché verre on Ilford Multigrade Contrast paper. (right)

치유자. 2018. 히네밀레 동판 흰색 종이에 에칭. 62.2×75.9cm.
Healers. etching on Hahnemühle copperplate white paper.

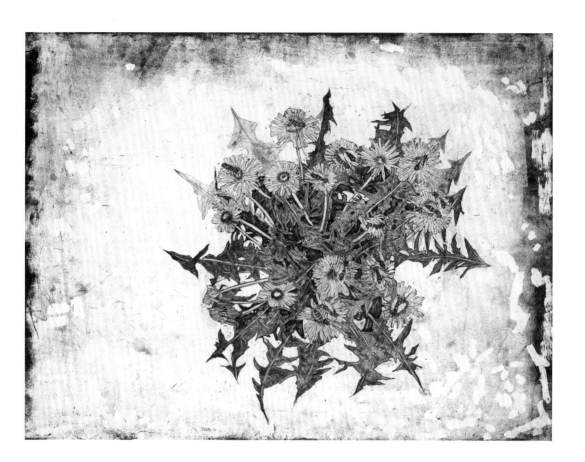

가슴 II. 1994. 네팔 종이에 인쇄, 콜라주. 157.5×139.7cm.
Bosoms II. collage of printed Nepalese paper.

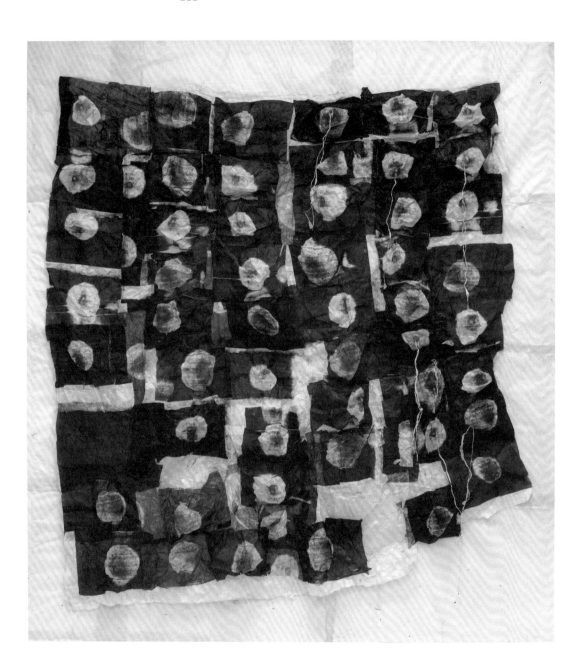

무제(머리카락). 1990. 미츠마시 종이에 2색 석판. 91.4×91.4cm.
Untitled (Hair). lithograph in 2 colors on custom made Mitsumashi paper.

p.123의 세부. (pp.124-125)
Detail of p.123.

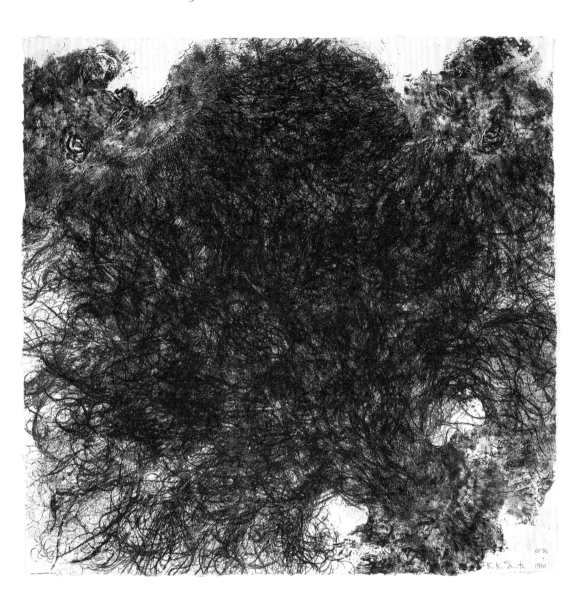

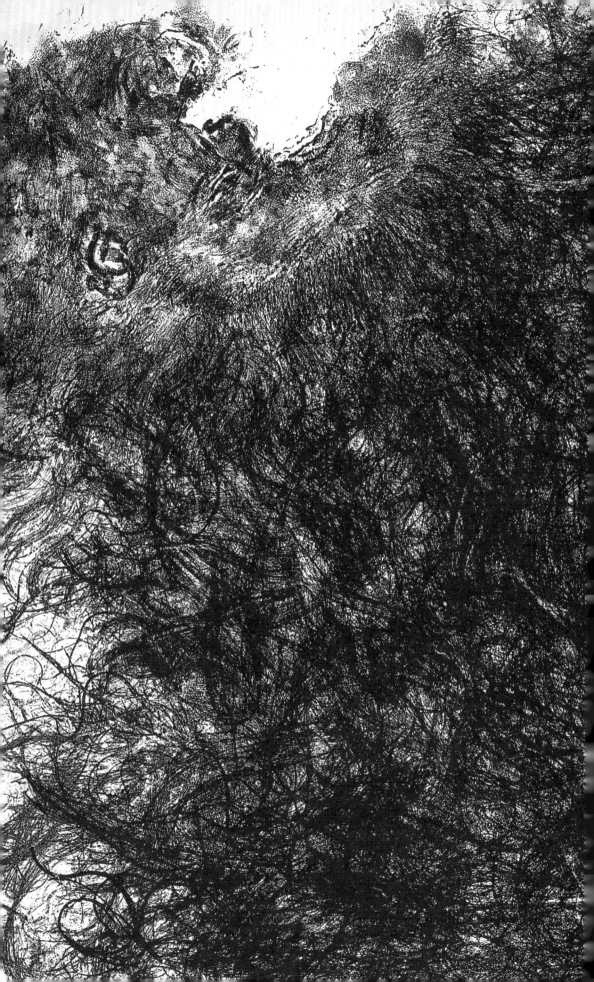

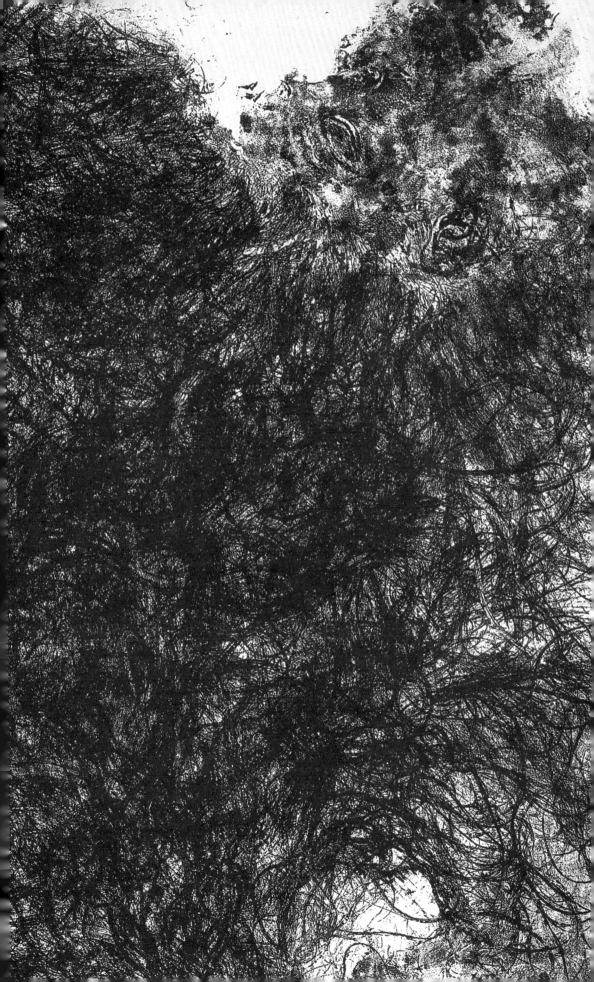

내분비학. 1997. 20장으로 구성된 책. 네팔 종이, 모호크 수퍼파인 텍스트 종이, 티아라 스타화이트 종이, 세키슈 토리노코 감피 종이에 사진 평판, 메이메이 버센부르거의 텍스트 콜라주. 53.9×53.3cm.
Endocrinology. book of 20 photolithographs with collaged text by Mei-mei Berssenbrugge on Nepalese, Mohawk Superfine Text, Tiara Starwhite, Sekishu Torinoko gampi paper.

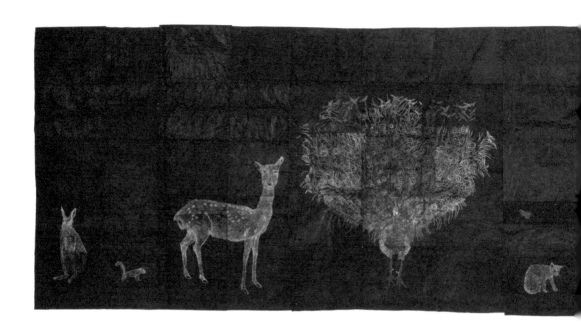

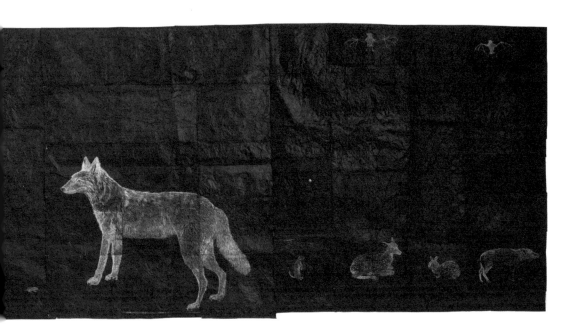

검은색 동물 드로잉. 1996-1998. 네팔 종이에 에칭 잉크. 231.1×938.5cm.
Black Animal Drawing. etching ink on Nepalese paper.

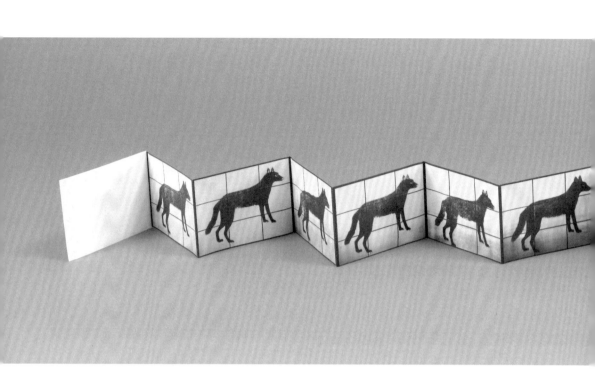

동행자. 2000. 아코디언 북. 서머싯 종이에 사진 평판, 일본 종이에 사진 평판 부속물.
접은 상태 17.8×22.2×1.9cm, 펼친 상태 17.8×311.2cm.
Companion. book of accordion-folded photolithographs on mold-made Somerset paper with
insert of folded photolithograph on handmade Japanese paper.

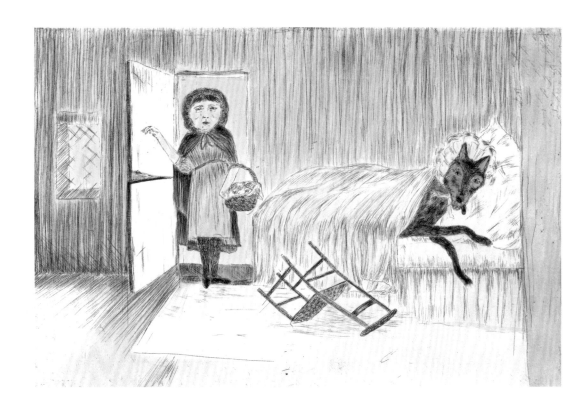

<u>귀가</u>. 2008. 손더스 수채 HP종이에 에칭, 채색. 53.3×71.1cm.
Homecoming. etching with hand-coloring on Saunders Watercolor HP paper.

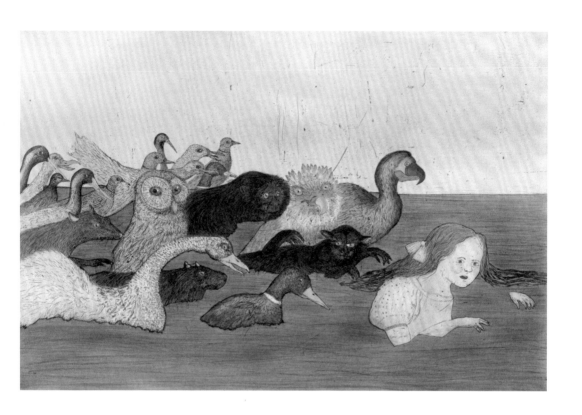

눈물 웅덩이 II. 2000. 앙투카 종이에 요판 인쇄, 수채. 129.5×189.9cm.
Pool of Tears II. intaglio with hand water coloring on En Tout Cas paper.

지배. 2012. 6개의 패널, 스테인드글라스, 마우스 블로운 유리에 검은색 페인트, 에나멜
채색. 252.7×515.6cm.

Dominion. 6 panels, stained glass, mouth-blown clear antique glass, black paint and enamel
colors, fired and leaded diptych.

무제(여자와 나뭇잎). 2009. 토리노코 종이에 석판, 채색. 198.1×109.2cm.
Untitled (woman with leaves). lithograph with hand-coloring on Torinoko paper.

밴시 펄스. 1991. 토리노코 종이에 4색 석판, 알루미늄박, 12점. 각 57.2×77.5cm.
Banshee Pearls. set of 12 lithographs in 4 colors with aluminum leaf applique on Torinoko paper.

나침반. 2017. 로신 프라하 종이에 시아노타이프, 금박. 각 57.4×41.3cm.
Compass. cyanotype and gold leaf on Losin Prague paper.

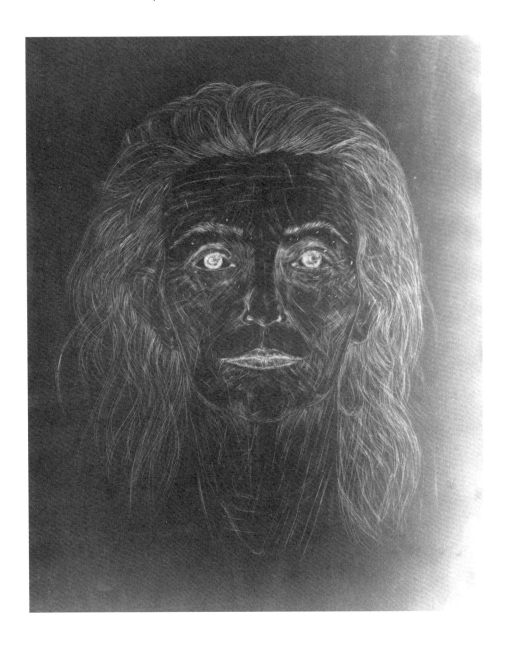

새 더미. 1997-1998. 누비 담요에 실크스크린 잉크. 가변 설치. 각 162.6×170.2cm.
Flight Mound. silkscreen ink on quilted blankets.

새들의 파멸. 1997. 에칭 5점. 각 81.9×121.9cm.
Destruction of Birds. suite of 5 etchings.

가진 사람이 임자. 1985. T. H. 손더스 종이에 실크스크린, 모노타이프, 잉크.
각 55.7×43cm.
Possession is Nine-Tenths of the Law. screenprint and monotypes with ink additions
on mold-made T. H. Saunders paper.

목 1990. 종이에 잉크. 45.7×30.5cm.
Neck. ink on paper.

무제(토르소). 1988. 종이에 잉크. 57.2×78.7cm.
Untitled (Torsos). ink on paper.

병 속의 손. 1983. 유리병, 조류, 라테스, 물. 30.5×15cm.
Hand in Jar. glass, algae, latex and water.

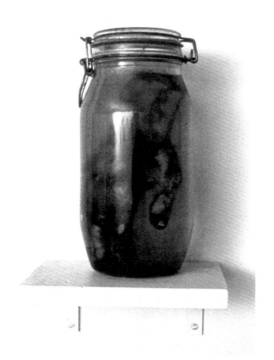

소화계. 1988. 덕타일 주철. 157.5×68.6×3.8cm.
Digestive System. ductile iron.

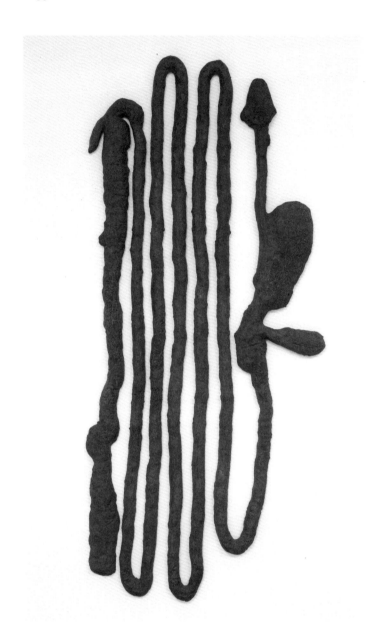

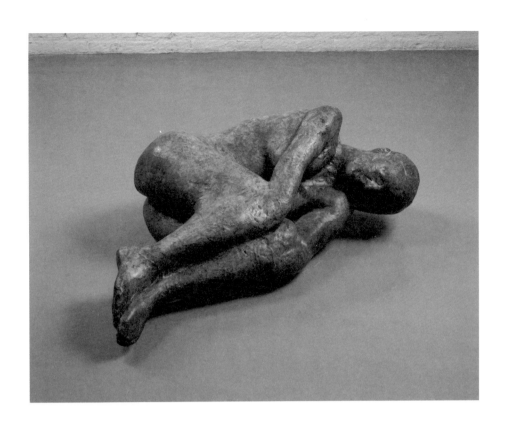

피 웅덩이. 1992. 청동에 채색. 35.6×55.9×99.1cm.
Blood Pool. painted bronze.

성모 마리아. 1992. 밀랍, 무명, 나무. 171.5×66×36.8cm. (p.155)
Virgin Mary. wax, cheesecloth and wood.

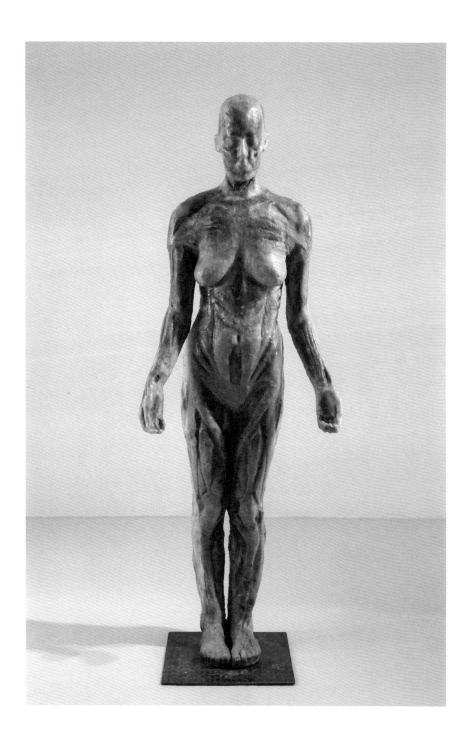

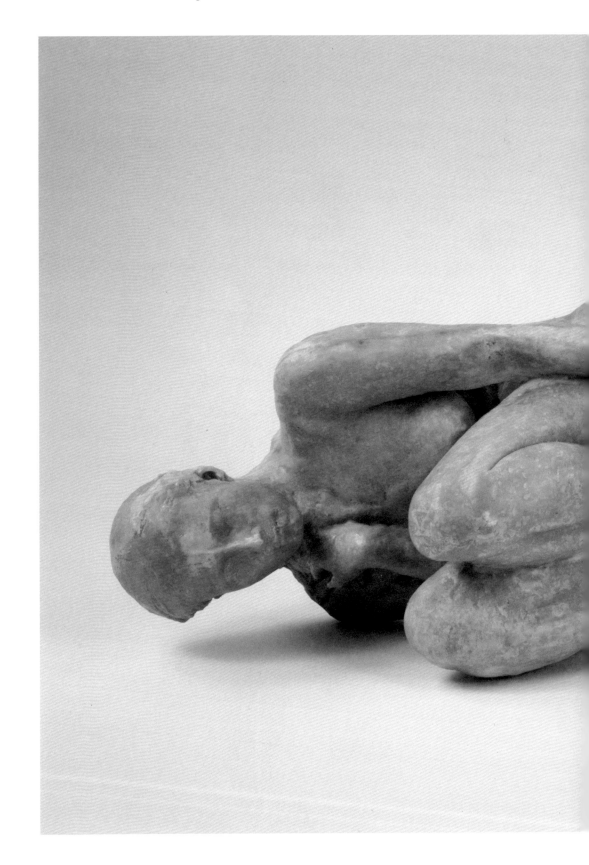

허니 와스. 1995. 밀랍. 39.4×91.4×50.8cm.
Honeywax. beeswax.

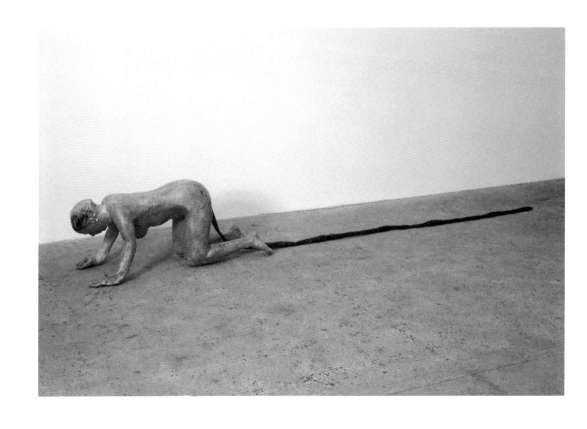

테일. 1992. 밀랍, 안료, 파피에 마세. 406.3×58.4×58.4cm.
Tale. wax, pigment, and papier-mâché.

소변보는 몸. 1992. 밀랍, 유리 구슬(2.5cm부터 38cm까지 다양한 길이의 줄 23개).
가변 설치. 68.6×71.1×71.1cm.
Pee Body. wax and glass beads (23 strands of varying lengths, 2.5 to over 38cm long).

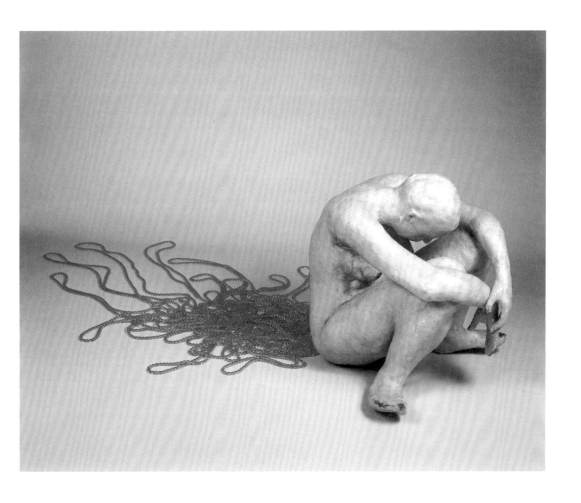

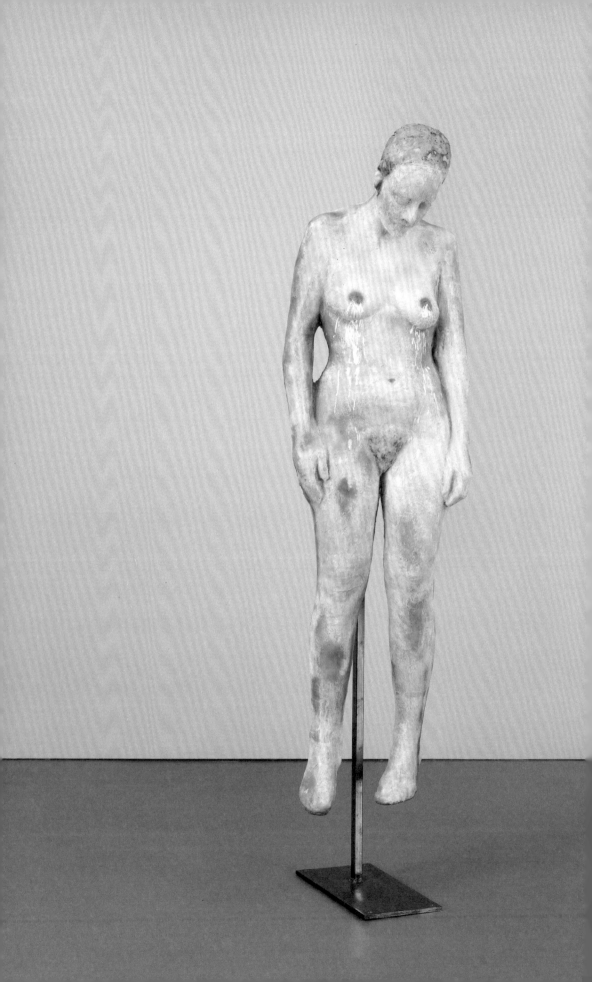

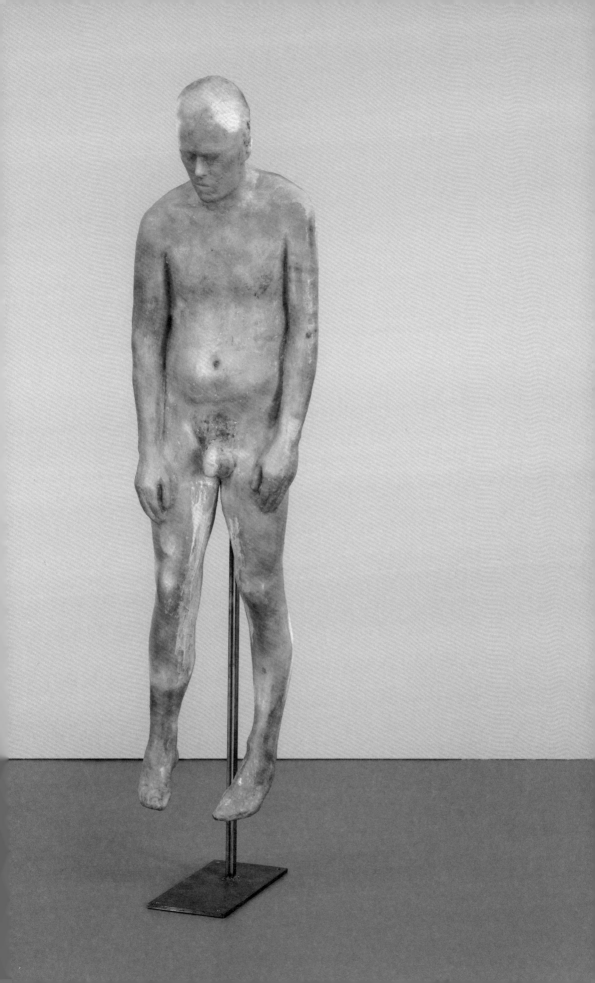

무제. 1990. 밀랍. 198.1×181.6×54cm. (pp.162-163)
Untitled. beeswax and microcrystalline wax figures.

무제. 1995. 갈색 종이, 메틸셀룰로오스, 말총. 134.6×127×45.7cm.
Untitled. brown paper, methyl cellulose and horsehair.

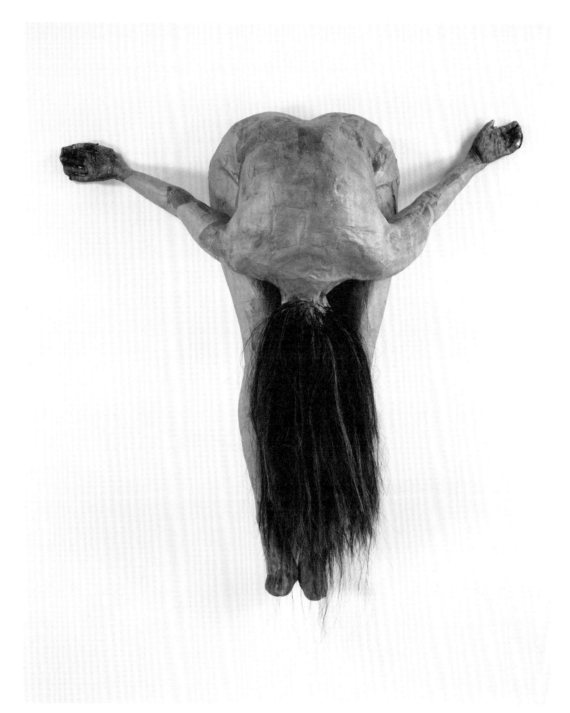

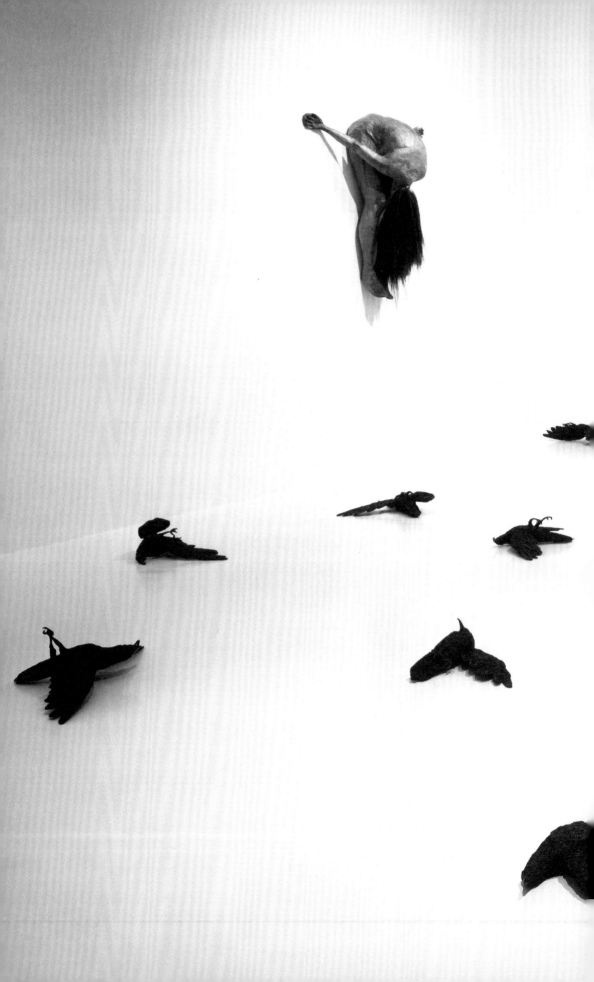

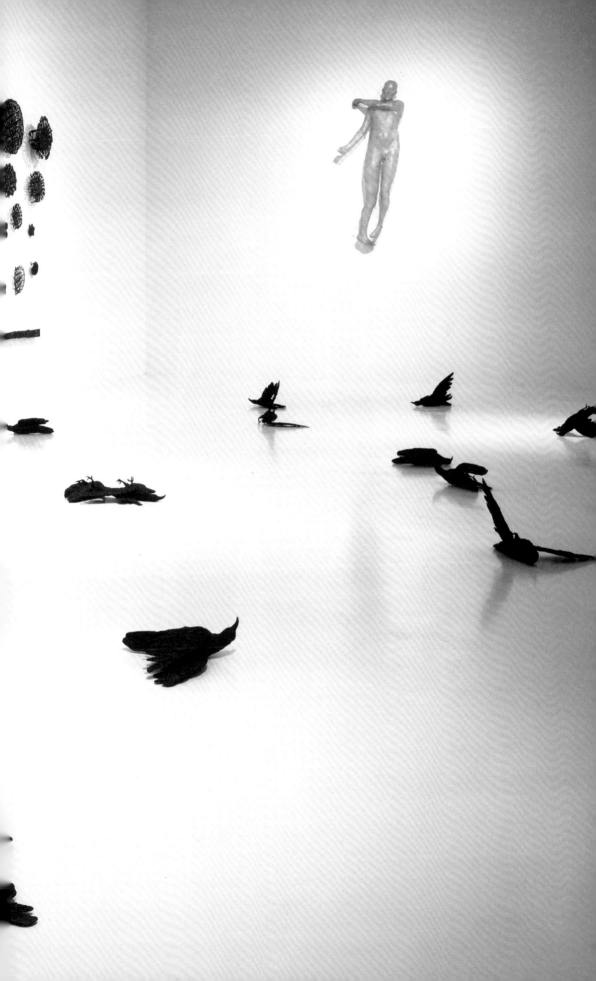

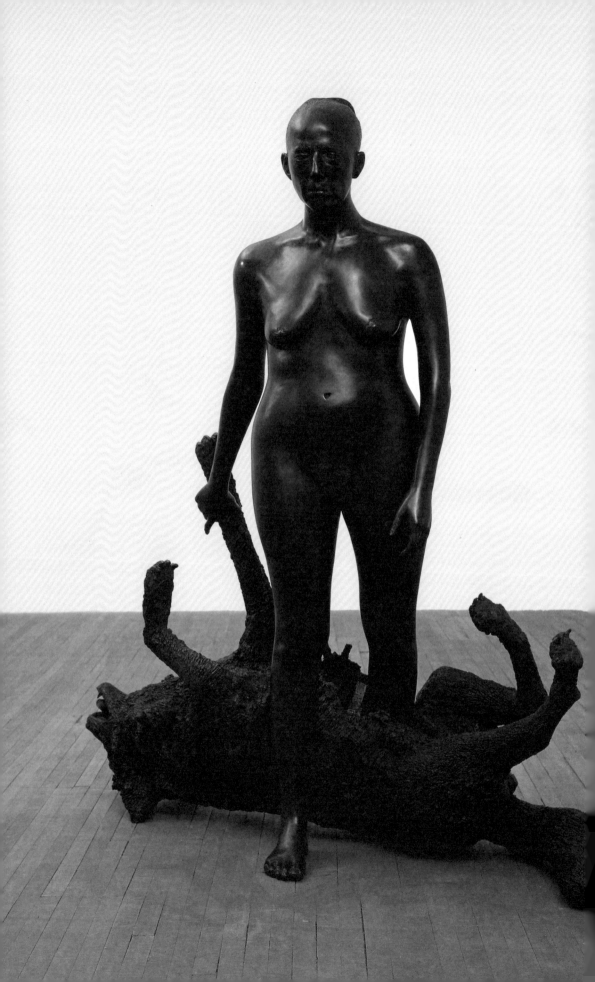

저지 까마귀. 1995. 실리콘 청동, 가변 설치(바닥). (pp.166-167)
Jersey Crows. silicon bronze (installation on the floor).

황홀. 2001. 청동. 170.8×157.5×66.7cm.
Rapture. bronze.

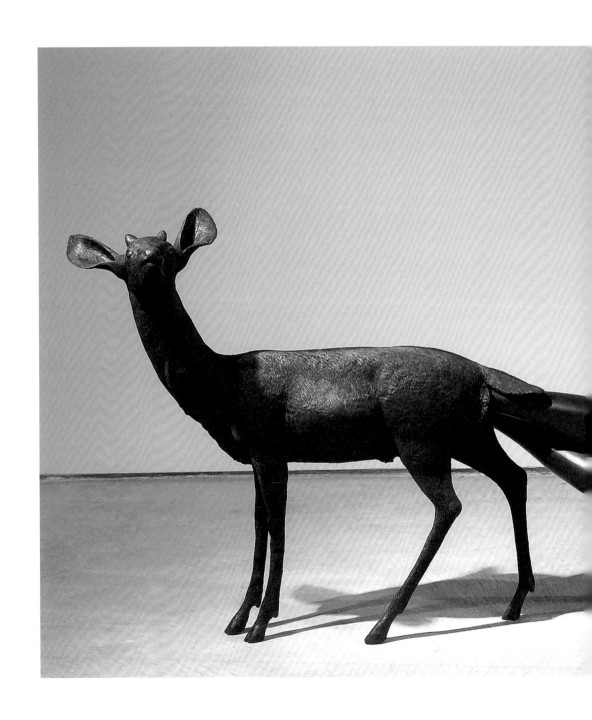

탄생. 2002. 청동. 99.1×256.5×61cm.
Born. bronze.

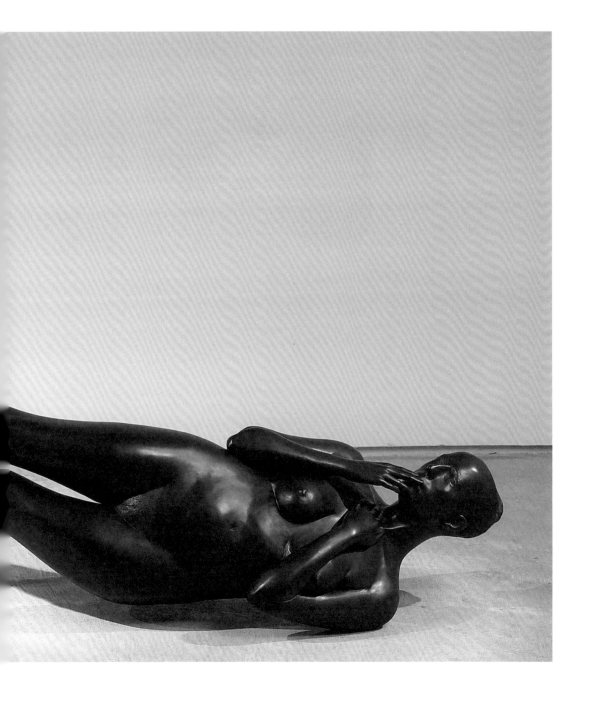

릴리스. 1994. 청동, 유리 눈알. 81.3×68.6×44.5cm.
Lilith. bronze with glass eyes.

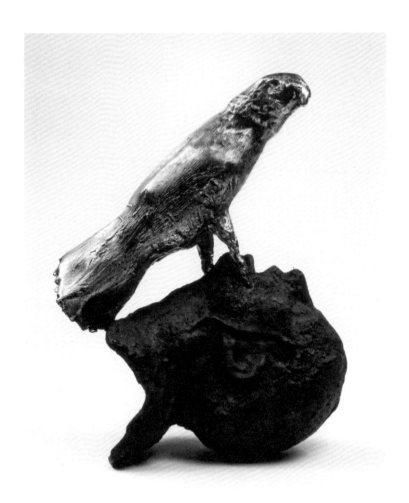

새와 있는 두상 II. 1995. 실리콘 청동, 백색 청동. 34.9×27.3×15.2cm.
Head with Bird II. silicon bronze and white bronze.

데이지 체인. 1992. 청동, 쇠사슬. 가변 설치. (p.175)
Daisy Chain. cast bronze with steel chain.

못발 짚은 달. 2002. 알루미늄, 청동. 가변 설치. (pp.176-177)
Moon on Crutches. cast aluminum and bronze.

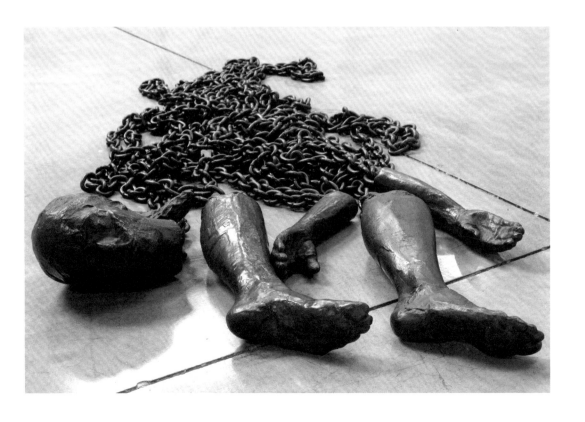

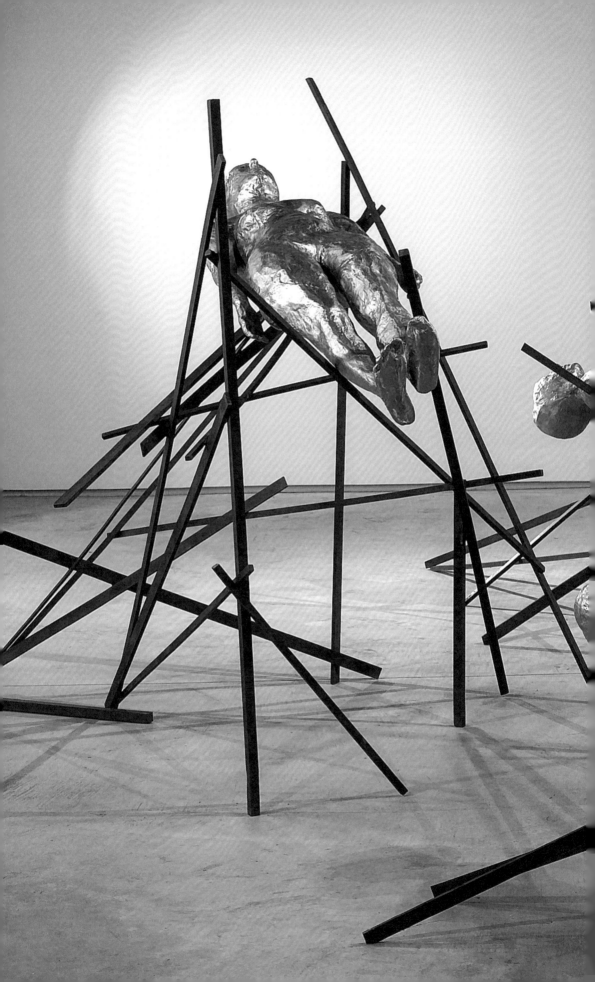

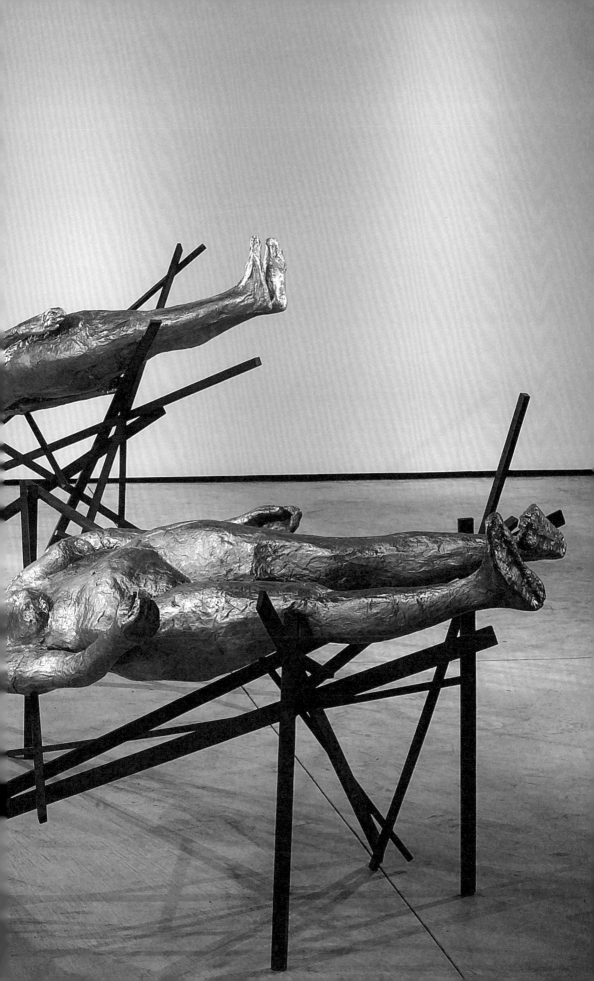

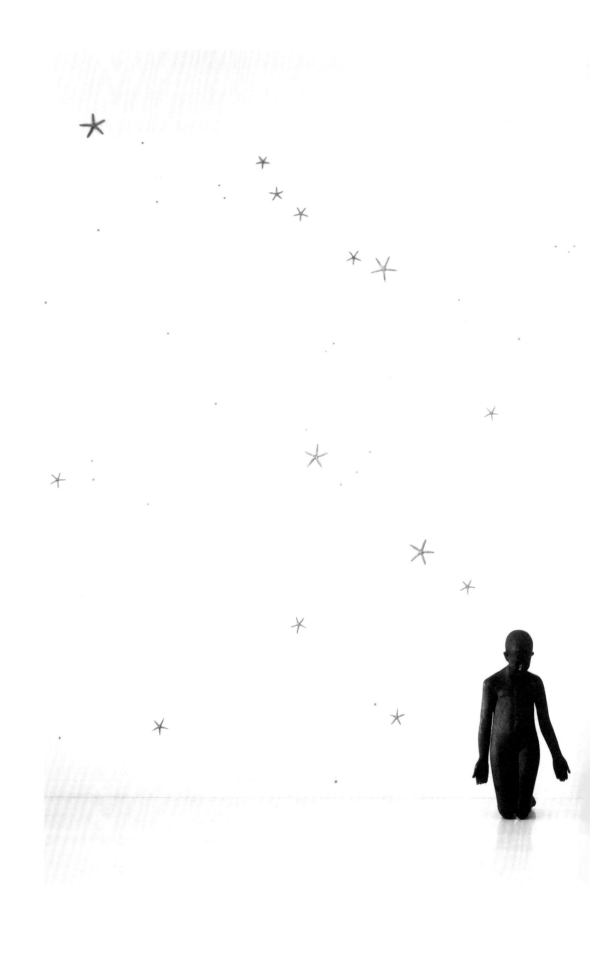

<u>푸른 소녀</u>. 1998. 실리콘 청동. 가변 설치.
Blue Girl. silicon bronze.

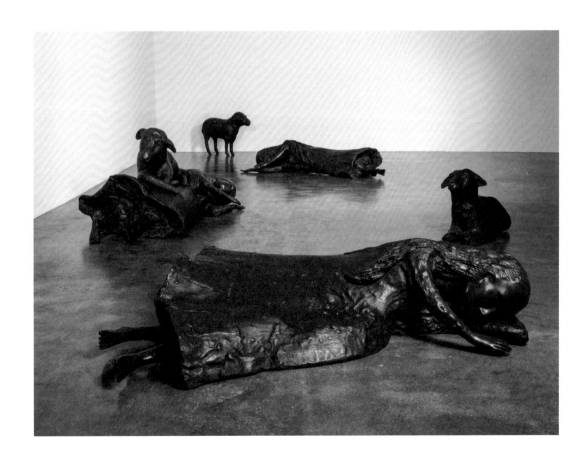

초원(꿈꾸기, 배회하기, 잠자기, 둘러보기, 기대기). 2009. 청동. 가변 설치. 서 있는 양
77.5×33×106.7cm, 엎드려 있는 양 57.2×101.6×38.1cm, 여인과 양 86.4×208.3×99.1cm,
양팔을 뻗고 있는 여인 45.1×213.4×119.4cm, 팔을 베고 있는 여인 45.7×198.1×134.6cm.
Pasture (Sleeping, Wandering, Slumber, Looking About, Rest Upon). bronze.

꿈. 1992. 에치젠 고조 기즈키 종이에 2색 요판 인쇄. 106×196.9cm.
Sueño. intaglio in 2 colors on Echizen Kouzo Kizuki paper.

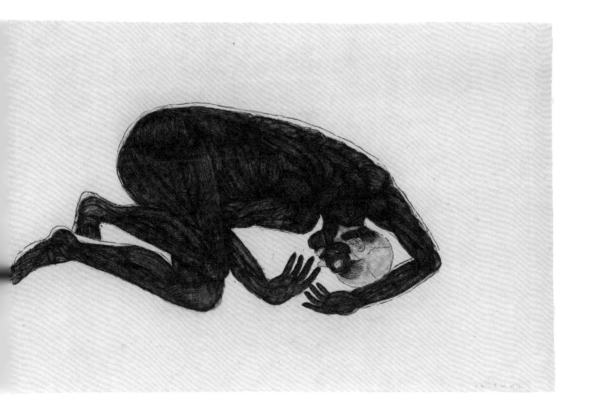

184

회합. 2014, 면 자카드 태피스트리, 294.6×193cm.
Congregation, cotton Jacquard tapestry.

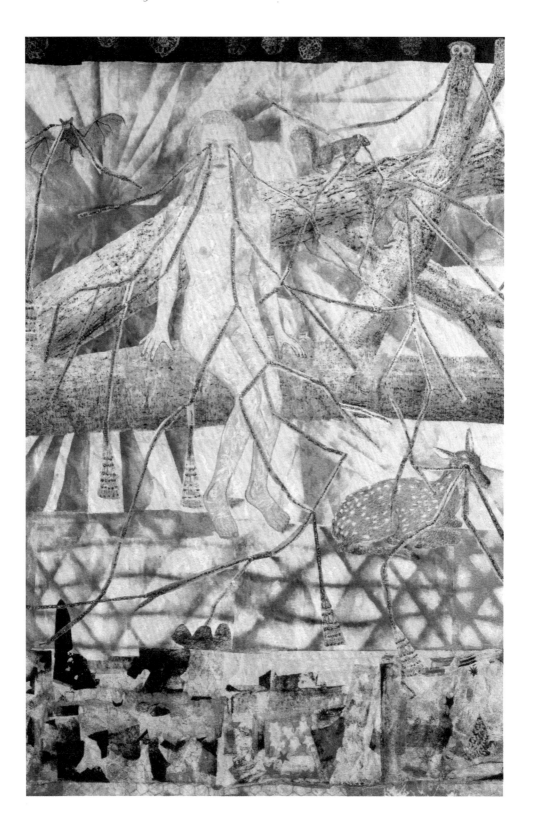

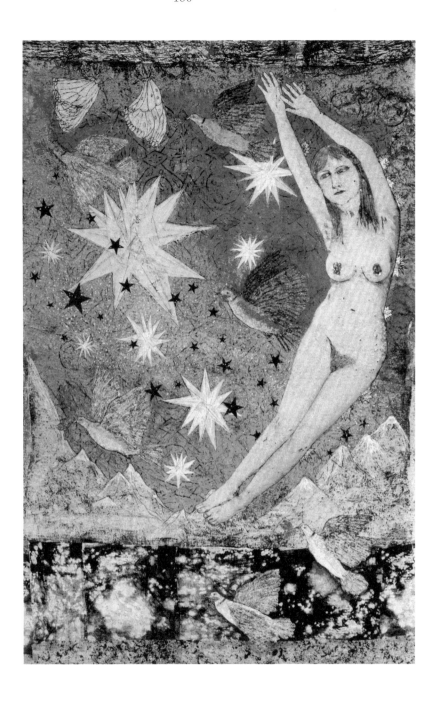

하늘. 2012. 면 자카드 태피스트리. 287×190.5cm.
Sky. cotton Jacquard tapestry.

지하. 2012. 면 자카드 태피스트리. 293.4×190.5cm. (p.187 위)
Underground. cotton Jacquard tapestry. (p.187 top)

땅. 2012. 면 자카드 태피스트리. 294.6×191.8cm. (p.187 아래)
Earth. cotton Jacquard tapestry. (p.187 bottom)

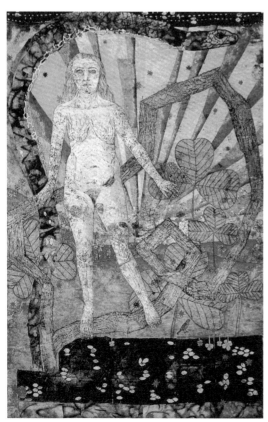

의회. 2017. 면 자카드 태피스트리, 은사. 287×190.5cm.
Parliament. cotton Jacquard tapestry with silver threads

방문자. 2015. 면 자카드 태피스트리. 302.3×194.3cm.
Visitor. cotton Jacquard tapestry.

대성당. 2013. 면 자카드 태피스트리. 294.6×190.5cm.
Cathedral. cotton Jacquard tapestry.

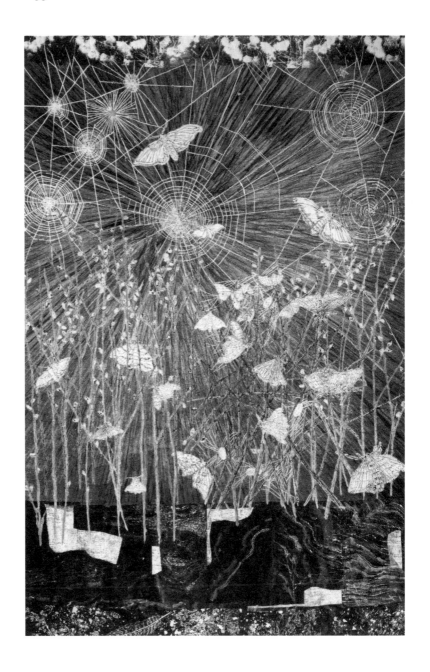

행운. 2014. 면 자카드 태피스트리. 294.6×193cm. (p.192 왼쪽)
Fortune. cotton Jacquard tapestry. (p.192 left)

머무름. 2015. 면 자카드 태피스트리. 287×190.5cm. (p.192 오른쪽)
Sojourn. cotton Jacquard tapestry. (p.192 right)

실 잣는 이. 2014. 면 자카드 태피스트리에 채색, 금박. 294.6×193cm.
Spinners. cotton Jacquard tapestry, hand painting and gold leaf.

p.193의 세부.
Detail of p.193.

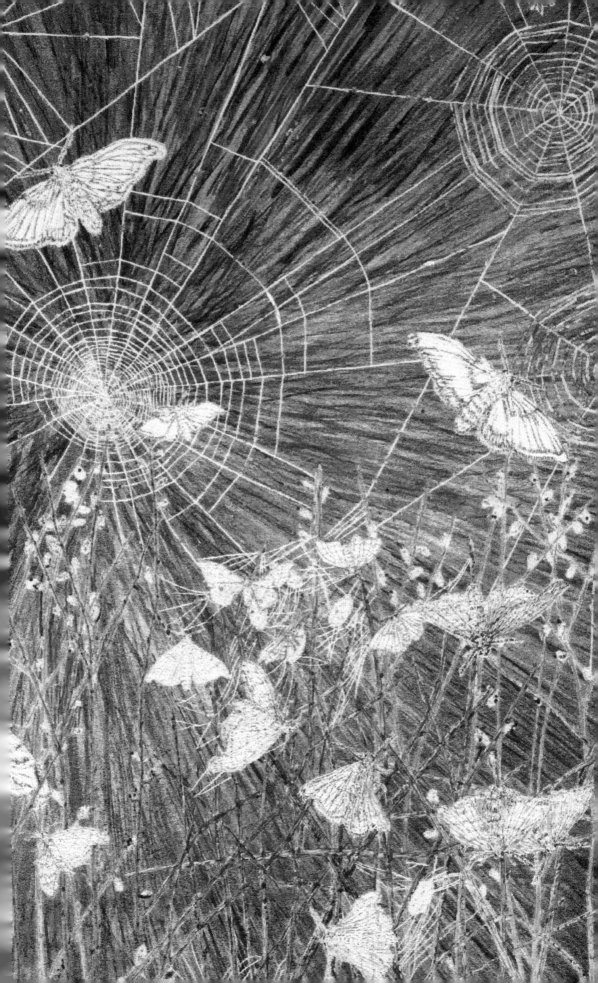

인도. 2012. 면 자카드 태피스트리. 287×190.5cm.
Guide. cotton Jacquard tapestry.

항구. 2015. 면 자카드 태피스트리. 302.3×194.3cm.
Harbor. cotton Jacquard tapestry.

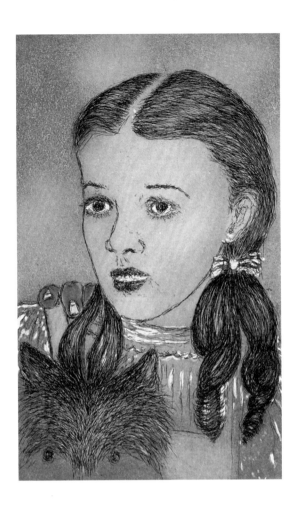

블루 프린트: 도로시. 1999. 하네뮐레 종이에 에칭, 아쿼틴트, 드라이포인트,
컬러 프린트. 15점 중 1점. 38.1×30.5cm.
Blue Prints: Dorothy. 1 from a set of 15 etching, aquatint and drypoints,
printed in color, on mold-made Hahnemühle paper.

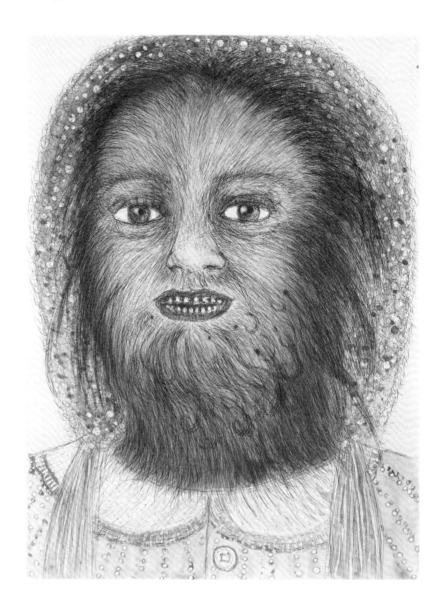

블루 프린트: 늑대 소녀. 1999. 하네뮐레 종이에 에칭, 아쿼틴트, 드라이포인트,
컬러 프린트. 15점 중 1점. 50.8×40.6cm.
Blue Prints: Wolf Girl. 1 from a set of 15 etching, aquatint and drypoints,
printed in color, on mold-made Hahnemühle paper.

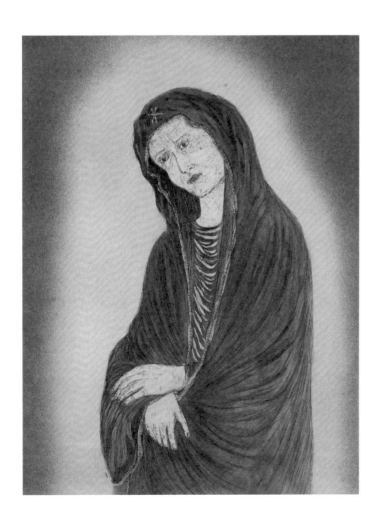

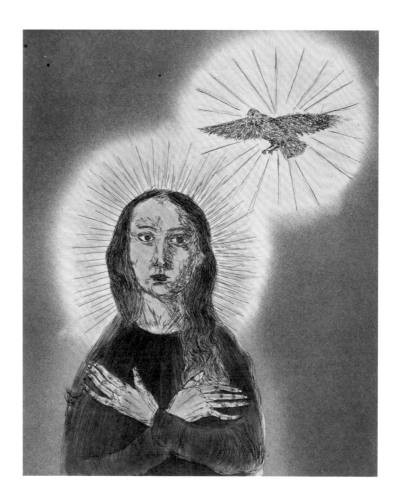

블루 프린트: 성모 마리아. 1999. 하네뮐레 종이에 에칭, 아쿼틴트, 드라이포인트,
컬러 프린트. 15점 중 1점. 50.8×40.6cm. (p.200)
Blue Prints: Virgin Mary. 1 from a set of 15 etching, aquatint and drypoints,
printed in color, on mold-made Hahnemühle paper.

블루 프린트: 성모 마리아와 비둘기. 1999. 하네뮐레 종이에 에칭, 아쿼틴트,
드라이포인트, 컬러 프린트. 15점 중 1점. 50.8×40.6cm.
Blue Prints: Virgin with Dove. 1 from a set of 15 etching, aquatint and drypoints,
printed in color, on mold-made Hahnemühle paper.

새와 알. 1996 석고, 끈. 새 6.7×21×6cm, 끈 75.6cm, 알 3.2×3.2×4.1cm.
Bird and Egg. plaster and string.

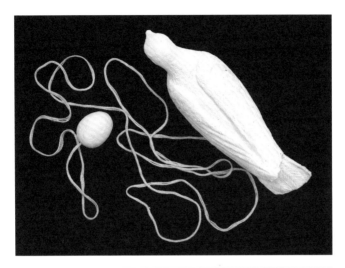

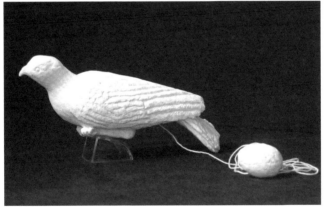

노른자. 1999. 유리. 1.9×3.8×3.8cm. (위 왼쪽)
Yolk. glass. (top left)

알. 2000. 유리. 10.8×17.1×10.8cm. (위 오른쪽)
Egg. glass. (top right)

작은 산. 1993-1996. 쇼트 크리스털. 4.1×10.5×8.9cm. (아래 왼쪽)
Little Mountain. Schott crystal. (bottom left)

꼬리뼈. 1997. 크리스털. 4.1×11.4×13.7cm. (아래 오른쪽)
Tail. kiln-cast lead crystal. (bottom right)

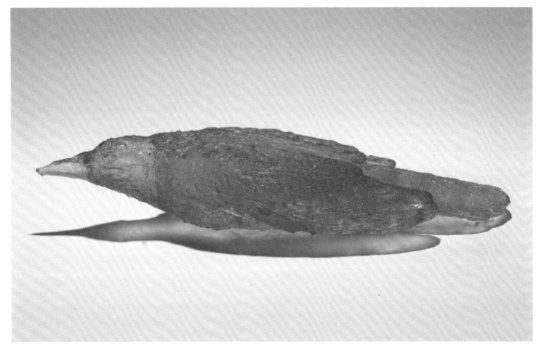

무제. 2011. 유리. 9.5×12.7×9.5cm. (위 왼쪽)
Untitled. glass. (top left)

무제(청동 주조한 새 둥지). 1990년대. 청동. 4.4×16.5×24.1cm. (위 오른쪽)
Untitled (cast bronze bird's nest). bronze. (top right)

무제(장밋빛 레진 새). 1999. 레진. 5.1×26×8.3cm. (아래)
Untitled (rose resin bird). resin. (bottom)

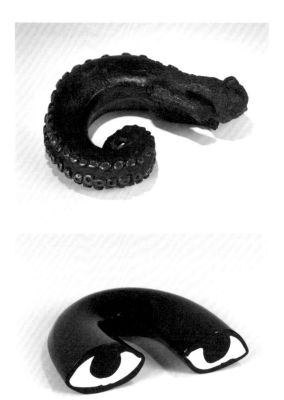

옥토푸시. 1998. 인청동. 5.1×19.1×16.2cm. (왼쪽 위)
Octopussy. phosphorous bronze. (left top)

무제. 1994. 황동. 4.4×10.2×11.4cm. (오른쪽)
Untitled. brass. (right)

삼백안. 1997. 유리. 3.5×16.8×10.8cm. (왼쪽 아래)
Sanpaku. glass. (left bottom)

무제. 1994. 청동. 3.8×12.7×14cm. (위 왼쪽)
Untitled. bronze. (top left)

무제(자기로 구운 죽은 고양이의 상반신). 1998. 자기. 5.1×11.4×6.4cm. (위 오른쪽)
Untitled (porcelain dead cat half upper body). porcelain. (top right)

무제(죽은 고양이의 상반신). 1998. 청동. 5.1×12.7×7.6cm. (아래 왼쪽)
Untitled (dead half cat, upper torso). bronze. (bottom left)

추락한 박쥐. 1998. 청동, 루비. 7×16.5×10.8cm. (아래 오른쪽)
Crashed Bat. bronze and ruby. (bottom right)

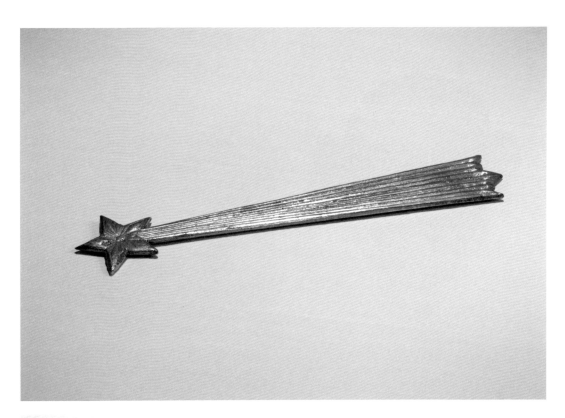

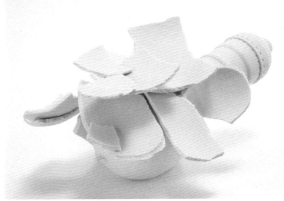

<u>꼬리 달린 별</u>. 1997. 스털링 실버. 0.6×19.7×3.8cm. (위)
Star with Tail. sterling silver. (top)

<u>라이트 캐처</u>. 2011. 자기. 26×19.1×12.7cm. (아래)
Light Catcher. porcelain. (bottom)

무제(아기). 1987. 파피에 마세에 금칠. 4.8×12.7×5.7cm. (위 왼쪽)
Untitled (baby). 1987. gold-painted papier-mâché. (top left)

개구리. 1999. 유리. 5.4×13×14cm. (위 오른쪽)
Frog. glass. (top right)

대답. 1996. 자기, 철사. 6.4×31.8×7.3cm. (아래)
Answer. porcelain and wire. (bottom)

미스 메이. 2007 잉크젯 프린트에 흑연, 콜라주. 50.8×61cm.
Miss May. inkjet print with graphite and collage.

<u>무제(두폭화)</u>. 1999. 아이리스 프린트(왼쪽 프린트에 연필 드로잉). 각 25.4×20.3cm.
Untitled (Diptych). Iris print with pencil drawing by artist over left print.

<u>무제</u>. 2001. 아이리스 프린트. 50.8×40.6cm. (p.213)
Untitled. Iris print.

늑대가 있는 무제. 2001. 아이리스 프린트. 40.6×45.7cm.
Untitled with Wolf. Iris print.

눈먼. 2001. 아이리스 프린트. 55.9×40.6cm. (p.216)
Blinded. Iris print.

선견자. 2001. 아이리스 프린트. 50.8×40.6cm.
Seer. Iris print.

흰 고양이. 1999. 아이리스 프린트. 30.5×45.7cm.
White Cat. Iris print.

그녀의 총신들. 1999. 아이리스 프린트. 50.8×55.9cm.
Her Minions. Iris print.

선지자. 1999. 아이리스 프린트. 40.6×40.6cm.
Visionary. Iris print.

나비, 박쥐, 거북이. 2000. 아이리스 프린트, 콜라주. 각 29.2×29.2×3.2cm.
Butterfly, Bat, Turtle. dimensional Iris print with collage.

Butter fly

Butter fly BAT

Tartle

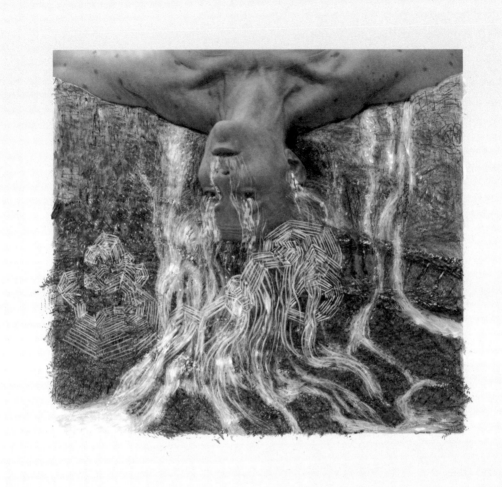

폭포 I. 2013. 엔트라다 종이에 피그먼트 잉크젯, 채색. 85.7×89.5cm. (p.224 위)
The Falls I. pigmented inkjet with hand-coloring on Entrada Natural Rag paper. (p.224 top)

폭포 II. 2013. 엔트라다 종이에 피그먼트 잉크젯. 85.7×89.5cm. (p.224 아래)
The Falls II. pigmented inkjet on Entrada Natural Rag paper. (p.224 bottom)

폭포 III. 2013. 엔트라다 종이에 피그먼트 잉크젯, 채색. 85.7×89.5cm.
The Falls III. pigmented inkjet with hand-coloring on Entrada Natural Rag paper.

3월 초. 2014. 젤라틴 실버 프린트에 채색. 30.5×45.4cm.
Early March. gelatin silver print with hand painting.

3월 7일. 2014. 젤라틴 실버 프린트에 채색, 글리터, 보드에 부착. 30.5×45.4cm.
March 7th. gelatin silver print with hand painting and glitter mounted to board.

<u>10월 중순</u>. 2014. 크로모제닉 프린트에 글리터, 보드에 부착. 15.2×22.9cm. (p.230 위)
Mid-October. chromogenic print with glitter mounted to board. (p.230 top)

<u>8월 31일</u>. 2014. 크로모제닉 프린트에 채색, 글리터, 보드에 부착. 15.2×22.9cm. (p.230 아래)
August 31st. chromogenic print with hand painting and glitter mounted to board. (p.230 bottom)

<u>무제(〈목발 짚은 붉은 달〉의 손)</u>. 2002. 크로모제닉 컬러 프린트. 32.1×48.3cm. (위)
Untitled (Hand of "Red Moon on Crutches"). chromogenic color print. (top)

<u>무제(허니 왁스)</u>. 1995. 엑타컬러 프린트. 50.8×61cm. (아래)
Untitled (Honeywax). Ektacolor Print. (bottom)

달 셋(세폭화). 1998. 포토그라비어. 각 81.9×60.9cm.
Moon Three (Triptych). photogravure.

The witch's familiars call forth the forest silent.
She hears home.

On still moonlight a witch alone haunts the dark.
She's been touched.

The witch smells her consort, her hairs wander.

A raven comes and perches on the witch.
Her eyes shine out night, then a wind comes up.

The witch flickers the dark stars and eats from the fruit.

<u>위기 모면</u>. 2002. 라나 그라비어 종이에 5점 포토그라비어, 활자 인쇄. 각 50.8×40.6cm.
Out of the Woods. set of 5 digitally manipulated photogravures with hand-set type on Lana
Gravure paper.

기타 등등. 1999. 세키슈 토리노코 감피 종이, 마사 종이, 하네뮐레 동판 종이에 6색 석판,
2색 요판 인쇄, 아플리케. 113×68cm.
Etc. Etc. lithograph in 6 colors and intaglio in 2 colors with applique on Sekishu Torinoko
gampi, Masa, and Hahnemuhle copperplate paper.

지렁이. 1992. 일본 종이에 요판 인쇄, 콜라주. 108.6×157.5cm.
Worm. intaglio with collage on Japanese paper.

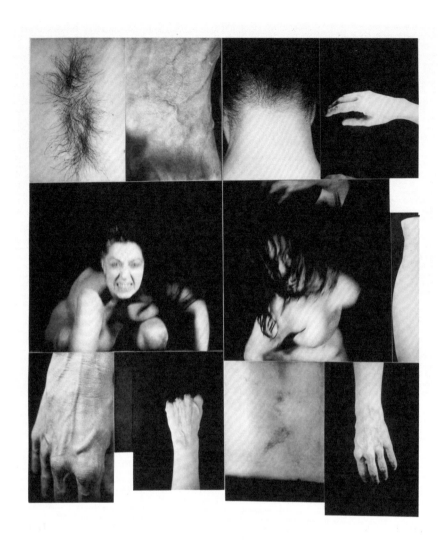

라스 아니마스. 1997. 아르슈 앙투카 종이에 요판 인쇄, 포토그라비어. 152.7×125.1cm.
Las Animas. intaglio with photogravure on Arches En Tout Cas paper

239

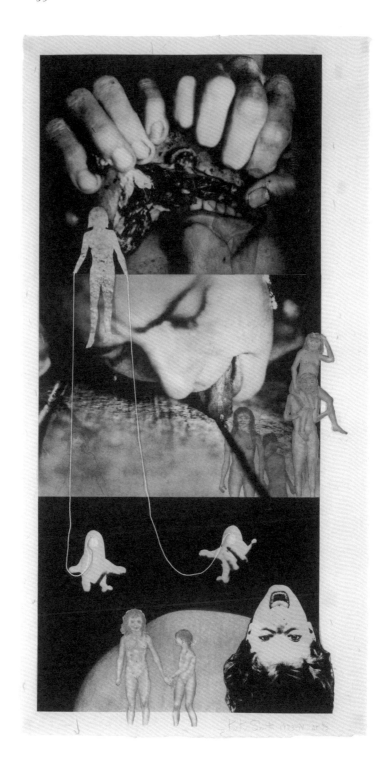

꼭두각시. 1993-1994. 감피 종이에 2색 요판 인쇄, 콜라주. 고지 기즈키 종이로 배접.
147.3×73.7cm.
Puppet. intaglio in 2 colors with collage on gampi hinged to Kouzi-Kizuki paper.

자유낙하. 1994. 에치젠 고조 기즈키 종이에 요판 인쇄, 포토그라비어, 에칭, 드라이포인트.
84.5×106.7cm.
Free Fall. intaglio with photogravure, etching, and drypoint on Echizen Kozo Kizuki paper.

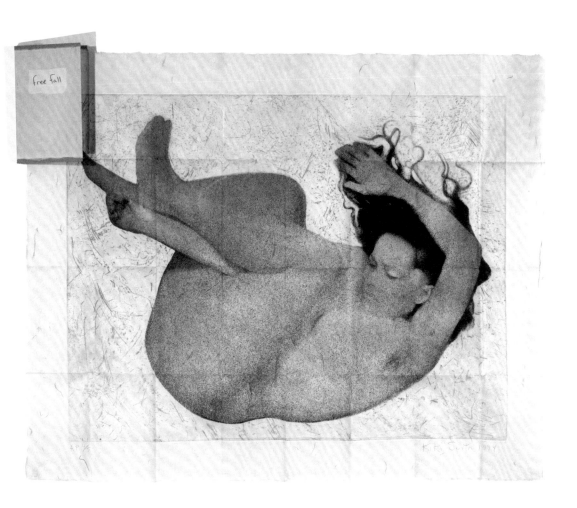

free fall

청동으로 만든 사람 머리와 손발이 긴 쇠사슬로 연결되어 바닥에 널브러져 있다. 팔뚝과 정강이 중간에서 잘린 손발의 어중간한 길이가 더욱 불길하게 느껴지고, 무더기로 쌓인 쇠사슬은 언뜻 내장이나 핏줄처럼 보인다. 작품 제목은 〈데이지 체인(Daisy Chain)〉(1992, p.175). 설마 데이지를 이어 만든 그 꽃목걸이? 당혹스러운 시선이 무겁고 딱딱한 금속 표면을 훑으며 방황한다. 환한 데이지꽃들은 어디로 갔는가?[1]

'익숙하고 편안한 것에 저항하는 시도는 낯설고 불편하다.' 미술관에서 낯설고 불편한 것을 대할 때, 이 동어반복 같은 문장을 마음에 새기면 위로가 되는 경우가 있다. '이것은 어떤 익숙하고 편안한 것에 대한 저항일까?' 또는 '나는 왜 이것이 낯설고 불편할까?' 자문하면 순간적으로 들었던 당혹감과 반발심이 누그러지기도 한다. 게다가 익숙하고 편안할수록 쉽게 느껴진다는 점을 생각하면, 낯설고 불편한 그 시도들이 어렵기까지 한 것도 이해할 만해진다. 다다(Dada) 이후 한 세기 남짓한 예술사, 그중에서도 특히 1970년대부터 지금까지 이어지는 동시대 예술(contemporary art)은 '반예술(反藝術, anti-art)'에 이를 정도로 기존 예술의 정의와 가치에 저항해 왔고, 키키 스미스의 방대한 예술세계는 그 속에 뚜렷한 흔적을 새기고 있다. 우리는 왜 이것이 낯설고 불편한지 물어야 하리라.

저항으로서의 페미니즘 예술

이십세기에 있었던 두 번의 세계대전은 인간 이성이 합리적이라는 가정을 근본에서부터 뒤흔들었다. 세계 각지에서 새로운 세계를 요구하는 전방위적인 행동이 분출했다. 유럽에서는 '금지하는 것을 금지한다!'라는 슬로건을 내건 68혁명이 일어나 국가와 종교, 가부장제의 전통적 권위와 차별을 거부하고 성평등, 인권, 생태주의와 같은 새로운 가치들을 사회 전체로 확산시켰다. 미국에서는 1950년대부터 흑인의 시민권과 참정권, 사회적 차별 방지를 요구하는 대대적인 민권 운동이 시작되었고, 반문화를 자처한 히피 운동과 베트남전쟁 반대 운동이 이어졌다.

가장 선도적이고 격렬한 저항은 예술 영역에서 이루어졌다. 1960년대와 1970년대를 관통하며 예술 현장에는 팝아트와 개념미술, 미니멀리즘, 해프닝, 신체예술, 대지예술, 사진, 실험 영화, 공공예술 등 기존의 체제와 예술의 정의에 저항하는 새롭고

1
여성의 몸을 쇳덩이와 쇠사슬이 달린 족쇄로 형상화하고, 제목은 이와 상반된 낭만적 이미지를 연상케 함으로써, 여성들이 처한 생의 무게와 모순된 상황을 표현했다.

2
Peggy Phelan, "Survey,"
Art and Feminism, ed. by
Helena Reckitt, London:
Phaidon Press, 2001. p.19;
페기 펠런, 헬레나 레킷
편, 오숙은 역, 『미술과
페미니즘』, 미메시스, 2007;
캐롤린 코스마이어, 신혜경
역, 『페미니즘 미학입문』,
경성대학교 출판부, 2009.
p.207.

3
국내에는 「왜 위대한 여성
미술가는 없었는가?(Why
Have There Been No Great
Women Artists?)」와 최초
논문이 발표되고 삼십 년
뒤에 저자가 최초 논문의
논점과 그간의 변화를
다시 짚어 본 「왜 위대한
여성 미술가는 없었는가?
30년 후」를 함께 묶은 『왜
위대한 여성 미술가는
없었는가?』(린다 노클린,
이주은 역, 아트북스,
2021)가 출간되어 있다.

실험적인 예술적 시도들이 다투어 등장하며 '동시대 예술'이라는 예술사의 특정한 한 시대를 열었다.[2] 동시대 예술의 큰 흐름 중 하나는 의식적인 예술 사조로서의 페미니즘 예술인데, 1971년에 발표된 페미니즘 예술운동의 출범 선언문과도 같은 「왜 위대한 여성 미술가는 없었는가?」라는 논문에서 미국 미술사학자이자 예술비평가인 린다 노클린(Linda Nochlin)은 '여성을 그린 그림은 넘쳐나는데, 왜 여성이 그린 그림은 없는가?'라는 질문과, 나아가 '예술의 위대함은 어디에서 연유하는가?'라는 질문을 통해 전문적인 예술 교육 과정에서 여성을 체계적으로 배제해 온 제도의 역사와 구조를 밝히고 낭만적 천재 개념이 어떻게 남성 지배를 공고히 하면서 여성의 예술적 성취를 가로막아 왔는지 논증했다.[3]

키키 스미스는 1960년대에 시작된 히피 운동과 1970년대에 본격화된 페미니즘 예술로부터 직접적인 영향을 받았다. 히피 운동으로부터는 자연친화적 사상과 동양 문화에 관한 관심, 개방적이고 자유주의적인 태도뿐만 아니라, 일상 도구와 옷 등을 직접 만들어 쓰는 경험을 통해 이후 예술 작업의 밑바탕이 될 기술과 지식을 얻었다. 페미니즘 예술로부터 받은 영향은 그보다 더 직접적이다. 스미스가 뉴욕으로 거처를 옮기고 본격적으로 예술가의 길을 탐색하던 1970년대 후반과 1980년대는 페미니스트 예술가들이 고군분투하며 예술계 내에서 조금씩 입지를 넓혀 가던 때였다. 당시 페미니즘 예술은 남성 예술가의 전유물처럼 인식된 회화보다는 사진과 영상을 포함한 새로운 매체와 설치, 퍼포먼스 같은 다양한 형식을 활발하게 실험했다. 주제 면에서는 여성 신체에 대한 대상화와 억압에 반대하는 의미에서의 여성 신체성 가시화에 초점을 맞추고 있었다. 스미스는 특히 에바 헤세, 리 본테쿠(Lee Bontecou), 낸시 스페로(Nancy Spero), 아이다 애플브루그(Ida Applebroog), 루이즈 부르주아 등의 작품들을 접하며 자기 예술세계의 방향과 결을 잡아 나갔다.

그러나 페미니즘 예술은 느슨하게 구성된 개념인 데다 끊임없이 논쟁과 변화를 겪는 중이라 실체를 명확하게 정의하기가 쉽지 않다. 최근에는 페미니즘 예술이 구성된 1970년대와는 상황이 달라졌으므로 페미니즘 예술을 해체하거나 '포스트페미니즘(post-feminism)' 예술로 이행해야 한다는 주장도 제기된다. 스미스는 한 사람의 시민으로서 페미니스트임을 공개적으로 인정하면서도 자신의 예술이 정치적 의미의 페미니즘 예술로 해석되는 것에는

4
Kiki Smith, conversation
with Petra Giloy-Hirtz,
"Kiki Smith: Procession: 'A
Wonder Version of Life',"
Kiki Smith: Procession, ed. by
Petra Giloy-Hirtz, Munich:
Haus der Kunst & Prestel,
2018. p.25. 필자 역.

반대한다. 여성으로서 살아가는 자기 경험에서 나온 작품들이 '교훈적'으로 읽힐 위험을 피하고자 하기 때문이다. "나의 많은 작품이 공적 공간에서 여성으로 살아가는 치욕에 관한 것이다. 우리 젠더에는 엄청난 치욕이 첨부돼 있다. 문화의 아무것도 우리의 경험을 논하지 않기 때문이다. (…) 공적 공간에서 그것을 견뎌낼 수 있는지 알기 위해서, 내게는 '여자-아이'로서의 경험을 가지고 문화 안에서 버티는 것이 중요하다"라고 키키 스미스는 말한다.4

전장(戰場)이 된 여성의 몸과 물질

오늘날 몸과 물질의 문제는 철학과 예술 양쪽 영역에서 중심적인 문제다. 그러나 이런 변화는 쉽지 않았다. 여성의 몸을 이야기하는 것 자체가 여성을 물질(자연)로 환원해 온 오랜 이항대립적 상징의 족쇄를 강화할 위험이 있기 때문에, 페미니즘 논의 내에서 몸과 물질성을 거론하는 것이 금기시되던 때도 있었다. 페미니즘 담론이 살아 있는 물질로서의 몸과 다양하게 변화하는 신체적 실천을 포괄하기 시작한 것은 비교적 최근의 일이며, 그것은 적잖은 진통과 논쟁을 동반하며 이뤄지는 현재진행형 사안이다.

5
캐롤린 코스마이어, 신혜경
역,『페미니즘 미학입문』,
p.258.

남성중심주의와 가부장적 질서에 물든 언어가 여성의 주체성을 표현하는 데 마땅하지 않을 때, 여성의 몸은 명확한 표현의 장이 되고, 몸이 지닌 본능적이고 당혹스러운 요소들은 예술적 상상력과 쉽게 연결된다.5 동시대 페미니즘 예술이 몸, 특히 여성의 몸을 드러내는 방식은 여러 층위에서 전복적이다. 전통적으로 예술의 객체이자 대상이었던 여성이 예술 활동의 주체로 나서는 자체가 전복적이고, 이상화 아니면 대상화되던 여성의 미적 가치에 저항하는 재현과 표현이 전복적이며, 은폐되고 감춰졌던 여성 섹슈얼리티의 양상들을 감각적으로 재현하며 성애와 역겨움의 반응을 실험하는 것도 전복적이다. 무엇보다 남성 천재가 만들어내는 불멸의 성과를 기리는 공간에 취약하고 죽을 운명인 몸을 도입하는 행위 자체가 전복적이다. 그리고 이 모든 경우는 인간을 이상화된 미의 기준으로 보는 인간중심주의를 해체하는 작업이기도 하다. 막말로 인간 아닌 누가 인간을 아름답게 보겠는가?

키키 스미스의 예술세계에서 여성의 몸과 물질성이 갖는 의미는 특별하다. 일찍부터 몸에 관심을 두었던 스미스는

예술사에서 가장 오래된 동시에 가장 애용되는 주제인 인간 또는 여성의 몸을 전혀 새로운 관점으로 동시대 예술 현장에 다시 소환했다. 공업 재료로 널리 쓰이는 덕타일 주철로 제작한 1988년 작 〈소화계(Digestive System)〉(p.153)와 종이에 잉크로 표현한 같은 연도 작품 〈무제(토르소)〔Untitled(Torsos)〕〉(p.149)는 각각 소화계와 상반신 근육 구조를 재현한다. 실크스크린과 모노타이프 판화 기법으로 제작된 1985년 작 〈가진 사람이 임자(Possession is Nine-Tenths of the Law)〉(p.147)는 잉크를 덧칠한, 사실적인 아홉 가지 주요 장기를 보여준다. 이 작품명이 암시하듯이, 해부학적인 신체 부위와 장기를 다루는 초기 작품들에서 스미스가 드러내는 것은 특수한 몸이 아니라 누구에게나 있는 보편적인 몸이다.

1991년 한 인터뷰에서 스미스는 "우리 몸은 기본적으로 강탈당했다"고 말하며 자신의 예술이 자신의 영역을 되찾으려는 시도임을 밝혔다.[6] 인체 장기와 부위를 형상화한 작품 하나하나가 자신의 몸을 확인하는 호명인 셈이다. 이들 초기 작품에 묘사된 몸은 여성인지 남성인지 특정하기도 불가능하다. 인체를 구성하는 주요 기관인 피부가 빠져 있기 때문이다. 피부는 문제적이다. 나와 세계의 경계인 동시에 성별과 인종, 나이, 빈부, 미추의 낙인이 찍히는 차별과 폭력의 장소이기 때문이다. 스미스는 피부를 걷어냄으로써 누구에게나 공통으로 존재하는 몸의 물질성을 드러낸다.

스미스는 그처럼 완고한 차별의 현장인 피부의 취약성을 종이로 표현한다. 그가 조각과 드로잉 작품 등에 두루 쓰는 산닥나무로 만드는 일본산 감피 종이(雁皮紙, Japanese gampi paper)와 월계수의 아종인 다프네 관목으로 만드는 네팔산 로크타 종이(Nepali lokta paper)는 쭈글쭈글하고 얇고 반투명하면서도 어느 정도는 견고해서 피부와 매우 유사한 느낌을 준다. 1997년에 시인 메이메이 버센부르거(Mei-mei Berssenbrugge)와 협업하여 만든 실험적인 아티스트북 〈내분비학(Endocrinology)〉(p.127)은 종이를 오려서 잉크를 묻혀 찍은 장기들이 반투명한 종이에 비쳐, 손상되기 쉬운 장기들을 얇은 피부가 감싸고 있는, 취약한 몸을 책 자체로 형상화한다. 그러니 우리는 스미스가 '피부'로 쓰는 감피 종이와 로크타 종이에 그리고 찍고 붙인 수많은 드로잉과 판화와 콜라주 작품을 일종의 문신으로 볼 수 있으리라. 2012년도 작품인 〈약속(Promise)〉(pp.66-67)에 나타나는 푸른 꽃들은 실제로 작가의

6
Kiki Smith, conversation with Kristen Brooke Schleifer, "Inside and Out: An Interview with Kiki Smith," *The Print Collector's Newsletter*, vol. 22, no. 3, July-August, 1991, p.86.

두 팔에 새겨진 푸른 성좌 문신을 닮았다.

　신체 기관을 탐색하던 스미스는 생명의 증거로서 체액의
순환과 배출 작용에 주목한다. 살아 있다는 것은 피와 땀과 눈물과
타액과 고름과 젖과 생리혈과 정액과 오줌과 똥을 배출하는
것이다. 그의 '몸'들은 이내 길게 똥 줄기를 끌며 바닥을 기거나,
엉거주춤 서서 생리혈을 흘리거나, 쪼그리고 앉아 오줌을
누기 시작했다. 반응은 격렬했다. 관객들은 수치심과 혐오감을
토로했다. 비평가들은 불가리아 출신 프랑스 철학자인 쥘리아
크리스테바(Julia Kristeva)의 '아브젝시옹(abjection)' 개념을 빌려
분석을 시도했다. 비체(卑體)로 번역되는 아브젝시옹은 주체가
언어적 상징계에 도달하는 과정에서 거부하고 추방한 언어화되지
못한 잔여물이다. 자아는 형성 과정에서 이질적이고 위협적으로
여겨지는 어떤 것들을 분비, 배출, 배제, 축출, 유기하지만, 완전히
분리되지 못한 채 혐오와 유혹의 양가적 감정 상태에 빠진다.[7]
그러나 배설 행위와 배설물이 표현된다는 이유만으로 키키
스미스의 작품에 크리스테바의 아브젝시옹 개념을 대입하는 것은
너무 단순한 접근이다.

　스미스는 한 인터뷰에서 〈테일〉(1992, p.158)이 에이즈와
낙태권 투쟁 등 몸에 대한 통제권을 가지지 못한 여성들의
경험에서 나왔다고 밝혔다.[8] 또한 몸은 모두가 공유하는 하나의
형태이면서도, 모두가 저만의 고유한 경험을 하는 무언가이기
때문에 몸에 주목하게 되었다고 말했다.[9] 이전과 이후 흐름과
함께 고려한다면, 그의 비천한 몸들은 몸이 하는 기본적인 활동인
배출과 배설을 가시화함으로써 생명의 일반적인 물질성을 가장
충격적인 형태로 드러낸다고 해석하는 것이 더 적절하다.

　키키 스미스의 몸들은 불결한 배설 행위를 하거나[〈트레인〉
(1993)], 기괴한 자세를 취하거나[〈릴리스(Lilith)〉(1994, p.172)],
피부가 벗겨진 해부용 사체 같은 외양을 가짐으로써[〈성모
마리아〉(1992, p.155)], 여성의 신체를 성애적으로 바라보거나
순수한 아름다움의 구현체로 이상화하는 전통적 '보기'의 가능성을
원천적으로 차단한다. 그 몸들은 남성 응시의 대상도 아니고
종교적이거나 정신적인 가치의 상징도 아닌, 그냥 살아 있는,
물질로서의 몸이다.

　일단 최초의 충격과 혐오가 가시고 나면, 현대의 공간
중에서도 가장 비일상적인 공간이랄 수 있는 매끈하고 반듯한

7
김은주, 『생각하는 여자는
괴물과 함께 잠을 잔다』,
봄알람, 2017, pp.161-162.

8
Kiki Smith, conversation
with Heidi Julavits, "Kiki
Smith," *Interview Magazine*,
July 17, 2017. https://www.
interviewmagazine.com/art/
kiki-smith

9
Robin Winters, "An Interview
with Kiki Smith," *Kiki Smith*,
Amsterdam: Institute of
Contemporary Art; The
Hague: Sdu Publishers, 1990,
pp.127-140.

미술관에 놓인 불결한 몸들은 관객들로부터 기묘한 공감을 끌어낸다. 먹고 숨 쉬고 배설하는 자신의 몸, 자기 생명의 특수하고도 보편적인 물질성을 새삼 돌아보게 만드는 것이다. 키키 스미스의 작품들은 몸에 대한 고전적인 이상화나 대중문화의 페티시화를 거부하며, 페미니즘과 정신분석, 후기구조주의 이론 측면에서 몸의 재현을 재개념화하는 비평적 담론 발전에 기여한다. 그러나 더욱 중요한 점은 그의 몸들이 물질성 차원에서 여성과 여성적 지위에 있는 것들의 경험을 보편화한다는 사실일 것이다.

새와 늑대, 변신하는 몸

키키 스미스의 관심은 1990년대 초반부터 본격적으로 인간의 몸에서 동물의 왕국으로 확대되는데, 특히 인간이 처한 환경적 조건을 반영하는 거울이라고 본 새들의 취약하고 위태로운 물질성에 집중한다. 여기에는 계기가 있다. 어느 날 스미스는 누군가가 자신을 불러 '새를 꺼내라!'고 명령하는 꿈을 꾸었다.[10] 스미스는 자신의 꿈을 형상화하여 사람의 입에서 새가 나오는 듯한 '기묘한 탄생'에 관한 작품을 만들었다. 유사한 모티프를 형상화한 1995년 작 〈새와 있는 두상 II(Head with Bird II)〉(p.174)은 실리콘 청동으로 거칠게 표현된 사람 머리와 흰 청동으로 매끄럽게 마감된 새의 질감 대비가 흥미로운데, 새가 죽은 사람의 생명력을 빨아들이는 듯이 보인다. 꿈을 통해 접근할 수 있는 무의식의 창조성에 주목하는 프랑스의 철학자 엘렌 식수(Hélène Cixous)는 기독교 성서가 불결하고 혐오스러운 것으로 배제한 존재로서 새와 여성이 동의어라고 말한다.[11]

그러나 스미스의 새들은 죽은 채인 경우가 많다. 1995년 작 〈저지 까마귀(Jersey Crows)〉(pp.166-167)는 살충제에 희생된 새들을 기린 작품으로, 하늘에서 떨어진 돌덩이 같은 검은 청동 까마귀들이 갤러리 바닥 여기저기에 배치되었고, 1997년 작품인 〈새들의 파멸(Destruction of Birds)〉(pp.144-145)에는 흑백으로 에칭한 죽은 새들이 가지런히 놓였다. 새들이 여성의 영혼이자 인간이 처한 환경적 조건을 반영하는 거울이라면 몹시 묵시록적인 광경이 아닐 수 없다. 그의 죽은 새들은 자기 장소를 잃고 사라져 가는 생명과 지금 인간이 자연과 맺고 있는 파괴적인 관계를 돌아보게 한다.

그에게 동물은 동료이자 짝이다. 여성이 남성/여성 이항대립의

10
Carsten Ahrens, "All Creatures Great and Small: Kiki Smith's Artistic Worlds," *Kiki Smith: All Creatures Great and Small*, ed. by Carl Haenlein, Hannover: Kestner Gesellschaft, 1999, p.40.

11
엘렌 식수, 신해경 역, 『글쓰기 사다리의 세 칸』, 밤의책, 2022, p.199.

희생자이듯 동물(자연)이 문화/자연 이항대립의 희생자라는
의미에서의 동료일 뿐만 아니라, 이 세상에 있기 위해, 살아
있기 위해 분투하는 물질성을 가진 동등한 존재라는 의미에서의
동료이다. 그는 여성과 동물이 대등하게 교류하며 섞이는 신화와
동화의 세계를 탐색한다. '빨간 망토' 우화는 반복적으로 등장하는
모티프이다. 빨간 망토 소녀와 늑대는 〈동행자(Companion)〉(2000,
pp.130-131)에서 여러 명의 소녀와 여러 마리의 늑대로 변주되면서
서로 교차되고, 〈블루 프린트: 늑대 소녀(Blue Prints: Wolf
Girl)〉(1999, p.199)에서는 하나의 몸으로 섞인다. 스미스는 우리가
동물에게 부여하는 인간의 특성과 우리가 자기 정체성을 구축하기
위해 인간의 것으로 취하는 동물의 특성에 천착하며 둘 간의
섞임과 변신을 꾀한다.

그러나 늑대의 존재가 암시하듯이, 우화에는 죽음과 폭력,
소멸의 그림자가 드리워 있다. 스미스는 몸, 자연, 살아 있는 물질에
필연적으로 따라붙는 생(生)의 고통과 사(死)의 폭력을 인정하고
포용한다. 그 근원적인 고통과 폭력에 대한 이해가 모든 살아
있는 물질을 향한 연민의 바탕이 되고, 그 바탕 위에서 몸들은
교차되고 변신한다. 2001년 작품인 〈황홀〉(pp.168-169)에서는
빨간 망토 소녀의 할머니를 잡아먹었던 늑대의 배에서 완전히
성장한 여성이 출현한다. 거친 늑대의 표면과 새로 출현한 여성의
매끈하고 당당한 표면이 극적인 대비를 이룬다. 2002년 작품인
〈탄생〉(pp.170-171)에서는 암사슴에게서 역시 완전히 성장한
여성이 태어난다. 물질의 차원에서 보편화된 여성의 몸은 동물과의
경계를 넘나든다. 이보다 더 당당한 에코페미니즘 선언도 없을
것이다.[12]

키키 스미스의 세계에서는 여성과 동물과 취약하고 연약한
것들, 비천하고 낮게 존재하는 것들이 물질의 질서 안에서
보존되고 재평가된다. 그 안에는 생명의 폭력성과 취약성,
조화로움과 안도감 같은 것이 날것 그대로 놓여 있다. 그곳은 더는
인간이 지배하지 않는, 인간이 자연과 동등하게 상호작용하는
곳이다.

환경인문학자이자 페미니즘 이론가인 스테이시
앨러이모(Stacy Alaimo)는 몸들을 가로지르는 운동을 강조하는
'횡단신체성(Trans-Corporeality)'이라는 개념을 제시한다. 이 개념은
인간과 세계의 물질적 연관성을 이해할 수 있는 새로운 인식론의

12
에코페미니즘
(écoféminisme)은
1974년 프랑스 작가
프랑수아즈 도본(Françoise
d'Eaubonne)이 저서
『페미니즘 아니면 죽음(Le
féminisme ou la mort)』에서
처음으로 사용한 용어이자
개념으로, 가부장제와
자연 파괴가 모두 서구
문화의 이항대립 구조에
기반하고 있음을 지적하며
페미니즘이 생태주의
의제들을 끌어안아야
한다고 보았다.

13
Stacy Alaimo, "Trans-
Corporeal Feminisms
and the Ethical Space of
Nature," *Material Feminisms*,
ed. by Stacy Alaimo, Susan
Hekman, Bloomington:
Indiana University Press,
2008. pp.238-239.

14
Kiki Smith, conversation with
Chuck Close, "Kiki Smith by
Chuck Close," *BOMB*, no.
49, October 1, 1994. https://
bombmagazine.org/articles/
kiki-smith-1

기반으로서, 인간과 자연, 환경을 분리해서 사고할 수 없는 지금의 현실에 맞는 새로운 윤리적, 정치적 입장을 구축하고자 시도한다.[13] 횡단신체성이 열어 줄 그 인식적 공간을 우리는 이미 키키 스미스의 작품들에서 확인할 수 있다.

만든다는 것과 공예

세상에 예술작품을 내놓는 것은 여기 있고자 하는 노력이며, 태어나고자 하는 것들, 현존하고자 하는 것들에 관한 일이다. 1994년에 있었던 한 인터뷰에서 키키 스미스는 예술이 천성적으로 축적되는 것이며, 세계를 물리적으로 현시하여 창조하는 작업이라서 좋다고 말했다.[14] 세계를 만들 때는 자신이 만드는 것에 책임을 져야 한다. 키키 스미스 작품의 많은 수는 이성에 가려져 있던 자기 안의 무언가를 꺼내 물리적으로 만든 것이다. 일단 만들어지면 그것을 다룰 수 있다. 스미스에게 만든다는 건 인식이나 마찬가지다.

키키 스미스는 끊임없이 만든다. 어디를 가든 손이 쉬는 법이 없다. 1992년 작품인 〈무제(장기 일곱 개)〔Untitled(7 Organs)〕〉와 1996년 작품인 〈새와 알(Bird and Egg)〉(p.203)과 같이 손의 흔적이 느껴지는 작품들이 많다. 우리는 이런 작은 상들을 세계 곳곳의 박물관에서 만날 수 있다. 고대 이집트에서도 고대 인도에서도 손으로 만든 조그만 상들이 일상생활을 아름답게 꾸미는 한편 무덤에 부장되고 신전에 봉헌되어 산 자들과 죽은 자들과 죽지 않는 자들에게 기쁨을 주었다.

스미스가 끊임없이 손을 움직여 만드는 갖가지 물건들은 예술가 본인의 세계를 구성하는 일이자 세상의 모든 존재에게 바치는 봉헌물이며, 생과 삶의 장소와 공간을 가꾸는 공예와 장식의 전통을 되살리는 일이다. 그는 공예에 대한 애착을 공공연히 드러내며 소위 순수예술과 공예의 경계를 간단하게 무시한다.

우리는 예술의 범주 자체가 여성과 여성적이라 여겨졌던 것들을 배제하는 가운데 구성되었다는 사실을 유념해야 한다. 지금 우리가 일반적으로 예술이라 생각하는 순수예술은 주요하게 건축과 조각, 회화, 시(문학), 음악, 무용 등을 포함하는 협소한 범주다. 르네상스 시대부터 십칠세기를 거치며 순수예술이라는 개념이 형성되는 과정에서 수예와 도예, 목공예, 금속공예 등

상상력과 창조성이 발휘되는 여러 영역이 '예술'에 포함되지
못하고 '공예'로 분리되었다. 대체로 여성이 주도적으로 참여하는,
가정을 아름답게 꾸미고 장식하는 '목적'을 가졌다고 평가되는
영역들이거나, 태피스트리처럼 창작자 개인을 특정하기 힘든, 공동
작업이 이루어지는 영역들이었다. 건축만큼 실용적 '목적성'과
공동 작업의 성격이 강한 영역도 없는 듯하지만, 남성의 영역이던
건축은 당연히 순수예술로 분류되었고, 여성적이라 여겨지던
미(美) 이외에 특별히 남성적이라 평가되는 '숭고(崇高)'와 같은
미적 가치들이 새로이 부각되며 그런 사고의 틀을 더욱 공고히
했다. 창조성을 발휘하는 천재적 (남성) 개인이라는 예술가 개념
또한 예술의 범주를 규정하는 데 큰 영향을 미쳤다.

　　이런 맥락에서 키키 스미스가 즐겨 쓰는 공예적인 재료와
장식적인 기법에 주목할 필요가 있다. 유리를 이용한 작품만
하더라도 작가는 〈노른자(Yolk)〉(1999, p.204)처럼 손안에 쏙
들어오는 유리 작품에서부터 크게는 〈서곡(Prelude)〉(2014, pp.108-
109)처럼 대형 스테인드글라스 작품에 이른다. 다양한 매체를
다양한 기법으로 능수능란하게 다루는 작가의 모습은 신기에
가깝게 느껴지는데, 그 재료와 기법의 많은 수가 전통적인 예술
현장에서는 찾아보기 힘든 것들이다. 그런 재료와 기법이 채택되고
미술관에 걸리는 것 자체가 공예와 예술의 구분에 도전하고 공예를
배제해 온 순수예술의 전통을 전복하는 일이다. 작가가 대부분의
작업을 집에서 해 온 것도 가정과 분리된 별도의 공간을 마련해
신성시해 온 남성중심적 예술 창작 관행에 대한 저항의 제스처일지
모른다.

　　그러나 공예가 순수예술의 장에 들어오면 일부 특성을
잃게 된다. 스미스의 작품들에서도 두드러지는 촉각적 특질과
그 '실용성' 말이다. 공예적 재료와 기법을 활용한 작품들은
매끈하거나 울퉁불퉁하거나 부드럽거나 뻣뻣한 질감이 특히
두드러져 저도 모르게 만져 보고 싶은 충동을 일으킨다. 그러나
주로 시각적 자극을 중심으로 설계된 예술 개념과 미술관 체계는
관람객에게 그런 촉각적 경험을 허용하지 않는다. 작가가 촉각을
통해 인식하고 창조한 물리적 세계를 우리가 제대로 누리려면 예술
개념과 전시 관행에 더 큰 폭의 변화가 필요할 것이다.

회귀하며 확장하는 키키 스미스의 세계

누구보다 왕성한 생산력을 보여주는 작가가 사십 년 넘게 펼치고 있는 예술세계를 일목요연하게 정리하기란 난망한 일이다. 자세히 들여다보기만 하면 그 끝없이 펼쳐지는 작품들 속에서 어떤 서사라도 끄집어낼 수 있을 것이다. 그런 중에도 몇몇 주제가 전개되는 양상이 두드러져 보이는데, 무엇보다 키키 스미스가 끊임없이 회귀하며 변주를 통해 그 주제들을 확장해내기 때문이다.

생명과 몸의 물질성, 자연, 우주와의 새로운 관계 맺음에 대한 작가의 관심은 초기작에서부터 뚜렷하게 드러난다. 1989년 작품인 〈검은 깃발(Black Flag)〉은 수정 과정에 있는 난세포와 비정상적 성장에 고통받는 지구, 우주 공간에 뜬 다른 천체를 동시에 떠올리게 한다. 로크타 종이에 여성의 가슴 이미지를 콜라주한 1994년 작품 〈가슴 II(Bosoms II)〉(p.121) 역시 세포와 차고 이지러지는 달의 형태를 닮았으며, 1996년 작품인 〈세포-달(The Cells - The Moon)〉(p.99)은 난세포와 조류와 바다 생물과 만다라를 연상케 하는 장식적인 이미지들과, 세포마다 안에 달이 들어 자주 달그락거린다는 문구(THE CELLS / THE MOON RATTLED INSIDE HER / FREQUENTLY)를 함께 보여준다. 1998년 작품인 〈달 셋(세폭화)〔Moon Three(Triptych)〕〉(pp.232-233)의 달 이미지들은 몸을 촬영한 의료용 이미지를 닮았다. 키키 스미스의 예술세계는 이처럼 반복적으로 몸의 물질성으로 회귀하며 끊임없는 변주를 통해 우주로까지 이어진다.

그의 세계는 세포에서 시작해 신체 장기와 부위, 인체의 여러 계로 뻗어 나가다가, 생명의 증거로서 배출/배설하는 여성의 몸, 대상화도 이상화도 거부하는 신화와 역사 속 여성의 몸, 동물(자연)과의 경계를 허물고 넘나드는 여성의 몸을 거쳐, 자연 그 자체와 우주 너머로 확장된다. 2014년 태피스트리 작품인 〈실 잣는 이(Spinners)〉(pp.193, 195)는 이렇게 확장된 키키 스미스의 세계를 분명하게 보여준다. 새보다 더 취약하고 연약한 존재인 나방들이 사방에 걸린 거미줄과 공존한다. 이 그물은 죽음과 폭력의 고통이 상존하는 물질계로서의 우주와 물질로서의 인간이 그리는 인다라망이다. 이미 나방으로 변신한 인간은 삼라만상의 모든 존재들을 반영하고 또 자신을 반영시킨다. 인간과 자연과 우주의 경계는 사라진다. 키키 스미스는 미묘하고 마술적이며 다른 세상 같은 독특한 우주 안에 모든 생명을 새겨 넣는다.

그런 의미에서 2006년 작품인 〈푸른 나무 위 푸른 별(Blue Stars on Blue Tree)〉(p.101)은 의미심장한 작품이다. 피부를 닮은 얇은 종이에 잉크로 그린 문신 같은 이 그림은 주름진 여성의 나신과 푸른 성좌를 보여준다. 십자가에 매달린 예수, 또는 레오나르도 다 빈치의 〈인체비례연구〉를 연상시키는 이 여성은, 그러나 죽음을 통해 영생을 구하지 않고 절대적인 미적 가치를 지시하지도 않는다. 다만 시공간을 살아내는 물질로서, 지구와 우주의 일부로서, 이 여성은 소멸을, 끝없이 확장하는 충만한 물질성으로 돌아갈 날을 기쁘게 기다리고 있다. 그때까지는 '자유낙하'. 정처 없이, 손에 닿는 대로, 끊임없이 세계를 만들어낼 일이다.

신해경(辛海京)은 서울대학교 미학과를 졸업하고 동대학원 미학과 석사 과정에 재학 중이다. 번역가로 활동하면서 생태와 환경, 사회, 예술, 노동 등 다방면에 관심을 가지고 있다. 옮긴 책으로 엘렌 식수의 『글쓰기 사다리의 세 칸』, 앤 섹스턴의 『저는 이곳에 있지 않을 거예요』, 존 버거의 『풍경들』 등이 있다.

Five Notes on the Boundary of Expanding Matter

Shin Haekyong

A person's head, hands and feet made of bronze connected by long chains lie sprawled across the floor. The odd lengths of the hands and feet cut in the middle of the forearms and shins feel ever more sinister, and the pile of chain looks like entrails or veins at first glance. The title of the work is *Daisy Chain* (1992, p.175). It couldn't be the flower necklace made from daisies, could it? Disconcerted gazes hover over the heavy and stiff metal surface. Where have the bright daisies gone?[1]

"The attempt to resist the familiar and comfortable is unfamiliar and uncomfortable." This tautological phrase can be comforting at times when encountering the unfamiliar and uncomfortable at a museum. When you ask yourself, "What kind of familiar and comfortable thing is this a resistance against?" or, "Why is this unfamiliar and uncomfortable to me?" the initial surge of disconcertedness or opposition you felt may be alleviated. In fact, it is not strange to find the attempts at the unfamiliar and uncomfortable hard to make out when the fact is that we find the familiar and comfortable easy to read. A little more than a century since Dada, art history—and especially contemporary art from the 1970s on—has resisted the definition and value of established art almost to the point of being "anti-art," and Kiki Smith's vast art world has certainly engraved its traces in this history. Why this is unfamiliar and uncomfortable is the question we must ask.

Feminist art as resistance

The two world wars in the twentieth century have fundamentally dismantled the notion that human reason is rational. From every corner of the world erupted a multifaceted action that demanded a new world. In Europe, the May 1968 protests under the slogan, "It is forbidden to forbid!" rejected traditional authority and discrimination that were embodied in such forms as the state, religion, and the patriarchy, and instead disseminated new values such as gender equality, human rights, and environmentalism. In the United States, a massive civil rights movement demanding the civil rights, enfranchisement, and equal treatment of African Americans was gathering momentum from the 1950s, followed by the hippie counterculture movement and the anti-Vietnam War protests.

The foremost and fiercest resistance took place in the art realm. New and experimental artistic attempts sprang up throughout the 1960s and 1970s. In the forms of pop art, conceptual art, minimalism,

[1]
Representing the female body with balls and chains and then naming the work with a title that evokes a contrasting, romantic image, Smith conveys the conditions that are inconsistent with the weight of life for women.

2

Peggy Phelan, "Survey," *Art and Feminism*, ed. by Helena Reckitt, London: Phaidon Press, 2001. p.19; Carolyn Korsmeyer, trans. by Shin Hyegyeong, *Peminijeum mihagimmun*, Busan: Kyungsung University Press, 2009, p.49; *Gender and Aesthetics: An Introduction*, London: Routledge, 2004.

3

Both the original paper *Why Have There Been No Great Women Artists?* and *Why Have There Been No Great Women Artists? Thirty Years Later*, in which the author discusses the points of her original paper and the changes that took place since its publication, are included in *Wae widaehan yeoseong misulganeun eopseonneunga* (Linda Nochlin, trans. by Lee Jooeun, Paju: Artbooks, 2021), available in South Korea.

happenings, body art, land art, photography, experimental film, and public art, such attempts resisted the existing system and definition of art, ushering in a distinct era in art history called "contemporary art." [2] One of the major streams of contemporary art was feminist art as conscious artistic thought. In 1971, American art historian and art critic Linda Nochlin published a paper titled "Why Have There Been No Great Women Artists?" which is widely regarded as a kind of declaration of the launch of the feminist art movement. In the paper Nochlin poses the questions of why there is no painting by women—despite the abundance of paintings *of* women—and where the greatness of art comes from. In attempting to answer these questions, Nochlin clarifies the history and structure of institutions that have systematically excluded women from professional art education and demonstrates how the romantic notion of genius has solidified male domination and precluded women's artistic achievements. [3]

Kiki Smith was directly influenced by the hippie movement of the 1960s and feminist art that began in earnest during the 1970s. From the hippie movement, she gained a nature-friendly worldview as well as an interest in Eastern culture, an open and liberal attitude along with the experience of making everyday items and clothes which gave her the skills and knowledge that would become the basis of her later practices.

The influence of feminist art is more direct. It was during the late 1970s and 1980s, when Smith moved to New York and actively explored the path of an artist, that feminist artists were struggling to cut their way through—and gradually gaining ground—within the art world. Feminist art during that time actively experimented with new media including photography and video, as well as installations and performance art rather than painting, which was perceived as the exclusive property of male artists. In terms of themes, the focus was on the representation of the female body in opposition to the objectification and oppression of the female body. Smith encountered the works by Eva Hesse, Lee Bontecou, Nancy Spero, Ida Applebroog, and Louise Bourgeois, and sought to define the direction and texture of her own art world.

Feminist art is a loosely constructed concept, however, and as it still undergoes continuous debates and changes, it is not easy to clearly identify its substance. Some argue, as of late, that because things are different now compared to the 1970s when feminist art was formed, it should either be deconstructed or shift to a "post-feminist" art. Kiki

Smith admits that as a citizen of a society, she is a feminist, yet she is opposed to her works being interpreted in terms of feminist art in its political sense. This is to avoid the danger of her works—which stem from her experience as a woman—being read "didactically." Kiki Smith mentioned, "A lot of it [the work] is about living through the shame of being female in public. There's an enormous amount of shame attached to your gender; nothing speaks to your experience in the culture.... It seems important for me to hang out there with my experience to be a girl-child, to see if I could live through that in public."[4]

4
Kiki Smith, conversation with Petra Giloy-Hirtz, "Kiki Smith: Procession: 'A Wonder Version of Life'," *Kiki Smith: Procession*, ed. by Petra Giloy-Hirtz, Munich: Haus der Kunst & Presetel, 2018, p.25.

The female body and matter as battleground

Today, the issue of body and matter is central to both philosophy and art. The shift, however, is not an easy one. There was a time when raising the issue of the body and materiality was deemed taboo within the feminist discourse because of the danger of possibly reinforcing the fetters of the long-standing binary symbol that has reduced women to matter (nature). It was not until quite recently that the feminist discourse started to embrace the body as living matter and the ever-changing bodily practices, and it remains an ongoing issue that is accompanied by considerable pain and controversy.

When language imbued with androcentric and patriarchal order is not adequate for expressing female subjectivity, the female body can be a field for clear expression, and the instinctive and perplexing elements of the body easily connect with artistic imagination.[5] The ways in which contemporary feminist art reveals the body—especially the female body—are subversive on many levels. It is subversive that women, traditionally the object of art, are now the subject of artistic activity; it is subversive to represent and express opposition to the aesthetic value of women which were either idealized or objectified; it is subversive to experiment with responses of eroticism and disgust in the sensuous representation of the various aspects of female sexuality; and finally, it is subversive to introduce the vulnerable and mortal body into a space that celebrates the immortal feats of the male genius. And all these cases are also a practice in deconstructing the anthropocentrism that sees humans as the idealized standard of beauty. After all, who, other than humans, would see humans as beautiful?

The female body takes on a special significance within Kiki Smith's art world. Smith has been interested in the body early on, and she re-

5
Carolyn Korsmeyer, trans. by Shin Hyegyeong, *Peminijeum mihagimmun*, p.258.

summoned the oldest and most favored subject in art history—the human or female body—into the contemporary art scene through a completely new perspective. *Digestive System* (p.153)—a 1988 work made of ductile iron, the kind widely used as industrial material—and *Untitled (Torsos)* (1988, p.149), created with ink on paper, represent the digestive system and the muscular structure of the upper body, respectively. The 1985 work *Possession is Nine-Tenths of the Law* (p.147) is a portfolio of screenprints and monotypes with ink additions, and it depicts nine key organs in realistic renderings. As the title implies, what Smith reveals in her early works on the anatomy of body parts and internal organs is not a particular body but a universal body that can belong to anyone.

In a 1991 interview, Smith stated that "[o]ur bodies are basically stolen from us," and expressed that her art was an attempt to reclaim her own realm.[6] Rendering organs and various parts of a human body is akin to making a roll call, as if to ascertain one's own body. It is impossible to determine whether the bodies depicted in these early works are female or male. This is because the skin, a major organ that constitutes the human body, is missing. The skin is a problematic one. It is the border between I and the world, while also being the very site of discrimination and violence where the stigma of gender, race, age, wealth and poverty, beauty and ugliness is marked. By removing the skin, Smith reveals the materiality of the body that is common to all.

In Smith's work, the fragility of the skin, the site of such unbending discrimination, is often expressed with paper. Used widely in Smith's sculptures and drawings, the Japanese gampi paper, made from the inner bark of the gampi bush, and the Nepali lokta paper, made from the inner bark of evergreen shrubs of the *Daphne* species, are wrinkly, thin, translucent, yet durable to some extent, giving it a similar feel to the skin. *Endocrinology* (1997, p.127), an experimental artist's book created in collaboration with poet Mei-mei Berssenbrugge containing paper cutouts as well as ink-stamped organs shown through translucent paper, embodies in the book itself the frailty of the human body, one in which organs that can easily be damaged are wrapped in thin skin. Along this line of thought, we can see the many drawings, prints, and collages that Smith imprinted as a kind of tattoo on the "skin" of gampi or lokta paper. In fact, the blue flowers in the 2012 work *Promise* (pp.66-67) resemble the constellation tattoos on the artist's arms.

Examining the body's organs and viscera, Kiki Smith pays attention

6

Kiki Smith, conversation with Kristen Brooke Schleifer, "Inside and Out: An Interview with Kiki Smith," *The Print Collector's Newsletter*, vol. 22, no. 3, July-August, 1991, p.86.

to the circulation and discharge of body fluids as clear evidence of life. To be alive is to excrete blood, sweat, tears, saliva, pus, milk, menstrual blood, semen, urine, and feces. We soon find Smith's "bodies" crawling on the floor while dragging with them trails of fecal matter, stooping over with menstrual blood dripping, or squatting to urinate. The reaction was fierce. Viewers poured out their reproach and disgust. Critics borrowed the concept of "abjection" from the Bulgarian-born French philosopher Julia Kristeva to supplement their analysis. The concept refers to the residue that could not be rendered into language, the residue that a subject rejected and expelled in the process of reaching the linguistic symbolic realm. In the process of its formation, the ego secretes, discharges, excludes, expels, and abandons those things that are considered foreign and threatening, yet their residues remain, and the ego falls into an ambivalent emotional state of disgust and temptation.[7] But to apply Kristeva's concept of abjection to Kiki Smith's work simply because the act of excretion and excrement were expressed is still too simplistic.

Kiki Smith said in an interview that *Tale* (1992, p.158) stemmed from the experiences of women who did not have control over their own bodies, experiences like the fight against AIDS and for abortion rights.[8] She also mentioned that she started to pay attention to the body because the body is a form that everyone shares, and with this shared body everyone has their experience.[9] Taking into consideration this context, it would be more appropriate to interpret Kiki Smith's lowly bodies into revealing the general materiality of life in the most shocking forms by visualizing the body's most basic activities of discharge and excretion.

Whether in the unclean act of defecation in *Train* (1993), or in the strange posture in *Lilith* (1994, p.172), or in what looks like a cadaver with its skin removed in *Virgin Mary* (1992, p.155), Kiki Smith's bodies shut off from the get-go the possibility of traditional "viewing" that either sexualizes the female body or idealizes it as the embodiment of pure beauty. These bodies are neither the object of the male gaze nor symbols of religious or psychological values; they are just bodies—bodies as living matter.

Once the initial shock and disgust subside, the filthy bodies placed in the sleek and orderly museum—perhaps the most unusual of modern spaces—elicit a strange sense of sympathy from the audience. The audience is able to re-examine their own body, one that eats, breathes

7
Kim Eunju, *Saenggakaneun yeojaneun goemulgwa hamkke jameul janda* [*A Thinking Woman Lies with the Monster*], Seoul: Baume à l'âme, 2017, pp.161-162.

8
Kiki Smith, conversation with Heidi Julavits, "Kiki Smith," *Interview Magazine*, July 17, 2017. http://www.interviewmagazine.com/art/kiki-smith

9
Robin Winters, "An Interview with Kiki Smith," *Kiki Smith*, Amsterdam: Institute of Contemporary Art; The Hague: Sdu Publishers, 1990, pp.127-140.

and excretes, and the particular yet universal materiality of their own life. Kiki Smith's works reject the classical idealization or pop culture's fetishization of the female body and contribute to the furthering of the critical discourses that reconceptualize the representation of the female body in terms of the theories of feminism, psychoanalysis, and post-structuralism. But perhaps even more important is the fact that Kiki Smith's bodies universalize women's experiences—and the experiences of the things placed in the status of the female—in terms of their materiality.

Bird, wolf, and the metamorphosizing body

From the early 1990s, Kiki Smith's interest expanded from the human body to the animal kingdom, and she paid especially close attention to the frail and precarious materiality of birds that she saw as a mirror to the environmental conditions humans find themselves in. There is a little story behind this interest. Smith once had a dream in which someone ordered, "Get the bird out!"[10] Smith represented this dream, creating a work about a "strange birth" that looked like a bird coming out of a human's mouth. Giving form to a similar motif, her 1995 work *Head with Bird II* (p.174) is an interesting contrast between the rough texture of the human head made of silicon bronze and the smooth finish of the bird made of white bronze. It looks as if the bird is sucking out the life force of a dead person. Hélène Cixous, a French philosopher who focuses on the creativity of the unconscious that is accessible through dreams, says that birds and women are synonymous in that they represent unclean and repulsive beings to be excluded within the Christian Bible.[11]

But Kiki Smith's birds are often dead. The 1995 work *Jersey Crows* (pp.166-167)—Smith's homage to the birds that have been killed by pesticides—comprising more than a dozen dead crows cast in bronze, are strewn across the gallery floor like rocks. The etchings of dead birds are neatly arranged in her 1997 work *Destruction of Birds* (pp.144-145). If birds are stand-ins for the souls of women and mirrors held up to the environmental conditions humans find themselves in, then these are truly apocalyptic sights. The dead birds in Kiki Smith's works force us to look at lives that are losing their places and disappearing as well as the destructive relationships humans have with nature.

For Kiki Smith, animals are companions and partners. They are companions in that just as women are sacrificed in the male/female

10
Carsten Ahrens, "All Creatures Great and Small: Kiki Smith's Artistic Worlds," *Kiki Smith: All Creatures Great and Small*, ed. by Carl Haenlein, Hannover: Kestner Gesellschaft, 1999, p.40.

11
Hélène Cixous, trans. by Shin Haekyong, *Geulsseugi sadariui se kan*, Seoul: Bamuichaek, 2022, p.199; *Three Steps on the Ladder of Writing*, New York: Columbia University Press, 1994.

dichotomy, animals (nature) are sacrificed in the culture/nature dichotomy. But they are companions also because they are equal beings with materiality, struggling to exist and survive in this world. Kiki Smith explores myths and fairy tales in which women and animals interact and mingle on an equal footing. The fable of "Little Red Riding Hood" is a recurring motif. In *Companion* (2000, pp.130-131), Little Red Riding Hood and the wolf alternate in variations of multiple girls and multiple wolves, and in *Blue Prints: Wolf Girl* (1999, p.190), the two blend into one body. Kiki Smith bores into the human traits that we confer upon animals and the animal traits that we, in order to construct our own identities, claim as human traits. What Smith seeks here is the mingling and transformation happening between the two.

But as we see in the intimidating existence of the wolf, shadows of death, violence, and extinction are cast over allegories. Kiki Smith affirms and embraces the sufferings of life and the violences of death that inevitably accompany the body, nature, and living matter. Understanding the underlying pains and violences becomes the basis for compassion for all living matter, and on that basis, bodies cross and transform into one another. In her 2001 work *Rapture* (pp.168-169), from the belly of the wolf that had once swallowed Little Red Riding Hood's grandmother appears a fully grown woman. There is a dramatic contrast between the rough surface of the wolf and the smooth, dignified surface of the newly emerged woman. Her 2002 work *Born* (pp.170-171) shows a similar scene in which a fully grown woman is birthed from a doe. The female body that is universalized on the level of materiality crosses over the boundary of animals. One would be hard-pressed to find another such confident declaration of ecofeminism.[12]

In Kiki Smith's world, women, animals, the vulnerable, the frail, the lowly, and the humble are preserved and re-evaluated within the order of matter. In this order the violence, the frailty, the harmony, and the reassurance of life exist in their raw form. It is a place where humans no longer dominate, where humans interact with nature on the same footing.

Environmental humanist and feminist theorist Stacy Alaimo proposes the concept of "trans-corporeality," which emphasizes movement across bodies. As a basis for a new epistemology by which the material connection between humans and the world could be understood, this concept attempts to construct a new ethical and

12
The term and concept of ecofeminism was first coined in 1974 by the French writer Françoise d'Eaubonne in her book *Le Féminisme ou la Mort*. She points out that both the patriarchy and the destruction of nature stem from the binary structures of Western culture, and argues that feminism is to embrace the agenda of environmentalism.

13
Stacy Alaimo, "Trans-
Corporeal Feminisms
and the Ethical Space of
Nature," *Material Feminisms*,
ed. by Stacy Alaimo, Susan
Hekman, Bloomington:
Indiana University Press,
2008. pp.238-239.

14
Kiki Smith, conversation
with Chuck Close, "Kiki
Smith by Chuck Close,"
BOMB, no. 49, October 1,
1994. https://bombmagazine.
org/articles/kiki-smith-1

political stance that is in keeping with the times wherein humans, nature, and the environment cannot be thought about separately.[13] This epistemological space that trans-corporeality will open can be identified in Kiki Smith's works.

To make, and the crafts

To put out a work of art into the world is an endeavor to be here, and it is about the things that desire to be birthed, to exist. In an interview given in 1994, Kiki Smith said, "I like that art is accumulative by nature, that you are physically creating the world..."[14] When you create a world, you must take responsibility for what you create. Many of Kiki Smith's works are physical creations of what was drawn out from within her, things that were hidden behind the veils of reason. Once created, they are manageable. For Smith, to create is to recognize.

Kiki Smith makes things—without stop. There is not a moment when her hands are not busy. There are many among her works—like the 1992 work *Untitled (7 Organs)* and *Bird and Egg* (1996, p.203)— where traces of the labor of her hands show. We find these statuettes in museums all over the world. Whether in ancient Egypt or in ancient India, hand-made statuettes beautified everyday life, but were also buried in tombs and consecrated in temples, bringing joy to the living, the dead, and the immortal.

The various objects that Kiki Smith makes with her hands are a practice of constructing her own world and they are also oblations to every being in the world, an act of reviving the tradition of crafts and decorations that tend the site and space of life and living. Kiki Smith openly expresses her love for crafts and flatly ignores the so-called divide between fine arts and crafts.

We must bear in mind that the category of art itself was constructed while excluding women and what was considered feminine. The fine arts as we generally understand it to be is a rather narrow category that mainly includes architecture, sculpture, painting, poetry (literature), music, and dance. In the formative process of the concept of fine arts that took place from the Renaissance to the seventeenth century, different areas where imaginative and creative facets were involved— like handicrafts, ceramics, woodcrafts, metalcrafts—did not make it into the realm of "art," and were instead separated into "crafts." These are areas that were considered to have women as leading participants,

areas that had a "purpose," such as decorating one's home, or areas of collaborative works like tapestry where it was difficult to specify one individual creator. One might think that there is no area more practical, purpose-centric, and collaborative as architecture, but it was easily categorized under the fine arts partly due to its male-dominated reality, and as concepts like the "sublime," regarded as more masculine, started to take center stage instead of concepts like "beauty," which was regarded as feminine, such frameworks were further solidified. The vision of the artist as the creative genius (male) individual also wielded much influence on defining the category of fine arts.

Given this context, it is worth paying attention to the crafts material and decorative techniques Kiki Smith employs. Take her use of glass, for example: it ranges from small glass works that can fit in your hand like *Yolk* (1999, p.204) to large-scale stained glass works like *Prelude* (2014, pp.108–109). Smith's skillful treatment of such a wide range of media *and* techniques feels more like wizardry. Those media and techniques are hard to come by in traditional art fields. To have such media and techniques selected and hung on museum walls is in itself a defiance of the divide between crafts and fine arts, a subversion of the tradition of fine arts that have excluded the crafts. That Smith worked on most of her works at home could even possibly be thought of as another act of defiance against the male-centric art practices, held sacred in a working space separate from their homes.

However, when the crafts enter the arena of fine arts, they lose some of their traits. Like their tactile quality that stands out in Kiki Smith's works as well as their "practicality." Works using crafts materials and techniques are particularly textured; they are smooth, bumpy, soft, or stiff, provoking the urge to touch them. The concept of art and the museum system mainly designed around visual stimulation does not afford such tactile experience to the viewer. This speaks to the need of a larger change in the concept of art as well as in exhibition practices so that the physical world that the artist perceived and created through the sense of touch could be fully appreciated.

The world of Kiki Smith, recurring and expanding

It is a difficult task to give a tidy summary of a world of art that has been unraveling for more than 40 years by an artist whose prolific power is unmatched. It takes a simple attentive look and you can draw

any narrative from the endless expanse of her works. Still, there are certain themes whose unfolding stand out, and it is because Kiki Smith persistently returns to and expands those themes through variations.

Smith's interest in the new relations between the materiality of life and the body, nature, and the universe is evident from her early works. *Black Flag* (1989) brings to mind the ovum in the process of fertilization, the Earth suffering from abnormal growth, and other celestial bodies floating in outer space—all at once. The same goes with *Bosoms II* (p.121), a 1994 work that collages images of female breasts on lokta paper, which at once looks like cells and the waxing and waning images of the moon. The 1996 work *The Cells - The Moon* (p.99) shows decorative images reminiscent of ova, algae, sea creatures, cosmic mandalas, along with a phrase that reads, "THE CELLS / THE MOON RATTLED INSIDE HER / FREQUENTLY." The moon images in the 1998 work *Moon Three (Triptych)* (pp.232-233) resemble medical images of the body. In this way, Kiki Smith's art world repeatedly returns to the materiality of the body and leads to the universe through persistent variation.

Her world begins with the cell; extends to organs and parts of the body; spreads to various systems of the human body; passes through the female body—that discharges/excretes as evidence of life, that in myth and history rejects both objectification and idealization, and that blurs the boundary between human and animals (nature) and crosses over it; then finally expands into nature itself and beyond the universe. The 2014 tapestry work *Spinners* (pp.193, 195) is a clear specimen of this expanded art world of Kiki Smith. Moths, more vulnerable and fragile than birds, coexist with spider webs everywhere. This web is an Indra's net where the pain of death and violence is ever-present, drawn together by the universe as a material world and by humans as material beings. Humans, already transformed into moths, reflect every being in the universe as well as themselves. The boundaries between humans, nature and the universe fade. Into a peculiar universe that is subtle, magical, and otherworldly, Kiki Smith carves every life.

In that sense, the 2006 work *Blue Stars on Blue Tree* (p.101) is particularly meaningful. This tattoo-like drawing inked on thin paper resembling skin shows a wrinkled woman's naked body and a blue constellation. This woman, reminiscent of Jesus on the cross or Leonardo da Vinci's *Study of the Proportions of the Human Body*, does not seek eternal life through death or point to an absolute aesthetic value.

Instead, as a material being living out time and space, as part of the Earth and the universe, this woman eagerly awaits extinction, the day when she will return to the fullness of materiality that is ever-expanding. Until then, it is a free fall. It is about creating the world—without a set direction, with whatever the hand touches, and perpetually.

Shin Haekyong graduated from the Department of Aesthetics at Seoul National University and is currently working on her master's in the same department. As a translator, her interests span various fields such as ecology, the environment, social issues, art, and labor. Her translated books include Hélène Cixous's *Three Steps on the Ladder of Writing*, John Berger's *Landscapes*, and Anne Sexton's *I Will Not Be Here: Selected Poems by Anne Sexton*.

살보다 벌거벗고, 뼈보다 강하며, 힘줄보다 탄력 있고,
신경보다 섬세한 이야기를 내가 쓸 수 있다면.
ㅡ사포1

되풀이되는 이야기들과 이야기의 신

유년의 신을 기억하고 싶다. 여성에 관해서나 별과 나방에 관하여,
새, 신화, 오래된 이야기들, 날지 않는 것들, 날기 위해 날개를 접는
것들, 세계의 닮은 얼굴들에 관하여 말하는 일은 범람에 대해
말하는 일이다. 유년의 나르시시즘2은 상상적으로만 기억될 수
있는 유년의 신일 것이다. 형상의 경계를 넘어 범람하는 상상들이
거기에 있다. 키키 스미스의 작업 가운데서 어린 여자들은
〈소녀(Girl)〉(2014, p.79)나 〈푸른 소녀(Blue Girl)〉(1998, pp.178-
179)와 같이 유독 '소녀(girl)'라는 이름 아닌 이름으로 불린다.
그에 비해 여자들은 각자의 이름들로 분절되고, 움직임이 된다.
메두사, 다프네, 준비에브, 성모 마리아. 그들은 태어나고(born),
추락하며(fallen), 꿈속을 걷는다(sleep walker). 이들은 소녀에게
없는 유방을, 성징을 드러낸 육체를 갖는다.

　　이들에게 주어지는 이름은 저마다의 이야기다. 메두사의
이름은 신에게 미움을 산 뒤 시선으로 타인을 돌로 만들게 된
여자, 그 잘린 머리가 남성 영웅의 방패에 장식되게 된 여자,
아름다웠으나 더는 아름답지 않게 된 여자, 처음부터 괴물이었던
여자, 인간의 형태를 지니고 있었으나 뱀들과 결합하게 된 여자를
이야기한다. 릴리스와 다프네는 달아나는 여자들, 달아나 버린
여자들, 사라져 버린 여자들이다. 이들은 쉼 없이 이전의 자신과
결별한다.

　　키키 스미스의 작업에는 '소녀'라는 이야기 이전의 유년, 또는
이야기가 된 여자들이 존재한다. 이들의 이야기는 흐릿하기에
신화적이다. 같은 이름을 둘러싸고 서로 다른 이야기들이 더께를
이룬다. 태어날 때부터 괴물이었던 메두사와 본래는 눈부시게
아름다웠으나 괴물이 되어 버린 메두사 사이의 경계가 흐려진다.
신화는 여럿으로 해석될 수 있는 불분명하고 모호한 지점들을
통해 하나의 완결된 해석에 저항하며, 상징의 영역으로 도약한다.
관객은 신화라는 열린 이야기에 스스로를 비춰 본다. 신화가
내비치는 것은 거기에 자기를 비춰 보는 사람의 눈길이다.

　　나는 키키 스미스의 작업을 이런 눈길로 독해하고자

1
고대 그리스 레스보스
섬에서 열번째 뮤즈로
칭송받던 여성 시인. 여성
공동체의 문화를 중심으로
다루는 사포의 시는 중세에
이르러 이교도성과 향락성
등을 이유로 교회에
의해 금서로 불태워지며
대부분 훼손된다. 여기
인용한 시는 차학경의
『딕테(Dictee)』(1982)에
영어로 실린 제사(題辭)를
필자가 번역한 것이다.

2
자크 라캉(Jacques
Lacan)에 따르면 여자는
상상계(오이디푸스 단계)를
극복할 수 없으므로, 남자와
같은 성장의 단계를 밟아
나갈 수 없다. 라캉의
논의를 전유한 뤼스
이리가레(Luce Irigaray)에
따르면 성장하기 위해서
여자아이는 유년의
자기성애적 면모를
극복하고 승화시켜야 할
필요에 직면한다. 뤼스
이리가레, 심하은·황주영
역, 『반사경』, 꿈꾼문고,
2021, p.49.

3
Kiki Smith, interview by Kaja
Perina, "Final Analysis: Kiki
Smith on Creative Struggle,"
Psychology Today, July 1, 2008.
https://www.psychologytoday.
com/intl/articles/200807/
final-analysis-kiki-smith-
creative-struggle, 필자 역.

4
Paul Ricœur, trans. by
Emerson Buchanan, *The
Symbolism of Evil*, Boston:
Beacon Press, 1969, p.348.

5
라캉에게 상징계로
진입하지 못한 여자란
상징계의 욕망이 세계의
전부라 인식하지 않는
존재이다. 이리가레는
상징 질서 바깥에 남겨져
있는 여자들과, 오직 침묵
상태로만 질서에 그 존재를
용납받고 있는 여자들에게서
무한한 가능성을 발견할
수 있다고 보았다. 뤼스
이리가레, 심하은·황주영
역, 『반사경』; 로즈마리
퍼트넘 통·티나 페르난디스
보츠·김동진 역, 『페미니즘,
교차하는 관점들』, 학이시습,
2019, pp.301–303.

6
리쾨르와 라캉 사이에는
프로이트 해석 문제를
비롯하여, 해소될 수
없는 불화가 자리한다. 폴
리쾨르, 변광배·전종윤 역,
『폴 리쾨르, 비판과 확신』,
그린비, 2013; 이양수, 『폴
리쾨르』, 커뮤니케이션북스,
2016.

7
Elizabeth Brown, *Kiki Smith:
Photographs*, Seattle: Henry
Art Gallery, University of
Washington, 2010, p.124.

한다. 이 독해는 소녀라는 잠재태로부터 셀 수 없는 이야기들
또는 포획되지 않는 움직임 그 자체로 변하는 여성의
메타모르포시스(μεταμόρφωσις, metamorphosis)에 관한 수수께끼를
풀어 나가려는 시도이다. 소녀가 이야기 이전의 가능성에
종속된다면 이름을 가진 여자들은 그 이름의 이야기에 종속된다.
그러나 키키 스미스에 따르면 '예술'은 그 부자유한 지점에
머무르지 않는다. "누군가 어떤 것(things)을 통제할 때, 그는
자기의 고유한 관점에 갇히게 될 것입니다. (…) 예술은 당신으로
하여금 실재에 대한 당신 자신의 환상이 아닌 세계의 실재를
따르도록 만듭니다."3 상징과 신화를 빌려, 그의 작품은 하나의
이야기가 되는 동시에 여럿으로 변하며 탈주를 시도한다. 그로써
'살을 말하며 살보다 더욱 벌거벗게 되고, 뼈를 말하며 뼈보다
단단해지며, 신경을 말하며 신경보다도 섬세해'진다.

　　상징은 스스로 내적인 충돌을 배태하는 말이다. 예컨대
데카르트적 인간 이해가 의혹에 부쳐진 이십세기 프랑스, 폴
리쾨르(Paul Ricœur)와 자크 라캉은 상징이라는 말을 둘러싸고
서로 다른 관점을 드러낸다. 리쾨르의 해석학은 상징을 '원초적
신비를 존중하는 해석'4이라 여겼다. 이로써 상징 언어는 인간의
유한성으로는 해부되지 않는 신비와 공명한다. 반면 라캉은
실재계나 상상계와 구분되는 상징계를 논한다. 실재계가 한계
너머의 포착될 수 없는 영역을, 상상계가 객관화되지 않는 유년의
나르시시즘을 가리킨다면 상징계는 언어적 세계의 질서를
가리킨다.5 그 세계에서 '원초적 신비'의 자리는 지워지거나,
시니피앙과 시니피에의 관계로 대체된다. 리쾨르는 라캉에 관해
어느 것 하나 이해하고 동의하기 어려웠다고 말한다.6

　　키키 스미스의 내러티브가 거기 무언가 있다는 것이
분명함에도 불구하고 모호하고 발견되기 어렵다는 평을 받는
것은7 작품이 지닌 상징성과 무관하지 않다. 상징은 신비와 질서를
동시에 가리킨다. 해독 불가능한 신비와 인간의 한계에 맞닿는
한편, 사회를 구성하는 소통의 가능성을 지시한다. 그러므로
상징성을 기반으로 한 작업은 더없이 모호하고, 더없이 명료하다.
상징은 그런 역설로 온갖 이야기들의 영원한 유년이 된다. 유년은
가능성이자 잠재태이며, 신비라는 나르시시즘적 상상을 등지지
않는다.

　　일부분이 지워지고 이가 빠진 오래된 이야기들, 신화들은 서로

8

이 신은 창작된 존재이자 창작자 자신이기도 하다. 이러한 키키 스미스의 관점은 예술가를 또 다른 신으로 보는 르네상스적 예술관과 연관된 것으로 해석된 바 있다. "수태고지로부터 예술가적 영감을 취하며, 키키 스미스는 옛 시대 예술가들의 전기들에서 찾아볼 수 있는, 예술가를 또 다른 신(alter deus)으로 여기는 개념에 대한 놀랍도록 새로운 해석에 도달했다." Martin Hentschel, "A Place to Meditate, a Place for Stories," *Kiki Smith: Her Memory*, Barcelona: Fundació Joan Miró, 2009, p.177. 필자 역.

9

라캉에게 상상계는 완전히 극복되거나 억압될 수 있는 것이 아니라 변증법적으로 연결되는 것이기도 했다. "언어의 세계요, 질서의 세계인 상징계로 진입하면서 이 거울단계는 사라지거나 프로이트의 경우처럼 억압되는 것이 아니라 변증법적으로 연결된다." 권택영, 「라캉의 욕망 이론」, 자크 라캉, 권택영 편, 민승기·이미선·권택영 역, 『욕망 이론』, 문예출판사, 1994, p.16.

다른 것들의 경계를 넘나든다. 모호한 것과 명료한 것의 경계가 흐려졌을 때 경계는 거짓이나 속박에 가까워진다. 상징으로부터 무수한 이야기들을 자아내고 무수한 이야기들로부터 상징을 자아내는 반복을 '신'이라고 할 수 있다면, 나는 키키 스미스의 작업물들로부터 신[8]이 되는 여자를 본다. 이들은 온갖 경계를 의혹하며 태어나는 존재이자, 그들을 가둔 것 너머로 날 수 있는 날개를 지닌 새이고 나방이며, 메타모르포시스의 몸이다. 그리고 이들은 되풀이라는 오래된 믿음을 지닌다. 낮에 짰던 베를 밤에 풀며 스스로를 지키던 이타카의 페넬로페처럼 그들은 이미 지어진 이야기를 허물고 다시 짓는다.

경계에 저항하는 나르시시즘과 메테오로스

밤에 죽는 신은 떠오르는 새벽과 함께 되살아난다. 죽음은 신을 가두고 되살리며 그의 신화에 발을 디딘다. 나방은 알에서 깨어나 알을 낳을 것이고, 사람은 배설 뒤에 다시 배설하는 존재이며, 별은 떠오르고 저물어 다시 떠오르길 거듭한다. 새들은 계절을 싣고 되돌아올 것이다. 이들의 주기(週期)는 변증법적으로 되풀이[9]되며 끊임없이 스스로를 변신시킨다.

별은 보이지 않았다가 모습을 드러낸다. 반드시 되돌아올 것이라는 믿음은 되풀이의 서사를, 탄생과 죽음의 반복은 변신의 서사를 자아낸다. 고대의 열두 신은 아버지의 배 속에서 거꾸로 되살아나며 맏이와 막내를 뒤바꾸고, 인간 아버지 없이 태어난 성자는 삶에서 죽음으로 이어지는 외길을 거슬러 걸으며 인간의 자리를 신의 자리로 뒤바꾼다. 삼위일체는 성부와 성자와 성령에 의해 서로 다른 것과 같은 것 사이의 경계를 허문다.

신화들은 서로 다르지만 서로 닮아 있다. 키키 스미스가 늑대의 배 속에서 걸어 나오는 이야기의 주인공을 보며 성모 마리아와 비너스의 탄생담을 읽어낼 수 있다고 말한 까닭은 여기에 있지 않을까.[10] 이 이야기들은 모두 아직 자기를 갖지 못한 이의 자리와, 자기를 거머쥐게 된 이의 자리를 오간다.

변주되는 이야기들은 그 닮음을 통해 감추어졌던 유년의 나르시시즘을 상기시킨다. 내가 아니지만 나와 같은 것, 하염없이 들여다보고 있지만 온전히 손에 넣을 수는 없는 것, 영원히 무수한 가능성을 잃지 않는 것, 내가 아닌 이의 눈에는 나의 눈길대로 보이지 않는 것이 그 닮음이라는 신비 가운데

10
키키 스미스는 하나의
서사가 다른 무수한
서사들과 관계를 맺고
있다는 사실을 이야기한다.
"만약 당신이 '빨간 망토'
우화에서 그녀와 할머니가
늑대 밖으로 나오는
장면을 본다면 당신은
그저 하나의 그림으로
보겠지만, 내게 그것은 달
위의 성모 마리아와 같고,
또는 바다에서 나오는
비너스와 같아요. 당신도
알다시피 이것들은 모두
탄생담(birth story)입니다.
그 여인들은 늑대 밖으로
나오며 탄생하는 거죠." Kate
Bernheimer, Francine Prose,
Kiki Smith, Wendy Weitman,
and Jack Zipes, "Retelling
Little Red et al: Fairy Tales
in Art & Literature," A Panel
Discussion, Fairy Tale Review,
vol.1, Detroit: Wayne State
University Press, 2005, p.93.
필자 역.

존재한다. 나르시시즘을 앓는 이는 모든 이야기들로부터 스스로를 발견할 수 있다. 그들은 자신을 자신에게 가두는 동시에 쉼 없이 자신으로부터 흘러넘치며 아이러니가 된다. 나르시시즘의 아이러니는 상징과 닮아 있다. 모호하지만 명료하고, 부자유하며 자유롭다.

이런 도취적 몰입과 그 한계는 내게 기독교 문명에서 고대 그리스어 '메테오로스(μετέωρος, meteoros)' 개념을 다루는 방식을 연상시키기도 한다. 메테오로스는 기독교 성경의 「누가복음」 12장 29절과 관련된다. "너희는 무엇을 먹을까 무엇을 마실까 하여 구하지 말며 근심하지도 말라." 이 구절에서 '공중에 매달린 듯 불안한 근심의 상태'를 이르는 말인 '메테오리조(μετεωρίζω, meteorizo)'는 '공중에 떠오른, 매달린, 불확실한' 등의 뜻을 지닌 메테오로스에서 파생된 말이다.

앞서 나오는 22절의 "너희 목숨을 위해 무엇을 먹을까 몸을 위해 무엇을 입을까 염려하지 말라"는 구절에서 염려를 뜻하는 것이 '대상에 대해 괴로울 정도로 관심을 보인다'는 의미의 '메림나오(μεριμνάω, merimnao)'라면, 메테오리조는 불확실성에 의한 근심을 의미한다. 메림나오로부터 메테오리조로 이어지는 이 구절들은 집착에 의한 고통으로부터 허공에 떠오른 듯한 불확실성으로 나아가는 흐름을 보여준다.

두 구절 사이에 자리하는 것은 24절 "까마귀를 생각하라. 심지도 않고 거두지도 않으며 골방도 없고 창고도 없으되 신이 기르니 너희는 새보다 얼마나 더 귀하냐"이다. 이로써 24절의 까마귀는 메림나오와 메테오리조 사이에 자리하는 메타포인 동시에, 두 종류의 고통을 비켜 나가는 존재가 된다. 이 아이러니는 허공에 속해 있기에 확실성에 대한 집착으로부터 자유롭다. 공중을 누비며 허공의 불확실성을 체현하나 메테오리조의 근심에 붙들리지 않는다.

허공과 날짐승은 키키 스미스의 작업에서도 수차례 다루어진다. 〈항구(Harbor)〉(2015, p.197)의 검은 새들은 흩뿌려진 별들 곁에서 절벽을 넘어 비행한다. 〈하늘(Sky)〉(2012, p.186)과 〈회합〉(2014, p.185)의 여자들은 허공인 동시에 작품의 테두리 안쪽이기도 한 어느 지점에 자리한다. 이들은 잠시 무엇을 먹을까, 무엇을 마실까 근심하지 않는 듯 보인다. 예술은 불확실성이라는 메테오로스의 순간을 신비라는 아이러니에 대한 감각으로

도약시킨다.

한편으로 관객의 자리에서 바라볼 때 이 아름다운 알레고리에는 맹점이 존재한다. 이 유비는 지금, 여기로부터 멀리에 자리한다. 저 먼 곳의 서구 기독교 문명이 다른 문화권인 이곳에서 그곳과 같이 독해될 수는 없다. 단일한 공유(公有)에 저항하며 탈식민주의적 맥락에서 등장한 분유(分有, partager)[11]의 관점은, 공유와 달리 이곳과 저곳의 차이에 관심을 기울인다. 이곳은 고대 그리스가 아니고, 바빌로니아가 아니며, 단일한 국교를 지닌 국가가 아니다.

이곳의 해석 지평은 그곳과 다르다. 그들의 눈은 나의 눈이 아니다. 우리의 눈길은 가장 닮은 순간에도 서로 온전히 같을 수 없다. 키키 스미스의 작업은 서로 닮아 있으나 같지 않은, 세계 곳곳의 신비로운 근원 서사들을 떠올리게 만든다. 우리는 분명 서로 닮은 이야기들을 나눠 가지고 있다. 이 이야기들은 대개 근원 서사, 신화라 불린다. 작가는 오래된 이야기들이 지닌 닮음과 다름의 교차 지점을 응시한다. 이 교차점에 신이 되는 예술가, 또는 스스로 예술의 역동성이 된 여자들이 출현한다.

다프네나 준비에브 모티프 등을 둘러싼 키키 스미스의 작업들은 이야기를 하나의 이름 너머로 열어 보인다. 나무가 되어 가는 여자 또는 여자가 되어 가는 나무의 이미지는 나뭇가지, 나뭇잎, 손, 여자의 몸, 꼿꼿이 서서 팔을 벌린 자세, 여성이라는 성별 등으로 이뤄져 있다. 이런 조각들을 어떻게 꿰어 볼지 정하며, 우리는 베틀에 앉아 밤에 풀 베를 짓듯 이야기를 짓는다.

메타모르포시스와 서로 닮은 이야기들

다프네는 나무가 되는 신이다. 아폴론에게 쫓겨 물가까지 달아난 다프네는 아버지인 강의 신에게 자기를 구해 달라 빈다. 그 자리에 뿌리내리는 나무가 되는 것은 다프네의 바람이자, 아폴론적 로고스를 벗어나는 탈인간의 메타포이다. 키키 스미스는 손과 나뭇가지와 인간 여성으로 구성된 변신의 한 지점을 조형한다. 이로부터 다프네라는 신화를 읽어내는 일은 자연스럽게 손으로부터 나뭇가지로의 방향성으로 작품을 귀결시킨다. 이는 한 여자로부터 한 그루의 나무라는 미래를 발견하도록 이끈다.

나무가 되는 여자라는 메타포는 셰익스피어의 잔혹극 『타이터스 앤드로니커스(Titus Andronicus)』를 영화화한 줄리

11
오카 마리, 김병구 역, 『기억 서사』, 소명출판, 2004; 이재봉·사이키 가쓰히로 역, 『그녀의 진정한 이름은 무엇인가』, 현암사, 2016.

271

테이머(Julie Taymor) 감독의 「타이투스(Titus)」(1999)에서도 찾을 수 있다. 『타이터스 앤드로니커스』에는 수많은 살인과 폭력이 등장한다. 튜더 왕조 시대 셰익스피어의 첫번째 인기 작품이었던 이 잔혹극에서 라비니아는 두 손과 혀를 절단당한다. 그가 당한 폭력이 누구의 범죄였는지 고발하지 못하도록 죄인들이 저지른 짓이다. 영화는 이 처참한 죄의 장면을 절단당한 부위에 나뭇가지들이 꽂혀 있는, 나뭇가지들이 자라난 듯 보이기도 하는 라비니아의 모습으로 재현한다. 이는 매우 참혹한 형태의 다프네 이미지였고, 지나치게 잔인한 영화에 쏟아지는 혹평 가운데서 손과 나뭇가지가 결합된 라비니아 이미지는 기괴하고 참담한 무언가로 남겨진다.

잘려 나간 팔과 동화된, 살이 발려 나간 가느다란 뼈 같은 나뭇가지 이미지는 키키 스미스의 〈다프네(Daphne)〉(1993)에서도 발견된다. 이 작품에서 다프네로 지시된 육신은 폭발하듯 분출되는 나뭇가지들 또는 직선들로 머리와 팔과 다리를 대체당한다. 그에 비해 〈무제(여자와 나뭇잎)〔Untitled(woman with leaves)〕〉(2009, p.137)는 다프네와 같은 하나의 이름을 내걸지 않는다. 이 작품에서 여자는, 다른 여러 작품과 마찬가지로, 두 팔을 몸 위에 교차시켜 몸을 감추기보다 두 팔을 벌려 몸을 드러내 보이길 원하는 듯 보인다. 그 두 팔의 끝, 두 손에 겹쳐 있는 것은 나뭇잎이 달린 몇 개의 나뭇가지이다. 여자는 나뭇가지를 움켜쥐고 있기보다 그저 손을 내려뜨리고 있는 듯하다. 이로써 여자는 인간으로부터 나무로 나아가는 변신의 방향성에서 놓여나 서로 겹치는 여러 이야기 속에 놓인다.

인간형 신체와 식물의 결합은 무수하게 변주된 모티프이며 그 방향성은 크게 둘로 나뉜다. 인간으로부터 식물 되기, 식물로부터 인간 되기. 인간의 형상을 잃으며 식물의 형상으로 변한 여자들이 있는가 하면 그 반대도 있다. 버들 천모 '아부카허허'를 이야기하는 만주의 창세 신화에서, 세계는 한 차례의 멸망 이후 물에서 걸어 나오는 수초와 물고기의 형상으로부터 새로운 여신을 본다. 버들 천모 신화는 고구려의 유화 부인이나 조선의 태조 이성계가 만난 버드나무 아래 우물 곁의 여인 이야기와 맞닿는다. 거기 자리한 것은 세계수인 버드나무로부터 인간의 형태를 갖춘 의지가 나타나 역사를 써 내려간다는 믿음이다.

〈다프네〉와 〈무제(여자와 나뭇잎)〉는 두 작품의 시간적

12
키키 스미스가 처음부터
다프네를 의도하고
작업했던 것은 아니다. 팔이
나뭇가지인 여자가 떠올라
작업을 한 뒤, 그것을 본
친구가 '다프네'라고 부른
것을 계기로 작품명을
붙였다고 한다. Kiki Smith,
interview by David Frankel,
"In Her Own Words," *Kiki
Smith*, ed. by Helaine Posner,
Boston; New York; Toronto;
London: Bulfinch Press,
1998, p.40.

거리만큼, 서사성에 접근하는 방식에서 유의미한 차이를 보인다.
〈무제(여자와 나뭇잎)〉에서 작가는 식물과 인간이 겹쳐 있는
모습을 담아낼 뿐, 무엇이 무엇으로 변해 가고 있는 것인지, 혹은
그들이 정말로 서로 결합되어 있는 것인지 단언하지 않는다.
관객의 시선은 손으로부터 나뭇가지로, 삶에서 비극으로, 폐허에서
창조로, 어느 쪽으로든 나아갈 자유를 지닌다. 나뭇가지는 손이
되어 가고 있는가. 손은 나뭇가지가 되어 가고 있는가. 혹은 저
여인은, 지금 막 열매를 맺으려 하는 에덴의 나뭇가지 곁에서
자기의 미래를 관측 중인 것은 아닐까.[12]

〈황홀〉(2001, pp.168-169)은 늑대의 찢어진 듯 열린 복부에서
걸어 나오는 성인 여성으로 이뤄진 작업이다. 로마의 건국
신화에서 로물루스와 레무스를 기른 늑대는 인간 여성이었다면
왕에게 젖을 주어 기른 왕의 양어머니일 것이다. 그러나 인간이
아닌 늑대는 왕에게 젖을 준 짐승으로 남고, 영광의 역사에서
젖을 가진 무명의 짐승 또는 마르스를 지시하기 위한 여성형 연결
고리로 회자된다.

건국 신화의 늑대는 '라 루파(La Lupa)'라는 늑대의 여성명사
외의 다른 이름을 갖지 않는다. 늑대의 허물로부터 걸어 나오는
여성의 황홀은, 인간의 형상을 지니며 인간의 이름을 요구하게
되는 과정을 함축하고 있는지도 모른다. 짐승의 허물을 벗어던지는
대가로 인간으로 형상을 얻게 된 메타모르포시스의 서사는 한국의
단군 신화에서 왕을 낳는 여인인 웅녀의 일대기이기도 하다.
일반적으로 웅녀는 동굴에서 인간으로 변신했다고 알려져 있으나,
어떤 작품들 속에서 웅녀는 곰의 겉가죽을 찢고 그 바깥으로 걸어
나온다.

웅녀의 변신은 황홀함을 동반했을까. 키키 스미스의 작업
〈탄생〉(2002, pp.170-171)과 〈황홀〉은 하나였던 것이 둘로 나뉘는
서로 다른 방식을 나란히 제시한다. 여성은 자기와 하나였던 것의
배를 찢고 출현하거나, 그 산도를 빌려 출현한다. 어느 쪽이든
그것은 하나였던 것이 둘로 나뉘는 과정이자 자기였던 것을
벗어나는 과정이다. 자기를 가두고 있던 것을 파괴하는 일이
황홀이라 불릴 수 있다면, 자기를 잉태하고 있던 것을 떠나는 일은
근원적인 슬픔을 동반할 것이다.

샤를 페로와 그림 형제와 설화를 가져올 수도 있다. '빨간
망토'의 소녀는 늑대의 배 속에서 부활을 체험한다. '빨간 망토'

13
흉노를 비롯한 유라시아의 유목민들에게는 늑대 시조 신화가 존재했다. 동북아시아의 늑대 시조 신화와 로마 건국 신화를 나란히 살피며 문화 교류를 짐작하는 관점도 존재한다. 최혜영, 「고대 로마와 동북아시아의 신화 분석: 늑대와 새」 『지중해지역연구』 7권 1호, 부산외국어대학교 지중해지역원, 2005. 빌헬름 딜리히(Wilhelm Dilich)의 아틸라 그림과 같이, 게르만족 후손의 독일인들은 아틸라를 늑대인간의 모습으로 그렸다.

우화는 두 방향의 변신을 교차시키며 늑대와 사람 사이의 경계를 허무는 서사다. 이 기이한 이야기 속에서 늑대는 할머니로 변하고, 빨간 망토는 늑대 배 속에 든 소화물로서 잠시 늑대의 일부가 되었다가 자신과 하나가 되었던 것을 죽이며 사람으로 변한다. 잡아먹힌 자로부터 되살아난 자로의 전환은, 소녀에게 이후 누구에게나 도래하는 또 한 번의 죽음을 체험시킬 것이다. 그러므로 이때 발견되는 황홀은 자기를 집어삼킨 것을 찢고 나오는 황홀이자, 자기의 일부를 죽이는 자의 황홀이며, 여러 번 죽게 된 자의 황홀이다. 작품 〈황홀〉에 늑대로부터 걸어 나오는 여자들의 이야기를 덧씌워 읽는 작업은, 파괴와 변신, 반복에 황홀이라는 이름을 붙이는 일이다.

여자와 늑대는 다른 여러 작품들에서도 등장한다. 〈황홀〉과 닮았으나 다른 작품인 〈준비에브와 늑대(Geneviève and the May Wolf)〉(2000)에서 준비에브라 불린 여성은 늑대와 나란히 서 있다. 그의 한 손은 늑대에 닿을 듯 내밀어져 있고, 그 시선 역시 늑대를 향해 있다. 준비에브와 늑대는 서로를 위협하지 않는다. 이 모습을 가톨릭 성인인 준비에브의 실제 역사에 비춘다면, 늑대는 훈족의 영웅인 아틸라로 해석될 수 있을 것이다.[13]

오세기 중엽 아틸라와 훈족은 갈리아를 침공하여 휩쓴다. 신을 향한 믿음에 자신을 바친 소녀였던 준비에브는 훈족의 맹공이 파리를 향할 것임을 알게 되고, 그 소식에 사람들은 공포에 떤다. 준비에브는 겁에 질린 사람들을 이끌고 믿음의 장소로 들어선다. 신이 이끄는 대로 이끌리기를 선택하는 이 믿음은 그 헌정의 대가로 그들을 전쟁에서 보호한다. 이전까지 준비에브에게 충분한 존경 또는 존중을 건네지 않았던 자들은 이제 그를 성자로 추앙한다. 준비에브와 그가 자기를 바친 종교는 믿음과 신의 의지 사이에 이처럼 또렷한 인과의 서사를 부여했다.

이 이야기에 비추어, 늑대를 껴안거나 다스리거나 찢고 나오는 여자의 형상은 두 종류의 극복을 함축한다고 할 수 있을 것이다. 하나는 전쟁으로 인한 죽음의 공포에 대한, 다른 하나는 자기에게 이름을 붙이는 타인들에 대한 극복이다. 공포는 자기 내부에, 타인들은 자기 외부에 존재하므로 결국 이 극복은 자기의 안팎에 두루 걸쳐 있다. 자기와 하나가 되어 있던 늑대, 그러므로 잠시 자기이던 늑대를 파괴하며 새로운 자기를 태어나게 만든 빨간 망토의 탄생은 준비에브 이야기가 말하는 안팎의 극복과 서로

닮아 있다. 무엇이라고 불리든, 자기를 파괴하며 새로이 태어나는
여자들은 서로 닮은 신화를 지닌다. 이들의 유년은 서로 닮은
모습으로 태어날 신화들을 위한 잠재태이다.

아직 어떤 이야기로도 완결되지 않은 유년에게는 탄생의
황홀이 유예되어 있다. 이야기를 마치지 않았기에 온갖 이야기의
가능성이 되는 유년은, 모든 이야기들로부터 스스로를 보는
나르시시즘과 선연히 맞닿아 있는 듯도 하다. 소녀의 성장은 그를
릴리스, 준비에브, 웅녀로 만들 것이다. 소녀는 그렇게 이야기가
된다. '또 다른 신(alter deus)'은 겹쳐 놓이며 되풀이되는 이야기들에
의해 태어나고, 다시 태어난다. 형상이라는 제약이 상상이라는
역동성으로 도약할 때 이야기는 또 다른 신의 예술이 될 것이다.
그리고 그것은, 돌아오고 다시 돌아오는 삶의 주기와 같이,
되풀이된다.

최영건(崔榮健)은 연세대학교에서 국어국문학과 신학을 전공하고,
동대학원에서 국어국문학 석사학위를 받았다. 『문학의 오늘』 신인문학상(2014),
서울도시건축비엔날레 크로스로드 프라이즈(2021)를 수상했다. 장편 소설
『공기 도미노』(2017)와 단편집 『수초 수조』(2019) 등이 있다.

The Narrative of Gods, Born, then Born Again

Choi YeongKeon

1

A female poet who was
praised as the tenth muse
on the ancient Greek
island of Lesbos. During
the Middle Ages, Sappho's
poetry, which often dealt
with the culture of women's
community, was banned
and burned by the church
for reasons of paganism
and hedonism. Much of her
poetry was damaged as a
result. The line quoted here
is from the opening quote in
Theresea Hak Kyung Cha's
Dictee (1982).

2

According to Jacques Lacan,
women cannot overcome
the imaginary stage (the
Oedipus stage) and therefore
cannot go through the same
stages of growth as men.
Appropriating Lacan's
discussion, Luce Irigaray
argues that girls face the
need to overcome and
sublimate the narcissistic
aspects of childhood. Luce
Irigaray, trans. by Shim
Haeun, Hwang Juyeong,
Bansagyeong, Seoul: Kumkun
Books, 2021, p.49; *Speculum.
De l'autre femme*, Paris:
Éditions de Minuit, 1974.

May I write words more naked than flesh, stronger than bone, more resilient than sinew, sensitive than nerve. —Sappho[1]

Recurring stories and the gods of stories

I want to remember the gods of childhood. To speak of women, of stars and moths, of birds, of myths, of old tales, of things that do not fly, of things that fold their wings so as to fly, of resembling faces of the world— it is to speak of an overflow. The narcissism[2] of childhood is perhaps the god of the childhood that can only be remembered in the imaginary. The imaginations that overflow out of the boundaries of form are found there. In the works of Kiki Smith, young women are particularly referred to as "girl," as in *Girl* (2014, p.79) or *Blue Girl* (1998, pp.178-179). On the other hand, women are each articulated by their respective names, and by those names become movements—like Medusa, Daphne, Geneviève, and the Virgin Mary, for example. They are born and fallen, and they are sleep walkers. They have breasts, bodies that show sexual characteristics that are not present in girls.

The names given to them are their own stories. Medusa's name tells of a woman who was hated by the gods, turning into a being who turns others into stone by her gaze; a woman whose hair was cut off to adorn the male hero's shield; a woman who was beautiful but who no longer is; a woman who was a monster from the beginning; a woman who had a human form, but became one with snakes. Lilith and Daphne are women who flee, who fled, who disappeared. Without rest, they split from their former selves.

In Kiki Smith's works, one finds a childhood that exists before the story of a "girl," and also finds women who became stories. Their tales are mythical because they are hazy. Divergent stories encrust around the same name. The line between the Medusa who was born a monster and the Medusa who was originally extraordinary in her beauty but later became a monster blurs. Through points that are unclear, ambiguous, and open to multiple interpretations, myths resist a unified, conclusive interpretation, leaping forth into the realm of the symbolic. The audience casts itself in the open tale of mythology. What the mythology reflects back is the gaze of the person who had just cast themselves in it.

I would like to read Kiki Smith's work from this perspective. This reading is an attempt to unravel the puzzle of female metamorphosis (μεταμόρφωσις), a transformation that takes place from the potentiality of

3
Kiki Smith, Interview by
Kaja Perina, "Final Analysis:
Kiki Smith on Creative
Struggle," *Psychology Today*,
July 1, 2008. https://www.
psychologytoday.com/
intl/articles/200807/final-
analysis-kiki-smith-creative-
struggle

4
Paul Ricœur, trans. by
Emerson Buchanan, *The
Symbolism of Evil*, Boston:
Beacon Press, 1969, p.348.

5
For Lacan, women who fail
to pass into the symbolic
world are those who do
not recognize that the
desires of the symbolic
world are the entire world.
Irigaray believed that
infinite possibilities could
be found in women who
were left outside of the
symbolic order as well as
in women whose existence
was accepted only in their
silent state. Luce Irigaray,
trans. by Shim Haeun,
Hwang Juyeong, *Bansagyeong*;
Rosemarie Putnam Tong,
Tina Fernandes Botts, trans.
by Kim Dongjin, *Feminism,
Gyochahaneun gwanjeondeul*,
Seoul: Hagishiseup, 2019,
pp.301-303; *Feminism
Thought, A Comprehensive
Introduction*, Abingdon:
Routledge, 1989.

girls to countless tales or to movement itself that cannot be captured. If the stories of girls are subordinate to the possibility of the past, then the women who have names are subordinate to the stories behind their names. But according to Kiki Smith, "art" does not stay at this inconvenient point. "Because when one can control things, one is limited to one's own vision. (...) Art forces you to submit to the world's reality rather than to your own fantasy of reality."[3] Borrowing from symbols of mythologies, her works are at once a unified tale and attempts at transforming into a multiplicity and breaking loose. Thus, it becomes "more naked than flesh as the flesh is uttered, stronger than bone as the bone is uttered, and more sensitive than nerve as the nerve is uttered."

Symbol is a term that sparks internal conflict. In twentieth-century France, for instance, where the Cartesian understanding of human beings was being questioned, Paul Ricœur and Jacques Lacan showed different perspectives on the term symbol. Ricœur's hermeneutics treated symbols as "interpretations that respect the primordial mystery."[4] In this way symbolic language resonates with the mystery that cannot be dissected by human finitude. On the other hand, Lacan discusses the symbolic as distinct from the real and the imaginary. While the real points to a realm that is beyond reach and the imaginary to the narcissism of childhood that cannot be objectified, the symbolic refers to the order of the world of language.[5] In that world, the place of "primordial mystery" is either erased or replaced by the relation of the signified and signifier. Ricœur commented that it was difficult to understand or agree on anything about Lacan.[6]

The reason Kiki Smith's narrative is often commented on as vague and difficult to identify despite a sense of clarity of something being there is not unrelated to the symbolism of her works.[7] Symbols point to the mysterious and to order at the same time. It adjoins mystery that is indecipherable and the limits of human beings, but it also points to the possibility of communication that constitutes society. Therefore, works that have symbolism as their basis are supremely ambiguous *and* supremely lucid. With this paradox, symbols become the eternal childhood of every tale. Childhood is possibility and potentiality, and it does not turn its back on the narcissistic imagination of mystery.

Old tales and myths—whose parts are erased and chipped away— cross the boundaries of different things. When the boundary between the ambiguous and lucid is blurred, that boundary starts to feel more

6

Between Ricœur and
Lacan are irreconcilable
differences including the
problem of interpreting
Freud. Paul Ricœur, trans.
by Byeon Gwangbae, Jeon
Jongyoon, *Paul Ricœur,
Bipangwa Hwakshin*, Seoul:
Greenbee, 2013; *La critique et
la conviction*, Paris: Calmenn-
Levy, 1995.

7

Elizabeth Brown, *Kiki Smith:
Photographs*, Seattle: Henry
Art Gallery, University of
Washington, 2010, p.124.

8

These gods both created
beings and creators
themselves. This perspective
that Kiki Smith shows has
been analyzed as one that
relates to the Renaissance
idea of art wherein the
artist is regarded as another
kind of god. "By taking
artistic inspiration from the
Annunciation, Kiki Smith
arrives at an astonishing
new interpretation of the
notion of the artist as *alter
deus*, which is found in
artist biographies of old."
Marin Hentschel, "A Place
to Meditate, a Place for
Stories," *Kiki Smith: Her
Memory*, Barcelona: Fundació
Joan Miró, 2009, p.177.

like a lie or restraint. If we see the repeated evocation of endless tales
from symbols and symbols from endless tales as "gods," then I see in
Kiki Smith's works women becoming gods.[8] These are beings who are
born doubting every boundary. They are birds and moths with wings
that allow them to fly beyond the confinement—they are bodies of
metamorphosis. And they hold the old belief of repetition. Like Penelope
of Ithaca who defended herself by unweaving the burial shroud she had
woven during the day, they tear apart tales that have already been built,
only to build it again.

Narcissism and *meteoros* that resist boundaries

The god that dies at night is resurrected with the rising dawn. Death
imprisons and raises the gods and sets foot into their myths. Moths will
break out their eggs so as to lay eggs, humans are beings that excrete
again after excreting, stars rise and fall only to rise again. Birds return with
their seasons. Their cycles repeat dialectically,[9] constantly transforming
themselves.

Stars reveal themselves after remaining invisible. The belief that
there surely will be a return brings about a narrative of recurrence,
and the repetition of birth and death gives rise to a narrative of
transformation. The twelve ancient gods were resurrected upside down
in their father's belly, their eldest and youngest were swapped, and the
Son who was born without a human father walks along the single path
that goes from life to death, thereby transposing the position of humans
into the position of god. By way of the Father, the Son, and the Holy
Spirit, the Trinity blurs the boundary between the different and the same.

Myths are all so different from one another, yet they are all so
similar. Perhaps this is the reason why Kiki Smith said that one can
read the birth story of the Virgin Mary and Venus from the story of the
protagonist walking out a wolf's belly.[10] These stories go between the
realm of those who do not yet have themselves and the realm of those
who have seized themselves.

The varying tales remind us of the hidden narcissism of childhood
through their similarities. What is not me but what is like me, what
is persistently looked at yet cannot be fully grasped, not losing the
myriad possibilities that are eternal, that what is seen through the eyes
of someone who is not me cannot be seen according to my gaze—all
of this exist amid the mystery called similarity. Those who suffer

9

For Lacan, the imaginary is
not something that could
be completely overcome
or repressed but rather
something to be connected
dialectically. "As we enter the
symbolic world—the world
of language, the world of
order—this mirror stage does
not disappear or is repressed
as in Freud's case, but it
is dialectically connected."
Gwon Taekyoung, "Rakangui
yongmang iron [Lacan's
Theory of Desire]," Jacques
Lacan, trans. by Min
Seunggi, Lee Miseon &
Gwon Taekyoung, *Yongmang
iron [Theory of Desire]*, ed. by
Gwon Taekyoung, Seoul:
Moonye Publishing, 1994,
p.16.

10

Kiki Smith notes that one
narrative is connected to
countless other narratives.
"You know, if you just took
Little Red Riding Hood and
she and the grandmother
coming out of the wolf, and
you just look at that as a
picture, to me that's like the
Virgin Mary on the moon,
or Venus coming out of the
sea, you know it's all of these
birth stories, and it's these
women being born out of
wolves." Kate Bernheimer,
Francine Prose, Kiki Smith,
Wendy Weitman, & Jack
Zipes, "Retelling Little
Red et al: Fairy Tales in
Art & Literature," A Panel
Discussion, *Fairy Tale Review*,
vol. 1, Detroit: Wayne State
University Press, 2005, p.93.

from narcissism find themselves in every tale. They become an irony
wherein they imprison themselves while also constantly spilling out of
themselves. The irony of narcissism looks a lot like symbols. Ambiguous
but lucid, restricted yet free.

This euphoric immersion and its limitations remind us of how
Christian civilization interpreted the ancient Greek concept of *meteoros*
(μετέωρος). *Meteoros* is related to Luke 12:29 of the Christian Bible:
"And do not seek what you are to eat and what you are to drink, nor be
worried." In this passage, the word *meteorizo* (μετεωρίζω), which refers
to a state of anxiety as if suspended in the air, is derived from *meteoros*,
which means "to be lifted up high in the air, or to be uncertain."

In the preceding verse 22 that reads, "Therefore I tell you, do not be
anxious about your life, what you will eat, nor about your body, what you
will put on", the word anxious is translated from *merimnao* (μεριμνάω),
which means "to give attention to something to the point of pain."
Meteorizo denotes anxiety that stems from uncertainty. These verses that
connect from *merimnao* to *meteorizo* show the pain coming from excessive
attachment flowing into an uncertainty that feels like being suspended in
the air.

In between these two verses is verse 24: "Consider the ravens: they
neither sow nor reap, they have neither storehouse nor barn, and yet
God feeds them. Of how much more value are you than the birds!" In
this way the raven in verse 24 acts as a metaphor that exists between
metimnao and *meteorizo*, while also becoming an existence that deflects
the two kinds of suffering. This ironic being belongs in the air, thus free
from the obsession with certainty. It flies, embodying the uncertainty of
the air, yet does not get caught up in the anxiety of *meteorizo*.

The air and winged animals are frequently dealt with in Kiki Smith's
work. In *Harbor* (2015, p.197), black birds fly over the cliffs next to the
scattered stars. In *Sky* (2012, p.186) and in *Congregation* (2014, p.185),
the women are placed at a certain point that is both open air and within
the frame of the work. They seem not to worry about what to eat or drink
for a moment. Art thrusts the moment of *meteoros* into a sense of irony
that is mystery.

On one hand, from the perspective of the audience, there is a
blind spot to this beautiful allegory. The analogy is placed quite far
from the here and now. Western Christian civilization far over there
cannot be interpreted in the same way when brought here into a different

11
Oka Mari, trans. by Kim Byeonggu, *Gieok seosa [Memory/Narrative]*, Seoul: Somyeong Publishing, 2004; Oka Mari, trans. by Yi Jaebong, Saiki Katsuhiro, *Geunyeoui jinjeonghan ireumeun mueosinga [What Is Her "Right" Name: Third World Feminist Ideas]*, Seoul: Hyeonamsa, 2016.

culture. The perspective of *partager*,[11] which emerged in the context of postcolonialism, resists unitary public ownership and instead pays attention to the differences between here and there. This is not ancient Greece, nor is it Babylonia, and much less a state with a single religion.

The horizon of interpretation here is different from there. Their eyes are not mine. Even at our most similar moments, the ways we look cannot be wholly the same. Kiki Smith's work evokes those mysterious origin tales scattered across the world that resemble each other yet are not quite the same. We certainly have shares of stories that are like each other. These stories are often called origin tales, or mythologies. Smith gazes into the intersection of the similarities and differences of the tales of old. At this intersection appear artists who become gods, or women who have become the dynamism of art.

Kiki Smith's works that surround the motifs of Daphne and Geneviève open up tales that are beyond a single name. The image of a woman becoming a tree, or a tree becoming a woman, consists of branches, leaves, hands, a woman's body, an upright posture with outstretched arms, the female gender. Contemplating how to weave these pieces together, we put together tales as if to sit at our loom to weave cloth that will be unwoven at night.

Metamorphosis and tales that look like each other

Daphne is a god who becomes a tree. Chased by Apollo to the shore, Daphne invokes her river god father to save her. To become a tree that takes root at the site is both Daphne's wish and a metaphor for the posthuman who breaks away from the Apollonian logos. Kiki Smith sculpts that sliver of a moment within the transformation composed of hands, branches, and a female human. From this, the reading of Daphne's mythology naturally concludes the work in the direction of hands to branches. This leads to the discovery of a future that speaks of a tree coming from a woman.

The metaphor of a woman who becomes a tree can also be found in *Titus* (1999), Julie Taymor's film adaptation of Shakespeare's tragedy, *Titus Andronicus*. There are plenty of murders and violence in *Titus Andronicus*. Shakespeare's first popular play during the Tudor dynasty, the tragedy depicts Lavinia's tongue being cut out and her arms mutilated. This was inflicted by those who intended to keep her from revealing who committed the cruelty. This grisly crime scene is

reconstructed in the film by showing Lavinia in a way that seems either the branches are stuck to the mutilated area, or they are growing from it. It is the gruesome image of Daphne, and amid the flurry of harsh criticisms surrounding the excessive violence of the film, Lavinia's image, wherein hands and branches are fused, is left as something grotesque and gruesome.

The image of splintered twigs resembling hulled, bony arms that have fused to the severed arm is also what one finds in Kiki Smith's *Daphne* (1993). In the work, the body—as indicated by Daphne—has the head, arms and legs replaced by branches gushing out in straight shoots. *Untitled (woman with leaves)* (2009, p.137), on the other hand, does not put up a single name like Daphne. In this work, as it is in many of her other works, the woman seems to want to reveal her body with her arms wide open rather than hide her body by crossing her arms over the body. What overlaps her hands, or the ends of her arms, are a few branches with leaves. It seems more like the woman is letting her hands down and less like she is grabbing the branches. In this way, the woman is freed from the direction of human transforming into a tree and instead is placed where a multitude of stories overlap.

The fusing of the human body and plants is a motif with countless variations, and its direction is largely divided into two: from human to plant, or from plant to human. There are women who lose their human form and morph into plant form, and vice versa. In the creation myth of Manchuria, which tells the story of the willow mother Abka Hehe, the world sees a new goddess walking out of water in the form of a water plant and fish after a round of destruction. The myth of the Willow Mother is closely related to the story of the woman at the well under the willow tree encountered by Lady Yuhwa of Goguryeo or Yi Seong-gye, King Taejo of Joseon. What is found here is the belief that 'will' in human form emerges from the willow tree—a world tree—and writes history.

The two works—*Daphne* and *Untitled (woman with leaves)*—are as different in their narrative approach as their temporal distance. In *Untitled (woman with leaves)*, what the artist captures is just that the plant and human are overlapping. She does not assert what is changing into what, or whether they are really connected to each other. The viewer's gaze is free to wander in any direction, from hand to branch, from life to tragedy, from ruins to creation. Are the branches becoming hands?

12
It wasn't that Kiki Smith had
Daphne on mind when she
first started working on the
piece. The work was started
when a woman with arms of
tree branches came to her
mind, and it is known that
the title of the work was
chosen after a friend saw the
work and called it "Daphne."
Kiki Smith, interview by
David Frankel, "In Her Own
Words," *Kiki Smith*, ed. by
Helaine Posner, Boston;
New York; Toronto; London:
Bulfinch Press, 1998, p.40.

Are the hands becoming the branches? Or perhaps, could the woman be observing her future by the branch of Eden, which is about to bear its fruit?[12]

Rapture (2001, pp.168-169) is of a female figure that emerges from the open belly of a wolf. In the founding mythology of Rome, if the she-wolf that suckled Romulus and Remus were a human, she would be the king's adoptive mother. But the wolf remains as the beast who suckled the king, and within the history of glory, she is spoken of as an unnamed beast or a female link to point to Mars.

The wolf in the founding myth has no name other than *La Lupa*, the feminine noun for wolf. The rapture of a woman walking out of the wolf's skin may imply the process of taking on a human form to ask for a human name. The narrative of metamorphosis in which a human form is given in exchange for sloughing off the skin of a beast is also the story of Ungnyeo, the woman who gave birth to the king in the Korean Dangun myth. It is most commonly known that Ungnyeo transformed into a human in a cave, but in other literature, Ungnyeo tears open the bear's skin and walks out of it.

One wonders: was Ungnyeo's transformation accompanied by rapture? Kiki Smith's works *Born* (2002, pp.170-171) and *Rapture* present side by side the different aspects of what it looks like for one thing to be divided into two. A woman emerges from the belly of what was once one with her, or borrows its birth canal to emerge. Either way, it is a process in which what was once one divides into two, the process of breaking away from what was once herself. If the destruction of what once imprisoned her could be considered a rapturous event, then to leave what used to carry her would accompany a fundamental sorrow.

One can also think of Charles Perrault, the Brothers Grimm and the fairy tale genre. Little Red Riding Hood experiences resurrection in the belly of a wolf. The fable is a narrative that breaks down the boundary between wolf and human, crossing the transformations happening in two directions. In this strange tale, the wolf becomes the grandmother, the girl briefly becomes a part of the wolf as a parcel in its belly, only to soon turn into a human by killing what was once a part of her. The transition from being the devoured to the resurrected brings the experience of another death, one that would befall the girl as well as anyone after her. Thus, the rapture discovered here is a rapture of tearing open from within the one that devoured them, the rapture of putting to

death what was once a part of oneself, and the rapture of someone who got to die multiple deaths. To overlay the reading of *Rapture* with the tales of women who walk out of wolves is the practice of giving the name of rapture to destruction, transformation, and repetition.

Women and wolves appear in several other works as well. In *Geneviève and the May Wolf* (2000)—similar to *Rapture* yet quite different—a woman known as Geneviève stands alongside a wolf. One of her hands is stretched as if to touch the wolf, and her gaze is also toward the wolf. Geneviève and the wolf do not threaten each other. If this is to be reflected in the actual history of the Catholic saint Geneviève, the wolf can be interpreted as Attila, the hero of the Huns.[13]

In the middle of the fifth century, Attila and the Huns invades and sweeps through Gaul. Geneviève, a girl who dedicated herself to her faith in God, hears of the imminent invasion into Paris, whose population was terrified. Geneviève leads the terrified people into her place of faith. The faith to be led as God leads brings protection against the war. Those who had not previously shown Geneviève the right respect or reverence now venerate her as a saint. Geneviève and her devotion to her faith conferred such clear narrative to the causal relation between faith and the will of God.

In light of this story, it can be said that the figure of a woman embracing, subduing, or tearing open a wolf implies two kinds of overcoming. One is overcoming the fear of death brought about by war, and the other is overcoming others who name you. Fear lies within, while others exist externally, thus this overcoming is inside and out. The emergence of Little Red Riding Hood—rebirthing herself by destroying the wolf that was once one and the same as herself—looks a lot like Geneviève's story of the twofold overcoming. Whatever the tale is called, women who are born anew by self-destruction all share similar-looking myths. Their childhood is a potentiality for the myths that are to be born in each other's likeness.

For the childhood that has not yet been completed by any tale, the rapture of birth is deferred. The childhood that becomes the possibility for countless tales because the story has not been completed seems to be clearly in contact with the narcissism of seeing oneself in all the tales. The growth of the girl will make her into Lilith, Geneviève, and Ungnyeo. And like that, she becomes a tale. The *alter deus* is born, then born again, through tales that are layered and repeated. When the

13
The ancestral myth of the wolf was present within the nomad of Eurasia including the Huns. In examining the parallel between the ancestral myth of the wolf in Northeast Asia and the founding myth of Rome, there is also the view that infers the possibility of cultural exchange. Choi Hyeyoung, "Godae romawa dongbugasiaui sinhwa bunseok: neukdaewa sae [Analyzing the Mythology of Ancient Rome and Northeast Asia]", *Jijunghaejiyeogyeongu [Journal of Mediterranean Area Studies]*, vol. 7, no. 1, 2005. As can be observed in Wilhelm Dilich's painting of Attila, Germans of Germanic descent painted Attila as a werewolf.

restraint of form leaps to dynamism of imagination, tales will become the art of the *alter deus*. And like the cycle of life that returns and returns again, it will repeat yet again.

Choi YeongKeon majored in Korean Language and Literature as well as Theology at Yonsei University. She is received her master's degree from the Department of Korean Language and Literature at Yonsei. Choi was awarded the "Literature Today Award for New Writers" (2014) as well as the Seoul Biennale of Urban Architecture and Crossroads Prize (2021). Her works include the novel *Air Domino* (2017) and her collection of short stories, *Water Weeds* (2019).

제공처가 적혀 있지 않은 경우는
모두 작가와 페이스 갤러리
제공이다.

53 〈은빛 새〉. 2006. 네팔 종이에
잉크, 은색 과슈, 운모, 글리터, 흑연.
183.5×148cm. 케리 라이언 맥페이트
사진.

55 〈모임 III〉. 2008-2019. 네팔
종이에 잉크, 색연필, 흑연, 석판용
크레용, 콜라주. 213.4×254cm.
크리스틴 앤 존스 사진.

56-57 〈늑대와 함께 누워〉.
2001. 네팔 종이에 잉크, 흑연.
183.5×223.5cm. 엘런 페이지 윌슨
사진.

59 〈모든 곳(두 토끼)〉. 2010. 네팔
종이에 색연필, 잉크. 98.4×76.2cm.
톰 배럿 사진.

60-61 〈나는 들어갈 공간이 충분히
있도록 나 자신을 비워 뒀다〉.
2009. 네팔 종이에 잉크, 색연필.
188×257.8cm. 케리 라이언 맥페이트
사진.

62 〈황혼〉. 2009. 네팔 종이에 잉크,
글리터, 팔라듐박. 198.1×127cm. 케리
라이언 맥페이트 사진.

63 〈전환〉. 2010. 네팔 종이에 잉크,
색연필. 175.3×208.3cm. 고든 라일리
크리스마스 사진.

65 〈방문 III〉. 2007. 네팔 종이에
잉크, 흑연, 색연필, 운모, 콜라주.
223.8×216.5cm. 멀리사 굿윈 사진.

66-67 〈약속〉. 2012. 네팔 종이에
잉크, 콜라주. 155.6×205.7cm. 톰
배럿 사진.

68-69 〈그녀의 부케〉. 2007-2008.
네팔 종이에 잉크, 유리 글리터,
석판용 크레용, 실크; 마우스 블로운
유리에 유채, 백금박 및 황금박.
종이 186.7×217.2cm, 190.5×218.4cm,
유리 패널 각 60×50.2cm. 고든
라일리 크리스마스 사진.

71 〈검은 꽃 IV〉. 2008. 흑백
유리 판화, 마우스 블로운
유리. 49.5×39.4cm. 고든 라일리
크리스마스 사진.

72 〈진저〉. 2000. 하네뮐레 밝은
흰색 종이에 아쿼틴트, 에칭,
드라이포인트. 57.2×78.7cm. 작가 및
뉴욕 할런 앤드 위버 제공.

74 〈별자리〉. 1996. 네팔 종이에 4색
석판, 틸 장식. 146×78.7cm.
작가 및 유니버설 리미티드 아트
에디션 제공.

77 〈노래 부르는 사람〉. 2008.
알루미늄. 165.1×68.6×61cm.
폴커 도너 사진.

78 〈수태고지〉. 2008. 알루미늄,
나무. 156.2×81.3×48.3cm. 파스칼
마르티네스 사진.

79 〈소녀〉. 2014. 순은에 청동
좌대. 작품 52.1×31.8×8.9cm, 좌대
2.5×14×18.7cm, 전체 54.6×30.5×14cm.
케리 라이언 맥페이트 사진.

81 〈큰 나선 성운〉. 2017. 알루미늄.
83.8×64.1×5.7cm. 톰 배럿 사진.

82 〈메두사〉. 2004. 청동, 다이아몬드
조각. 172.7×50.8×30.5cm.
대구미술관 소장. 케리 라이언
맥페이트 사진.

84 〈물고기를 잡고 있는 물수리〉.
2017. 청동, 질산은 파티나.
47.6×29.2×17.8cm. 멀리사 굿윈 사진.

85(왼쪽) 〈별똥별〉. 2015. 순은.
25.7×21.6×7.6cm. 케리 라이언
맥페이트 사진.

85(오른쪽) 〈초승달 모양의 새〉.
2015. 순은. 29.2×20×7.6cm.
케리 라이언 맥페이트 사진.

86-87 〈혜성 VI〉. 2019. 청동.
236.2×101.6×7cm. 픠브 되를르 사진.

89 〈작은 파도〉. 2016. 청동, 백금박
및 황금박. 15.2×33×12.7cm. 크리스
그레이브스 사진.

90-95 〈세상의 빛〉. 2017. 로신
프라하 종이에 시아노타이프. 각
41.3×57.2cm. 멀리사 굿윈, 조너선
네스테룩 사진.

96-97 〈별자리〉. 1996. 납유리, 청동,
종이, 소다석회유리. 가변 설치.
CMoG 2013.4.38. 작가 및 페이스
갤러리 기증. 뉴욕 코닝 유리 박물관
제공.

99 〈세포-달〉. 1996. 청동.
200.7×182.9×6.4cm. 엘런 페이지
윌슨 사진.

101 〈푸른 나무 위 푸른 별〉.
2006. 네팔 종이에 잉크, 은박.
233.7×177.8cm. 케리 라이언
맥페이트 사진.

102 〈날씨〉. 2019. 청동.
208.3×339.1×92.7cm. 멀리사 굿윈
사진.

103 〈보내다〉. 2016. 청동, 질산은
파티나. 작품 35.6×76.2×12.7cm, 전체
36.2×91.4×30.5cm. 톰 배럿 사진.

105 〈홈〉. 2010. 네팔 종이에 잉크,
색연필. 49.5×74.9cm. 고든 라일리
크리스마스 사진.

106-107 〈나뭇가지〉. 2009. 청동,
파티나. 243.8×596.9cm. 리처드
니콜리 사진.

108-109 〈서곡〉. 2014. 6개의 패널,
스테인드글라스, 마우스 블로운
유리에 검은색 페인트, 에나멜
채색. 전체 252.9×485.8×1.6cm. 케리
라이언 맥페이트 사진.

110 〈방송〉. 2012. 3개의 패널, 유리에
채색, 은박 후면에 황동 프레임.
200.7×243.8cm. 조르조 베니 사진.

111 〈태두〉. 2012. 3개의 패널, 유리에
채색, 은박 후면에 황동 프레임.
200.7×243.8cm. 조르조 베니 사진.

112-113 〈무제(지구 프린트)〉. 1997.
감피 종이에 석판. 65.4×143.5cm.
보스턴 크라코 위트킨 갤러리 사진.

114(왼쪽) 〈무리 해-1월 초〉, 2018. 일퍼드 다계조 인화지에 유리 판화. 50.5×40.3cm. 톰 배럿 사진.

114(오른쪽) 〈무리 해-1월 말〉, 2018. 일퍼드 다계조 인화지에 유리 판화. 50.8×40.6cm. 톰 배럿 사진.

115(왼쪽) 〈무리 해-4월 초〉, 2018. 일퍼드 다계조 인화지에 유리 판화. 50.5×40.3cm. 톰 배럿 사진.

115(오른쪽) 〈무리 해-4월 말〉, 2018. 일퍼드 다계조 인화지에 유리 판화. 50.5×40.3cm. 톰 배럿 사진.

116(왼쪽) 〈무리 해-8월 초〉, 2018. 일퍼드 다계조 인화지에 유리 판화. 50.8×40.6cm. 톰 배럿 사진.

116(오른쪽) 〈무리 해-8월 말〉, 2018. 일퍼드 다계조 인화지에 유리 판화. 50.8×40.6cm. 톰 배럿 사진.

117(왼쪽) 〈무리 해-10월 초〉, 2018. 일퍼드 다계조 인화지에 유리 판화. 50.5×40.3cm. 톰 배럿 사진.

117(오른쪽) 〈무리 해-10월 말〉, 2018. 일퍼드 다계조 인화지에 유리 판화. 50.5×40.3cm. 톰 배럿 사진.

119 〈치유자〉, 2018. 하네뮐레 동판 흰색 종이에 에칭. 62.2×75.9cm. 톰 배럿 사진.

121 〈가슴 II〉. 1994. 네팔 종이에 인쇄, 콜라주. 157.5×139.7cm. 케리 라이언 맥페이트 사진.

123-125 〈무제(머리카락)〉, 1990. 미츠마시 종이에 2색 석판. 91.4×91.4cm. 작가 및 유니버설 리미티드 아트 에디션 제공.

127 〈내분비학〉, 1997. 20장으로 구성된 책. 네팔 종이, 모호크 수퍼파인 텍스트 종이, 티아라 스타화이트 종이, 세키슈 토리노코 감피 종이에 사진 평판, 메이메이 버센부르거의 텍스트 콜라주. 53.9×53.3cm. 작가 및 유니버설 리미티드 아트 에디션 제공.

128-129 〈검은색 동물 드로잉〉. 1996-1998. 네팔 종이에 에칭 잉크. 231.1×938.5cm. 고든 라일리 크리스마스 사진.

130-131 〈동행자〉, 2000. 아코디언 북. 서머싯 종이에 사진 평판, 일본 종이에 사진 평판 부속물. 접은 상태 17.8×22.2×1.9cm, 펼친 상태 17.8×311.2cm. 톰 배럿 사진.

132 〈귀가〉, 2008. 손더스 수채 HP종이에 에칭, 채색. 53.3×71.1cm. 작가 및 유니버설 리미티드 아트 에디션 제공.

133 〈눈물 웅덩이 II〉, 2000. 앙투카 종이에 요판 인쇄, 수채. 129.5×189.9cm. 작가 및 유니버설 리미티드 아트 에디션 제공.

134-135 〈지배〉, 2012. 6개의 패널, 스테인드글라스, 마우스 블로운 유리에 검은색 페인트, 에나멜 채색. 각 252.7×245.7cm, 전체 252.7×515.6cm. 조너선 네스테룩 사진.

137 〈무제(여자와 나뭇잎)〉. 2009. 토리노코 종이에 석판, 채색. 198.1×109.2cm. 작가 및 유니버설 리미티드 아트 에디션 제공.

138-139 〈밴시 펄스〉. 1991. 토리노코 종이에 4색 석판, 알루미늄박, 12점. 각 57.2×77.5cm. 작가 및 유니버설 리미티드 아트 에디션 제공.

140-141 〈나침반〉. 2017. 로신 프라하 종이에 시아노타이프, 금박. 각 57.4×41.3cm. 퓌브 되를르 사진.

142 〈새 더미〉. 1997-1998. 누비 담요에 실크스크린 잉크. 가변 설치. 각 162.6×170.2cm. 엘런 페이지 윌슨 사진.

144-145 〈새들의 파멸〉. 1997. 에칭 5점. 각 81.9×121.9cm. 엘런 페이지 윌슨 사진.

147 〈가진 사람이 임자〉, 1985. T. H. 손더스 종이에 실크스크린, 모노타이프, 잉크. 각 55.7×43cm. 케리 라이언 맥페이트 사진.

148 〈목〉. 1990. 종이에 잉크. 45.7×30.5cm. 엘런 라벤스키 사진.

149 〈무제(토르소)〉. 1988. 종이에 잉크. 57.2×78.7cm. 엘런 라벤스키 사진.

151 〈병 속의 손〉. 1983. 유리병, 조류, 라텍스, 물. 30.5×15cm.

153 〈소화계〉. 1988. 덕타일 주철. 157.5×68.6×3.8cm. 엘런 라벤스키 사진.

154 〈피 웅덩이〉. 1992. 청동에 채색. 35.6×55.9×99.1cm. 엘런 페이지 윌슨 사진.

155 〈성모 마리아〉. 1992. 밀랍, 무명, 나무에 철제 좌대. 171.5×66×36.8cm. 엘런 페이지 윌슨 사진.

156-157 〈허니 왁스〉. 1995. 밀랍. 39.4×91.4×50.8cm. 엘런 페이지 윌슨 사진.

158 〈테일〉. 1992. 밀랍, 안료, 파피에 마세. 406.3×58.4×58.4cm.

161 〈소변보는 몸〉. 1992. 밀랍, 유리 구슬(2.5cm부터 38cm까지 다양한 길이의 줄 23개). 가변 설치. 68.6×71.1×71.1cm. 하버드 미술관(포그 미술관) 소장. 하버드대학총장교우회 제공.

162-163 〈무제〉. 1990. 철제 스탠드에 밀랍. 전체 198.1×181.6×54cm. 휘트니 미술관 / 스칼라 제공.

165 〈무제〉. 1995. 갈색 종이, 메틸셀룰로오스, 말총. 134.6×127×45.7cm. 엘런 페이지 윌슨 사진.

166-167 〈저지 까마귀〉. 1995. 실리콘 청동. 가변 설치(바닥). 엘런 페이지 윌슨 사진.

168-169 〈황홀〉. 2001. 청동. 170.8×157.5×66.7cm. 리처드 맥스 트렘블레이 사진.

170-171 〈탄생〉. 2002. 청동. 99.1×256.5×61cm.리처드 맥스 트렘블레이 사진.

172 〈릴리스〉. 1994. 청동, 유리 눈알. 81.3×68.6×44.5cm. 엘런 페이지 윌슨 사진.

174 〈새와 있는 두상 Ⅱ〉. 1995. 실리콘 청동, 백색 청동. 34.9×27.3×15.2cm.

175 〈데이지 체인〉. 1992. 청동, 쇠사슬. 가변 설치. 고든 라일리 크리스마스 사진.

176-177 〈목발 짚은 달〉. 2002. 알루미늄, 청동. 가변 설치. 엘런 페이지 윌슨 사진.

178-179 〈푸른 소녀〉. 1998. 실리콘 청동. 가변 설치. 엘런 페이지 윌슨 사진.

180 〈초원(꿈꾸기, 배회하기, 잠자기, 둘러보기, 기대기)〉. 2009. 청동. 가변 설치. 서 있는 양 77.5×33×106.7cm, 엎드려 있는 양 57.2×101.6×38.1cm, 여인과 양 86.4×208.3×99.1cm, 양팔을 뻗고 있는 여인 45.1×213.4×119.4cm, 팔을 베고 있는 여인 45.7×198.1×134.6cm.

182-183 〈꿈〉. 1992. 에치젠 고조 기즈키 종이에 2색 요판 인쇄. 106×196.9cm. 작가 및 유니버설 리미티드 아트 에디션 제공.

185 〈회합〉. 2014. 면 자카드 태피스트리. 294.6×193cm. 매그놀리아 에디션 직조. 톰 배럿 사진.

186 〈하늘〉. 2012. 면 자카드 태피스트리. 287×190.5cm. 매그놀리아 에디션 직조. 리처드 개리 사진.

187(위) 〈지하〉. 2012. 면 자카드 태피스트리. 293.4×190.5cm. 매그놀리아 에디션 직조. 케리 라이언 맥페이트 사진.

187(아래) 〈땅〉. 2012. 면 자카드 태피스트리. 294.6×191.8cm. 매그놀리아 에디션 직조 케리 라이언 맥페이트 사진.

188 〈의회〉. 2017. 면 자카드 태피스트리, 은사. 287×190.5cm. 매그놀리아 에디션 직조. 톰 배럿 사진.

189 〈방문자〉. 2015. 면 자카드 태피스트리. 302.3×194.3cm. 매그놀리아 에디션 직조. 케리 라이언 맥페이트 사진.

191 〈대성당〉. 2013. 면 자카드 태피스트리. 294.6×190.5cm. 매그놀리아 에디션 직조. 케리 라이언 맥페이트 사진.

192(왼쪽) 〈행운〉. 2014. 면 자카드 태피스트리. 294.6×193cm. 매그놀리아 에디션 직조. 톰 배럿 사진.

192(오른쪽) 〈머무름〉. 2015. 면 자카드 태피스트리. 287×190.5cm. 매그놀리아 에디션 직조. 톰 배럿 사진.

193, 195 〈실 잣는 이〉. 2014. 면 자카드 태피스트리에 채색, 금박. 294.6×193cm. 매그놀리아 에디션 직조. 톰 배럿 사진.

196 〈인도〉. 2012. 면 자카드 태피스트리. 287×190.5cm. 매그놀리아 에디션 직조 및 사진.

197 〈항구〉. 2015. 면 자카드 태피스트리. 302.3×194.3cm. 매그놀리아 에디션 직조 및 사진.

198 〈블루 프린트: 도로시〉. 1999. 하네뮐레 종이에 에칭, 아쿼틴트, 드라이포인트, 컬러 프린트. 15점 중 1점. 38.1×30.5cm. 엘런 페이지 윌슨 사진.

199 〈블루 프린트: 늑대 소녀〉. 1999. 하네뮐레 종이에 에칭, 아쿼틴트, 드라이포인트, 컬러 프린트. 15점 중 1점. 50.8×40.6cm. 퓌브 되를르 사진.

200 〈블루 프린트: 성모 마리아〉. 1999. 하네뮐레 종이에 에칭, 아쿼틴트, 드라이포인트, 컬러 프린트. 15점 중 1점. 50.8×40.6cm. 멀리사 굿윈 사진.

201 〈블루 프린트: 성모 마리아와 비둘기〉. 1999. 하네뮐레 종이에 에칭, 아쿼틴트, 드라이포인트, 컬러 프린트. 15점 중 1점. 50.8×40.6cm. 멀리사 굿윈 사진.

203 〈새와 알〉. 1996. 석고, 끈. 새 6.7×21×6cm, 끈 75.6cm, 알 3.2×3.2×4.1cm. 톰 배럿 사진.

204(위 왼쪽) 〈노른자〉. 1999. 유리. 1.9×3.8×3.8cm. 톰 배럿 사진.

204(위 오른쪽) 〈알〉. 2000. 유리. 10.8×17.1×10.8cm.워커 아트 센터 사진.

204(아래 왼쪽) 〈작은 산〉. 1993-1996. 쇼트 크리스털. 4.1×10.5×8.9cm. 톰 배럿 사진.

204(아래 오른쪽) 〈꼬리뼈〉. 1997. 크리스털. 4.1×11.4×13.7cm. 작가 및 페이스 프린트 제공.

205(위 왼쪽) 〈무제〉. 2011. 유리. 9.5×12.7×9.5cm. 톰 배럿 사진.

205(위 오른쪽) 〈무제(청동 주조한 새 둥지)〉. 1990년대. 청동. 4.4×16.5×24.1cm. 톰 배럿 사진.

205(아래) 〈무제(장밋빛 레진 새)〉. 1999. 레진. 5.1×26×8.3cm. 케리 라이언 맥페이트 사진.

206(왼쪽 위) 〈옥토푸시〉. 1998. 인청동. 5.1×19.1×16.2cm. 톰 배럿 사진.

206(오른쪽) 〈무제〉. 1994. 황동. 4.4×10.2×11.4cm. 케리 라이언 맥페이트 사진.

206(왼쪽 아래) 〈삼백안〉. 1997. 유리. 3.5×16.8×10.8cm. 케리 라이언 맥페이트 사진.

207(위 왼쪽) 〈무제〉. 1994. 청동. 3.8×12.7×14cm. 케리 라이언 맥페이트 사진.

207(위 오른쪽) 〈무제(자기로 구운 죽은 고양이의 상반신)〉. 1998. 자기. 5.1×11.4×6.4cm. 톰 배럿 사진.

207(아래 왼쪽) 〈무제(죽은 고양이의 상반신)〉. 1998. 청동. 5.1×12.7×7.6cm. 케리 라이언 맥페이트 사진.

207(아래 오른쪽) 〈추락한 박쥐〉. 1998. 청동, 루비. 7×16.5×10.8cm. 엘런 라벤스키 사진.

208(위) 〈꼬리 달린 별〉. 1997. 스털링 실버. 0.6×19.7×3.8cm. 톰 배럿 사진.

208(아래) 〈라이트 캐처〉. 2011. 자기. 26×19.1×12.7cm. 멀리사 굿윈 사진.

209(위 왼쪽) 〈무제(아기)〉. 1987. 파피에 마세에 금칠. 4.8×12.7×5.7cm. 톰 배럿 사진.

209(위 오른쪽) 〈개구리〉. 1999. 유리. 5.4×13×14cm. 톰 배럿 사진.

209(아래) 〈대답〉. 1996. 자기, 철사. 6.4×31.8×7.3cm. 톰 배럿 사진.

211 〈미스 메이〉. 2007. 잉크젯 프린트에 흑연, 콜라주. 50.8×61cm. 피브 되를르 사진.

212 〈무제(두폭화)〉. 1999. 아이리스 프린트(왼쪽 프린트에 연필 드로잉). 각 25.4×20.3cm. 작가 및 페이스 프린트 제공.

213 〈무제〉. 2001. 아이리스 프린트. 50.8×40.6cm. 작가 및 페이스 프린트 제공.

215 〈늑대가 있는 무제〉. 2001. 아이리스 프린트. 40.6×45.7cm. 작가 및 페이스 프린트 제공.

216 〈눈먼〉. 2001. 아이리스 프린트. 55.9×40.6cm. 작가 및 페이스 프린트 제공.

217 〈선견자〉. 2001. 아이리스 프린트. 50.8×40.6cm. 작가 및 페이스 프린트 제공.

219 〈흰 고양이〉. 1999. 아이리스 프린트. 30.5×45.7cm. 작가 및 페이스 프린트 제공.

220 〈그녀의 총신들〉. 1999. 아이리스 프린트. 50.8×55.9cm. 작가 및 페이스 프린트 제공.

221 〈선지자〉. 1999. 아이리스 프린트. 40.6×40.6cm. 작가 및 페이스 프린트 제공.

223 〈나비, 박쥐, 거북이〉. 2000. 아이리스 프린트, 콜라주. 각 29.2×29.2×3.2cm. 작가 및 페이스 프린트 제공.

224(위) 〈폭포 I〉. 2013. 엔트라다 종이에 피그먼트 잉크젯, 채색. 85.7×89.5cm. 작가 및 유니버설 리미티드 아트 에디션 제공.

224(아래) 〈폭포 II〉. 2013. 엔트라다 종이에 피그먼트 잉크젯. 85.7×89.5cm. 작가 및 유니버설 리미티드 아트 에디션 제공.

225 〈폭포 III〉. 2013. 엔트라다 종이에 피그먼트 잉크젯, 채색. 85.7×89.5cm. 작가 및 유니버설 리미티드 아트 에디션 제공.

227 〈3월 초〉. 2014. 젤라틴 실버 프린트에 채색. 30.5×45.4cm.

229 〈3월 7일〉. 2014. 젤라틴 실버 프린트에 채색, 글리터, 보드에 부착. 30.5×45.4cm.

230(위) 〈10월 중순〉. 2014. 크로모제닉 프린트에 글리터, 보드에 부착. 15.2×22.9cm.

230(아래) 〈8월 31일〉. 2014. 크로모제닉 프린트에 채색, 글리터, 보드에 부착. 15.2×22.9cm.

231(위) 〈무제(〈목발 짚은 붉은 달〉의 손)〉. 2002. 크로모제닉 컬러 프린트. 32.1×48.3cm. 준비에브 핸슨 사진.

231(아래) 〈무제(허니 왁스)〉. 1995. 엑타컬러 프린트. 50.8×61cm.

232-233 〈달 셋(세폭화)〉. 1998. 포토그라비어. 각 81.9×60.9cm. 보스턴 크라코 위트킨 갤러리 사진 제공.

234-235 〈위기 모면〉. 2002. 라나 그라비어 종이에 5점 포토그라비어, 활자 인쇄. 각 50.8×40.6cm. 작가 및 유니버설 리미티드 아트 에디션 제공.

236 〈기타 등등〉. 1999. 세키슈 토리노코 감피 종이, 마사 종이, 하네밀레 동판 종이에 6색 석판, 2색 요판 인쇄, 아플리케. 113×68cm. 작가 및 유니버설 리미티드 아트 에디션 제공.

237 〈지렁이〉. 1992. 일본 종이에 요판 인쇄, 콜라주. 108.6×157.5cm. 작가 및 유니버설 리미티드 아트 에디션 제공.

238 〈라스 아니마스〉. 1997. 아르슈 앙투카 종이에 요판 인쇄, 포토그라비어. 152.7×125.1cm. 작가 및 유니버설 리미티드 아트 에디션 제공.

239 〈꼭두각시〉. 1993-1994. 감피 종이에 2색 요판 인쇄, 콜라주. 고지 기즈키 종이로 배접. 147.3×73.7cm. 작가 및 유니버설 리미티드 아트 에디션 제공.

241 〈자유낙하〉. 1994. 에치젠 고조 기즈키 종이에 요판 인쇄, 포토그라비어, 에칭, 드라이포인트. 84.5×106.7cm. 작가 및 유니버설 리미티드 아트 에디션 제공.

Images without their sources stated have been provided by the artist and Pace Gallery. .

———————————

53 *Silver Bird*. 2006. ink on Nepalese paper with silver gouache, mica, glitter and graphite, 183.5×148cm. Photograph by Kerry Ryan McFate.

55 *Assembly III*. 2008-2019. ink on Nepalese paper with colored pencil, graphite and lithographic crayon, collage, 213.4×254cm. Photograph by Christine Ann Jones.

56-57 *Lying with the Wolf*. 2001. ink and graphite on Nepalese paper, 183.5×223.5cm. Photograph by Ellen Page Wilson.

59 *Everywhere (double rabbit)*. 2010. colored pencil and ink on Nepalese paper, 98.4×76.2cm. Photograph by Tom Barratt.

60-61 *I Put Aside Myself That There Was Room Enough to Enter*. 2009. ink and colored pencil on Nepalese paper, 188×257.8cm. Photograph by Kerry Ryan McFate.

62 *Dusk*. 2009. ink on Nepalese paper with glitter and palladium leaf, 198.1×127cm. Photograph by Kerry Ryan McFate.

63 *Shift*. 2010. ink on Nepalese paper with colored pencil, 175.3×208.3cm. Photograph by Gordon Riley Christmas.

65 *Visitation III*. 2007. ink, graphite, colored pencil, mica and collage on Nepalese paper, 223.8×216.5cm. Photograph by Melissa Goodwin.

66-67 *Promise*. 2012. ink and collage on Nepalese paper, 155.6×205.7cm. Photograph by Tom Barratt.

68-69 *Her Bouquet*. 2007-2008. ink on Nepalese paper with glass glitter, lithographic crayon and silk tissue; oil paint on mouth-blown clear antique glass with white and yellow gold leaf, paper: 186.7×217.2cm, 190.5×218.4cm, glass panel: 60×50.2cm (each). Photograph by Gordon Riley Christmas.

71 *Black Flowers IV*. 2008. black and white cliché verre with mouth-blown reamy glass, 49.5×39.4cm. Photograph by Gordon Riley Christmas.

72 *Ginzer*. 2000. aquatint, etching and drypoint on Hahnemühle bright white paper, 57.2×78.7cm. Courtesy of the artist and Harlan and Weaver, New York.

74 *Constellations*. 1996. lithograph in 4 colors with flocking on Nepalese paper, 146×78.7cm. Courtesy of the artist and Universal Limited Art Editions.

77 *Singer*. 2008. cast aluminum, 165.1×68.6×61cm. Photograph by Volker Dohne.

78 *Annunciation*. 2008. cast aluminum, wood, 156.2×81.3×48.3cm. Photograph by Pascal Martinez.

79 *Girl*. 2014. fine silver on bronze base, figure: 52.1×31.8×8.9cm, base: 2.5×14×18.7cm, overall: 54.6×30.5×14cm. Photograph by Kerry Ryan McFate.

81 *Spiral Nebula (Large)*. 2017. aluminum, 83.8×64.1×5.7cm. Photograph by Tom Barratt.

82 *Medusa*. 2004. bronze with diamond chips, 172.7×50.8×30.5cm. Collection of Daegu Art Museum. Photograph by Kerry Ryan McFate.

84 *Osprey with Fish*. 2017. bronze with silver nitrate patina, 47.6×29.2×17.8cm. Photograph by Melissa Goodwin.

85 (left) *Shooting Star*. 2015. fine silver, 25.7×21.6×7.6cm. Photograph by Kerry Ryan McFate.

85 (right) *Crescent Bird*. 2015. fine silver, 29.2×20×7.6cm. Photograph by Kerry Ryan McFate.

86-87 *Sungrazer VI*. 2019. bronze, 236.2×101.6×7cm. Photograph by Phoebe d'Heurle.

89 *Small Wave*. 2016. bronze with white and yellow gold leaf, 15.2×33×12.7cm. Photograph by Kris Graves.

90-95 *the light of the world*. 2017. cyanotype on Losin Prague paper, 41.3×57.2cm (each). Photograph by Melissa Goodwin and Jonathan Nesteruk.

96-97 *Constellation*. 1996. lead glass, bronze, paper, soda lime glass, assembled dimensions variable. CMoG 2013.4.38. gift in part of the artist and Pace Gallery, New York. gift in part of the artist and Pace Gallery, New York. Courtesy of The Corning Museum of Glass, Corning, NY.

99 *The Cells - The Moon*. 1996. bronze, 200.7×182.9×6.4cm. Photograph by Ellen Page Wilson.

101 *Blue Stars on Blue Tree*. 2006. ink and silver leaf on Nepalese paper, 233.7×177.8cm. Photograph by Kerry Ryan McFate.

102 *The Weather*. 2019. bronze, 208.3×339.1×92.7cm. Photograph by Melissa Goodwin.

103 *Send*. 2016. bronze with silver nitrate patina, sculpture: 35.6×76.2×12.7cm, overall: 36.2×91.4×30.5cm. Photograph by Tom Barratt.

105 *Home*. 2010. ink on Nepalese paper with colored pencil, 49.5×74.9cm. Photograph by Gordon Riley Christmas.

106-107 *Bough*. 2009. bronze with patina, 243.8×596.9cm. Photograph by Richard Nicoli.

108-109 *Prelude*. 6 framed panels, stained glass, mouth-blown clear antique glass, black paint and enamel colors, fired and leaded, overall: 252.9×485.8×1.6cm. Photograph by Kerry Ryan McFate.

110 *Broadcast*. 2012. 3 panels, clear antic glass, painted and fired, silver leaf on backside, leaded and framed in brass frame, 200.7×243.8cm. Photograph by Giorgio Benni.

111 *Luminary*. 2012. 3 panels, clear antic glass, painted and fired, silver leaf on backside, leaded and framed in brass frame, 200.7×243.8cm. Photograph by Giorgio Benni.

112-113 *Untitled (Earth Print)*. 1997. lithograph on gampi paper, 65.4×143.5cm. Photograph by Krakow Witkin Gallery, Boston.

114 (left) *Sundog - First January*. 2018. cliché verre on Ilford Multigrade Contrast paper, 50.5×40.3cm. Photograph by Tom Barratt.

114 (right) *Sundog - Last January*. 2018. cliché verre on Ilford Multigrade Contrast paper, 50.8×40.6cm. Photograph by Tom Barratt.

115 (left) *Sundog - First April*. 2018. cliché verre on Ilford Multigrade Contrast paper, 50.5×40.3cm. Photograph by Tom Barratt.

115 (right) *Sundog - Last April*. 2018. cliché verre on Ilford Multigrade Contrast paper, 50.5×40.3cm. Photograph by Tom Barratt.

116 (left) *Sundog - First August*. 2018. cliché verre on Ilford Multigrade Contrast paper, 50.8×40.6cm. Photograph by Tom Barratt.

116 (right) *Sundog - Last August*. 2018. cliché verre on Ilford Multigrade Contrast paper, 50.8×40.6cm. Photograph by Tom Barratt.

117 (left) *Sundog - First October*. 2018. cliché verre on Ilford Multigrade Contrast paper, 50.5×40.3cm. Photograph by Tom Barratt.

117 (right) *Sundog - Last October*. 2018. cliché verre on Ilford Multigrade Contrast paper, 50.5×40.3cm. Photograph by Tom Barratt.

119 *Healers*. 2018. etching on Hahnemühle copperplate white paper, 62.2×75.9cm. Photograph by Tom Barratt.

121 *Bosoms II*. 1994. collage of printed Nepalese paper, 157.5×139.7cm. Photograph by Kerry Ryan McFate.

123-125 *Untitled (Hair)*. 1990. lithograph in 2 colors on custom made Mitsumashi paper, 91.4×91.4cm. Courtesy of the artist and Universal Limited Art Editions.

127 *Endocrinology*. 1997. book of 20 photolithographs with collaged text by Mei-mei Berssenbrugge on Nepalese, Mohawk Superfine Text, Tiara Starwhite, Sekishu Torinoko gampi paper, 53.9×53.3cm. Courtesy of the artist and Universal Limited Art Editions.

128-129 *Black Animal Drawing*. 1996-1998. etching ink on Nepalese paper, 231.1×938.5cm. Photograph by Gordon Riley Christmas.

130-131 *Companion*. 2000. book of accordion-folded photolithographs on mold-made Somerset paper with insert of folded photolithograph on handmade Japanese paper, folded: 17.8×22.2×1.9cm, unfolded: 17.8×311.2cm. Photograph by Tom Barratt.

132 *Homecoming*. 2008. etching with hand-coloring on Saunders Watercolor HP paper, 53.3×71.1cm. Courtesy of the artist and Universal Limited Art Editions.

133 *Pool of Tears II*. 2000. intaglio with hand water coloring on En Tout Cas paper, 129.5×189.9cm. Courtesy of the artist and Universal Limited Art Editions.

134-135 *Dominion*. 2012. 6 panels, stained glass, mouth-blown clear antique glass, black paint and enamel colors, fired and leaded diptych, 252.7×245.7cm (each), 252.7×515.6cm (overall). Photograph by Jonathan Nesteruk.

137 *Untitled (woman with leaves)*. 2009. lithograph with hand-coloring on Torinoko paper, 198.1×109.2cm. Courtesy of the artist and Universal Limited Art Editions.

138-139 *Banshee Pearls*. 1991. set of 12 lithographs in 4 colors with aluminum leaf applique on Torinoko paper, 57.2×77.5cm (each). Courtesy of the artist and Universal Limited Art Editions.

140–141 *Compass*. 2017. cyanotype and gold leaf on Losin Prague paper, 57.4×41.3cm (each). Photograph by Phoebe d'Heurle.

142 *Flight Mound*. 1997-1998. silkscreen ink on quilted blankets, installation variable, 162.6×170.2cm (each). Photograph by Ellen Page Wilson.

144-145 *Destruction of Birds*. 1997. suite of 5 etchings, 81.9×121.9cm (each). Photograph by Ellen Page Wilson.

147 *Possession is Nine-Tenths of the Law*. 1985. screenprint and monotypes with ink additions on mold-made T. H. Saunders paper, 55.7×43cm (each). Photograph by Kerry Ryan McFate.

148 *Neck*. 1990. ink on paper, 45.7×30.5cm. Photograph by Ellen Labenski.

149 *Untitled (Torsos)*. 1988. ink on paper, 57.2×78.7cm. Photograph by Ellen Labenski.

151 *Hand in Jar*. 1983. glass, algae, latex and water, 30.5×15cm.

153 *Digestive System*. 1988. ductile iron, 157.5×68.6×3.8cm. Photograph by Ellen Labenski.

154 *Blood Pool*. 1992. painted bronze, 35.6×55.9×99.1cm. Photograph by Ellen Page Wilson.

155 *Virgin Mary*. 1992. wax, cheesecloth and wood with steel base, 171.5×66×36.8cm. Photograph by Ellen Page Wilson.

156-157 *Honeywax*. 1995. beeswax, 39.4×91.4×50.8cm. Photograph by Ellen Page Wilson.

158 *Tale*. 1992. wax, pigment, and papier-mâché, 406.3×58.4×58.4cm.

161 *Pee Body*. 1992. wax and glass beads (23 strands of varying lengths, 2.5 to over 38cm long), installation variable, 68.6×71.1×71.1cm. Harvard Art Museums/Fogg Museum, Gift of Barbara Lee, Gift of Emily Rauh Pulitzer and Purchase in part from the Joseph A. Baird, Jr., Francis H. Burr Memorial and Director's Acquisition Funds, Photo © President and Fellows of Harvard College, 1997.82.

162-163 *Untitled*. 1990. beeswax and microcrystalline wax figures on metal stands. overall (installation): 198.1×181.6×54cm. Purchase, with funds from the Painting and Sculpture Committee. Inv.: 91_13a-d. 2022 © Photo Scala, Florance. Digital image Whitney Museum of American Art / Licensed by Scala.

165 *Untitled*. 1995. brown paper, methyl cellulose and horsehair, 134.6×127×45.7cm. Photograph by Ellen Page Wilson.

166-167 *Jersey Crows*. 1995. silicon bronze, installation variable (installation on the floor). Photograph by Ellen Page Wilson.

168-169 *Rapture*. 2001. bronze, 170.8×157.5×66.7cm. Photograph by Richard-Max Tremblay.

170-171 *Born*. 2002. bronze, 99.1×256.5×61cm. Photograph by Richard-Max Tremblay.

172 *Lilith*. 1994. bronze with glass eyes, 81.3×68.6×44.5cm. Photograph by Ellen Page Wilson.

174 *Head with Bird II*. 1995. silicon bronze and white bronze, 34.9×27.3×15.2cm.

175 *Daisy Chain*. 1992. cast bronze with steel chain, dimensions variable. Photograph by Gordon Riley Christmas.

176-177 *Moon on Crutches*. 2002. cast aluminum and bronze, installation dimensions variable. Photograph by Ellen Page Wilson.

178-179 *Blue Girl*. 1998. silicon bronze, installation variable. Photograph by Ellen Page Wilson.

180 *Pasture (Sleeping, Wandering, Slumber, Looking About, Rest Upon)*. 2009. bronze, overall installation dimensions variable, standing sheep: 77.5×33×106.7cm, resting sheep: 57.2×101.6×38.1cm, woman with sheep: 86.4×208.3×99.1cm, woman with arms extended: 45.1×213.4×119.4cm, woman with arm behind head unique: 45.7×198.1×134.6cm.

182-183 *Sueño*. 1992. intaglio in 2 colors on Echizen Kouzo Kizuki paper, 106×196.9cm. Courtesy of the artist and Universal Limited Art Editions.

185 *Congregation*. 2014. cotton Jacquard tapestry, 294.6×193cm. Published by Magnolia Editions, Inc. Photograph by Tom Barratt.

186 *Sky*. 2012. cotton Jacquard tapestry, 287×190.5cm. Published by Magnolia Editions, Inc. Photograph by Richard Gary.

187 (top) *Underground*. 2012. cotton Jacquard tapestry, 293.4×190.5cm. Published by Magnolia Editions, Inc. Photograph by Kerry Ryan McFate.

187 (bottom) *Earth*. 2012. cotton Jacquard tapestry, 294.6×191.8cm. Published by Magnolia Editions, Inc. Photograph by Kerry Ryan McFate.

188 *Parliament*. 2017. cotton Jacquard tapestry with silver threads, 287×190.5cm. Published by Magnolia Editions, Inc. Photograph by Tom Barratt.

189 *Visitor*. 2015. cotton Jacquard tapestry, 302.3×194.3cm. Published by Magnolia Editions, Inc. Photograph by Kerry Ryan McFate.

191 *Cathedral*. 2013. cotton Jacquard tapestry, 294.6×190.5cm. Published by Magnolia Editions, Inc. Photograph by Kerry Ryan McFate.

192 (left) *Fortune*. 2014. cotton Jacquard tapestry, 294.6×193cm. Published by Magnolia Editions, Inc. Photograph by Tom Barratt.

192 (right) *Sojourn*. 2015. cotton Jacquard tapestry, 287×190.5cm. Published by Magnolia Editions, Inc. Photograph by Tom Barratt.

193, 195 *Spinners*. 2014. cotton Jacquard tapestry, hand painting and gold leaf, 294.6×193cm. Published by Magnolia Editions, Inc. Photograph by Tom Barratt.

196 *Guide*. 2012. cotton Jacquard tapestry, 287×190.5cm. Published by Magnolia Editions, Inc. Image © Magnolia Editions, Inc.

197 *Harbor*. 2015. cotton Jacquard tapestry, 302.3×194.3cm. Published by Magnolia Editions, Inc. Image © Magnolia Editions, Inc.

198 *Blue Prints: Dorothy*. 1999. 1 from a set of 15 etching, aquatint and drypoints, printed in color, on mold-made Hahnemühle paper, 38.1×30.5cm. Photograph by Ellen Page Wilson.

199 *Blue Prints: Wolf Girl*. 1999. 1 from a set of 15 etching, aquatint and drypoints, printed in color, on mold-made Hahnemühle paper, 50.8×40.6cm. Photograph by Phoebe d'Heurle.

200 *Blue Prints: Virgin Mary*. 1999. 1 from a set of 15 etching, aquatint and drypoints, printed in color, on mold-made Hahnemühle paper, 50.8×40.6cm. Photograph by Melissa Goodwin.

201 *Blue Prints: Virgin with Dove*. 1999. 1 from a set of 15 etching, aquatint and drypoints, printed in color, on mold-made Hahnemühle paper, 50.8×40.6cm. Photograph by Melissa Goodwin.

203 *Bird and Egg*. 1996. plaster and string, bird: 6.7×21×6cm, string: 75.6cm, egg: 3.2×3.2×4.1cm. Photograph by Tom Barratt.

204 (top left) *Yolk*. 1999. glass, 1.9×3.8×3.8cm. Photograph by Tom Barratt.

204 (top right) *Egg*. 2000. glass, 10.8×17.1×10.8cm. Photograph by Walker Art Center.

204 (bottom left) *Little Mountain*. 1993-1996. Schott crystal, 4.1×10.5×8.9cm. Photograph by Tom Barratt.

204 (bottom right) *Tail*. 1997. kiln-cast lead crystal, 4.1×11.4×13.7cm. Courtesy of the artist and Pace Prints.

205 (top left) *Untitled*. 2011. glass, 9.5×12.7×9.5cm. Photograph by Tom Barratt.

205 (top right) *Untitled (cast bronze bird's nest)*. 1990s. bronze, 4.4×16.5×24.1cm. Photograph by Tom Barratt.

205 (bottom) *Untitled (rose resin bird)*. 1999. resin, 5.1×26×8.3cm. Photograph by Kerry Ryan McFate.

206 (left top) *Octopussy*. 1998. phosphorous bronze, 5.1×19.1×16.2cm. Photograph by Tom Barratt.

206 (right top) *Untitled*. 1994. brass, 4.4×10.2×11.4cm. Photograph by Kerry Ryan McFate.

206 (bottom) *Sanpaku*. 1997. glass, 3.5×16.8×10.8cm. Photograph by Kerry Ryan McFate.

207 (top left) *Untitled*. 1994. bronze, 3.8×12.7×14cm. Photograph by Kerry Ryan McFate.

207 (top right) *Untitled (porcelain dead cat half upper body)*. 1998. porcelain, 5.1×11.4×6.4cm. Photograph by Tom Barratt.

207 (bottom left) *Untitled (dead half cat, upper torso)*. 1998. bronze, 5.1×12.7×7.6cm. Photograph by Kerry Ryan McFate.

207 (bottom right) *Crashed Bat*. 1998. bronze and ruby, 7×16.5×10.8cm. Photograph by Ellen Labenski.

208 (top) *Star with Tail*. 1997. sterling silver, 0.6×19.7×3.8cm. Photograph by Tom Barratt.

208 (bottom) *Light Catcher*. 2011. porcelain, 26×19.1×12.7cm. Photograph by Melissa Goodwin.

209 (top left) *Untitled (baby)*. 1987. gold-painted papier-mâché, 4.8×12.7×5.7cm. Photograph by Tom Barratt.

209 (top right) *Frog*. 1999. glass, 5.4×13×14cm. Photograph by Tom Barratt.

209 (bottom) *Answer*. 1996. porcelain and wire, 6.4×31.8×7.3cm. Photograph by Tom Barratt.

211 *Miss May*. 2007. inkjet print with graphite and collage, 50.8×61cm. Photograph by Phoebe d'Heurle.

212 *Untitled (Diptych)*. 1999. Iris print with pencil drawing by artist over left print, 25.4×20.3cm (each). Courtesy of the artist and Pace Prints.

213 *Untitled*. 2001. Iris print, 50.8×40.6cm. Courtesy of the artist and Pace Prints.

215 *Untitled with Wolf*. 2001. Iris print, 40.6×45.7cm. Courtesy of the artist and Pace Prints.

216 *Blinded*. 2001. Iris print, 55.9×40.6cm. Courtesy of the artist and Pace Prints.

217 *Seer*. 2001. Iris print, 50.8×40.6cm. Courtesy of the artist and Pace Prints.

219 *White Cat*. 1999. Iris print, 30.5×45.7cm. Courtesy of the artist and Pace Prints.

220 *Her Minions*. 1999. Iris print, 50.8×55.9cm. Courtesy of the artist and Pace Prints.

221 *Visionary*. 1999. Iris print, 40.6×40.6cm. Courtesy of the artist and Pace Prints.

223 *Butterfly, Bat, Turtle*. 2000. dimensional Iris print with collage, 29.2×29.2×3.2cm (each). Courtesy of the artist and Pace Prints.

224 (top) *The Falls I*. 2013. pigmented inkjet with hand-coloring on Entrada Natural Rag paper, 85.7×89.5cm. Courtesy of the artist and Universal Limited Art Editions.

224 (bottom) *The Falls II*. 2013. pigmented inkjet on Entrada Natural Rag paper, 85.7×89.5cm. Courtesy of the artist and Universal Limited Art Editions.

225 *The Falls III*. 2013. pigmented inkjet with hand-coloring on Entrada Natural Rag paper, 85.7×89.5cm. Courtesy of the artist and Universal Limited Art Editions.

227 *Early March*. 2014. gelatin silver print with hand painting, 30.5×45.4cm.

229 *March 7th*. 2014. gelatin silver print with hand painting and glitter mounted to board, 30.5×45.4cm.

230 (top) *Mid-October*. 2014. chromogenic print with glitter mounted to board, 15.2×22.9cm.

230 (bottom) *August 31st*. 2014. chromogenic print with hand painting and glitter mounted to board, 15.2×22.9cm.

231 (top) *Untitled (Hand of "Red Moon on Crutches")*. 2002. chromogenic color print, 32.1×48.3cm. Photograph by Genevieve Hanson.

231 (bottom) *Untitled (Honeywax)*. 1995. Ektacolor Print, 50.8×61cm.

232-233 *Moon Three (Triptych)*. 1998. photogravure, 81.9×60.9cm (each). Photograph by Krakow Witkin Gallery, Boston.

234-235 *Out of the Woods*. 2002. set of 5 digitally manipulated photogravures with hand-set type on Lana Gravure paper, 50.8×40.6cm (each). Courtesy of the artist and Universal Limited Art Editions.

236 *Etc. Etc*. 1999. lithograph in 6 colors and intaglio in 2 colors with applique on Sekishu Torinoko gampi, Masa, and Hahnemühle copperplate paper, 113×68cm. Courtesy of the artist and Universal Limited Art Editions.

237 *Worm*. 1992. intaglio with collage on Japanese paper, 108.6×157.5cm. Courtesy of the artist and Universal Limited Art Editions.

238 *Las Animas*. 1997. intaglio with photogravure on Arches En Tout Cas paper, 152.7×125.1cm. Courtesy of the artist and Universal Limited Art Editions.

239 *Puppet*. 1993-1994. intaglio in 2 colors with collage on gampi hinged to Kouzi-Kizuki paper, 147.3×73.7cm. Courtesy of the artist and Universal Limited Art Editions.

241 *Free Fall*. 1994. intaglio with photogravure, etching, and drypoint on Echizen Kozo Kizuki paper, 84.5×106.7cm. Courtesy of the artist and Universal Limited Art Editions.

키키 스미스는 미국의 미술가로, 1954년 1월 18일 독일 뉘른베르크에서 건축가이자 조각가인 아버지 토니 스미스와 오페라 가수이자 배우인 어머니 제인 로런스 스미스의 장녀로 태어났다. 1955년 미국 뉴저지 사우스오렌지로 이주해, 그해 태어난 쌍둥이 여동생 시턴, 베아트리스와 함께 성장했다. 여동생들과 함께 아버지를 도와 조각 작품의 종이 모형을 만들곤 했고, 마크 로스코, 바넷 뉴먼 등 기성세대의 예술가들뿐만 아니라 젊은 예술가들이 집에 자주 드나들었기에, 어릴 적부터 예술을 자연스럽게 접할 수 있는 환경에 노출되어 있었다.

1972년 고등학교 졸업 후 제빵 기술을 배우기 위해 직업학교에 들어갔으나, 섬유디자인이나 공예, 패션에 더 관심을 두었다. 1974년 미국 코네티컷의 하트퍼드 아트스쿨에 입학해 영화를 공부하다가 중퇴하고 1976년 뉴욕에 정착한다. 전기 기술자 조수, 그리고 타임스스퀘어의 틴 팬 앨리 바에서 일하던 즈음, 『그레이 해부학』 책 한 권을 얻게 된다. 그 후 1978년에는 작가이자 영상 제작자인 찰리 에이헌의 소개로 뉴욕 행동주의 미술가 단체인 콜랩에서 활동을 시작한다. 이곳에는 제니 홀저, 톰 오터네스, 제인 딕슨, 마이크 글리어, 로버트 골드먼 등이 함께 활동했는데, 대안 공간이나 길거리 등에서 전시를 열었다. 이들은 모두 동시대 대안 매체에 관심을 가졌고 대부분이 사회 문제를 다루는 작품을 만들었다. 1980년 스미스는 콜랩의 전시 「더 타임스스퀘어 쇼」에 처음으로 작품을 출품했다. 아홉 개의 천 조각을 격자로 꿰매 만든 이 작품은, 푸른색 배경에 눈, 입, 절단된 팔다리가 그래픽디자인 형식으로 묘사되어 있다.

가족, 공동체, 그리고 동료들의 죽음을 비롯해 에이즈, 가정폭력, 임신중절, 감금, 젠더 평등 등 1980년대 당시 미국의 사회정치적 문제는 스미스가 신체를 주제로 작업하게 된 배경이 된다. 베아트리스와 함께 1985년 응급구조사 훈련을 받기도 했는데, 이 영향으로 신체 장기와 체액을 비위계적인 관점으로 해체해 작품에서 다룬다. 1990년대에 이르러서는 인물의 전신상을 제작하기 시작하고, 배설하거나 생리혈을 흘리는 등의 파격적인 모습 때문에 미술사에서 이 시기

Kiki Smith is an American artist born in Nuremberg, Germany in 1954 as the eldest daughter of the architect and sculptor Tony Smith and the opera singer and actress Jane Lawrence Smith. She moved with her family to South Orange, New Jersey, USA in 1955, where she grew up with her twin sisters Seton and Beatrice, who were born that year. Together with her sisters, she would help her father make paper models of his sculptures. Artists of her father's generation like Mark Rothko and Barnett Newman as well as younger artists frequented their house, imparting upon her an early familiarity with art.

After graduating from high school in 1972, she went to trade school for baking but was more interested in textile design, crafts, and fashion. Later she enrolled at Harford Art School in Connecticut in 1974 to study film, but dropped out and moved to New York in 1976, where she worked as an electrician's assistant as well as in the bar called Tin Pan Alley in Times Square. It was around this time that the artist was given a copy of *Gray's Anatomy*. In 1978, with the introduction by writer and filmmaker Charlie Ahearn, Smith joined Collaborative Projects, Inc. (Colab), a New York-based artist activism collective. Jenny Holzer, Tom Otterness, Jane Dickson, Mike Glier, and Robert Goldman were all active in Colab, holding exhibitions in alternative spaces as well as in the streets. The group was collectively interested in contemporary alternative mediums and many in the group made art that dealt with social issues. In 1980, Smith presented a painting for the first time for Colab's exhibition, *The Times Square Show*. The painting is made up of nine sheets of muslin sewn together in a grid. On each piece of fabric Smith repeats an eye, a mouth, and amputated limbs painted flat and graphic against a blue background.

In the 1980s, the loss of family, community, and colleagues combined with the American political-social issues of the time—such as AIDS, domestic violence, abortion, incarceration, and gender inequality—became a backdrop to Smith's interest in the body. Smith and her sister Beatrice trained to become emergency medical technicians,

작품은 '애브젝트 아트'로 흔히 분류, 언급된다. 1991년 휘트니 비엔날레에서 처음 공개된 작품 〈무제〉(1990)는 마주보는 스탠드에 매달려 축 늘어진 채 체액을 흘리는 남녀 한 쌍을 과감하게 묘사했다. 또한 유리나 테라코타, 밀랍으로 신체 장기를 표현하고, 사람의 피부를 닮은 네팔 종이로 조각을 만드는 등 재료에서도 실험적 태도를 유지했다. 분야를 넘나드는 스미스의 활동은 곧 다양한 협업으로 이어졌다. 할런 앤드 위버, 유니버설 리미티드 아트 에디션 등의 판화 스튜디오, 매그놀리아 에디션과 같은 태피스트리 스튜디오, 또 왈라 왈라 앤드 워크숍 아트 패브리케이션과 같은 주조 공장을 포함해 각 분야의 전문가들과 협업했고, 지금도 이어 가고 있다.

2000년대부터는 동물, 자연, 우주로 주제의 범위가 넓게 확장되고 서정적이고 환상적인 분위기를 띠게 된다. 종교, 신화, 문학에서 도상을 가져와 새로운 내러티브를 직조하는가 하면, 더욱 다양한 매체를 다루는 유연함을 보인다. 이는 문학가들과 함께한 출판으로도 이어졌는데, 시인 메이메이 버센부르거와 만든 『내분비학』(1997), 『화합』(2006), 에밀리 디킨슨의 시에 그림을 넣은 『표본』(2007) 등이 그 예이다. 그밖에 수재나 무어, 레슬리 스칼라피노, 앤 월드먼 등의 작가와도 협업했다.

스미스의 작업은 오늘도 여전히 미지의 길을 정처 없이 거닐고 있다.

대표 전시로는 뉴욕 더 키친에서 열린 첫 개인전 「생명은 살고 싶어 한다」(1983), 에이즈를 주제로 낸 골딘이 기획해 뉴욕 아티스트 스페이스에서 열린 단체전 「목격자들: 우리의 소멸에 맞서」(1989-1990), 휘트니 비엔날레(1991, 1993, 2002), 뉴욕 현대미술관 개인전 「프로젝트 24: 키키 스미스」(1990-1991), 평면 매체와 소형 오브제를 집중적으로 다룬 「키키 스미스: 판화, 책, 물건들」(2003-2004) 등이 있다. 특히 「키키 스미스: 모임, 1980-2005」(2005-2007)은 미니애폴리스의 워커 아트 센터를 시작으로, 샌프란시스코 현대미술관, 휴스턴 현대미술관, 뉴욕 휘트니 미술관을 순회한 작가의 대표 전시로 평가된다. 독일 쿤스트할레 빌레펠트에서 개최한

an experience that informed her practice as she deconstructed human organs and bodily fluids from a non-hierarchical perspective. In the 1990s, she started to work with full-length human figures, producing works that art historians now commonly categorize and refer to as "abject art" due to its shocking appearances that involved excrement or menstrual blood. *Untitled* (1990), first unveiled at the Whitney Biennial in 1991 boldly depicting a man and a woman in wax hanging limply on adjacent stands, both portrayed leaking bodily fluids. Her experimental approach was consistent in her use of material as well: she would sculpt bodily organs in glass, terracotta, or wax, and often made sculptures from Nepalese paper that resemble human skin. Today Smith's interdisciplinary approach has led her to work with print workshops like Harlan & Weaver and Universal Limited Art Edition; tapestry studios such as Magnolia Editions, Inc.; foundries like Walla Walla and Workshop Art Fabrication; and other craftspeople and workshops around the globe.

From the 2000s, the scope of her subjects expanded to include animals, nature, and the universe, giving her works a lyrical and fantastical hue. By fluidly blending iconographies from various religions, mythologies, and literature Smith wove new narratives together in her work. This also led to collaborating with literary writers to produce published works, such as *Endocrinology* (1997) and *Concordance* (2006), both a collaboration with poet Mei-mei Berssenbrugge, and *Sampler* (2007), which added imagery to Emily Dickinson's poetry. Other writers Smith has collaborated with include Susanna Moore, Leslie Scalapino, and Anne Waldman.

Today her work continues to meander an unknown path.

Some of her notable exhibitions include: *Life Wants to Live* (1983), her first solo exhibition held at The Kitchen, New York; *Witnesses: Against Our Vanishing* (1989-1990), a group exhibition curated by Nan Goldin at Artists Space, New York; the Whitney Biennale (1991, 1993, 2002); *Projects 24: Kiki Smith* (1990-1991), her solo exhibition at the Museum of Modern Art, New York; and *Kiki Smith:*

「키키 스미스, 시턴 스미스, 토니 스미스」(2012)는
조각가인 아버지, 사진가인 동생과 함께 토니
스미스 탄생 백 주년을 맞아 진행한 삼인전이다.
이후 제57회 베네치아 비엔날레(2017), 독일
뮌헨 하우스 데어 쿤스트에서의 「키키 스미스:
행렬」(2018), 파리조폐국에서 프랑스 최초의
개인전 「키키 스미스」(2019-2020) 등이 열렸다.
한국에서는 서울 국제갤러리에서 2000년,
서울과 대구 리안갤러리에서 2014년 소규모로
소개되었고, 2022년 국내 미술관 개인전으로는
최초로 서울시립미술관에서 「키키 스미스 —
자유낙하」가 열려 지난 사십여 년간의 작품
활동이 책과 함께 소개된다.

그의 작품은 뉴욕 현대미술관, 뉴욕
휘트니 미술관, 뉴욕 구겐하임 미술관, 뉴욕
브루클린 박물관, 뉴욕 메트로폴리탄 미술관,
샌프란시스코 드 영 박물관, 로스앤젤레스 카운티
미술관, 훔레베크 루이지애나 현대미술관, 런던
테이트 미술관, 런던 빅토리아 앤드 앨버트
박물관, 스톡홀름 현대미술관, 보스턴 미술관,
워싱턴 디시 국립미술관, 한국 국립현대미술관,
대구미술관, 오사카 국립미술관을 비롯한 세계
전역의 여러 미술관, 박물관에 소장되어 있다.

1994년부터 뉴욕 페이스 갤러리
소속으로 활동하고 있고, 현재 뉴욕대학교와
컬럼비아대학교 겸임교수로 재직하면서 판화를
가르치고 있다.

Prints, Books and Things (2003-2004), a survey on her use of flat media and small objects. A retrospective of her work titled *Kiki Smith: A Gathering, 1980-2005* (2005-2007), is often regarded as one of her most notable exhibitions, opening at the Walker Art Center, Minneapolis and traveling to San Francisco Museum of Modern Art, the Contemporary Arts Museum, Houston and to the Whitney Museum of American Art, New York. *Kiki Smith, Seton Smith, Tony Smith* (2012) was held at Kunsthalle Bielefeld, Germany, celebrating the centenary of Tony Smith's birth together with her sister photographer Seton Smith. Following exhibitions include the 57th Venice Biennale (2017), *Kiki Smith: Procession* (2018) at Haus der Kunst, and *Kiki Smith* (2019-2020) at Monnaie de Paris, her first solo exhibition in France. In Korea, Kukje Gallery, Seoul (2000) and Leeahn Gallery, Seoul and Daegu (2014) each held smaller-scale exhibitions of her work. In 2022, *Kiki Smith—Free Fall* is held at Seoul Museum of Art as the first solo exhibition at a museum in Korea, and along with a book, the exhibition introduces an oeuvre that spans more than forty years.

Smith's work is held in public collections throughout the United States and abroad including the Museum of Modern Art, New York; Whitney Museum of American Art, New York; Solomon R. Guggenheim Museum, New York; Brooklyn Museum, New York; the Metropolitan Museum of Art, New York; the de Young Museum, San Francisco; Los Angeles County Museum of Art; Louisiana Museum of Modern Art, Humlebæk, Denmark; Tate, London; Victoria and Albert Museum, London; Moderna Museet, Stockholm, Sweden; Museum of Fine Arts, Boston; National Gallery of Art, Washington, D.C.; National Museum of Modern and Contemporary Art, Korea; Daegu Art Museum, Korea; and National Museum of Art, Osaka, Japan, among others.

Kiki Smith has been represented by Pace Gallery since 1994, and she is currently an adjunct professor at NYU and Columbia University, instructing students in printmaking.

키키 스미스 — 자유낙하
초판1쇄 발행일 2022년 12월 15일
초판2쇄 발행일 2023년 2월 1일
발행인 李起雄 발행처 悅話堂
경기도 파주시 광인사길 25 파주출판도시
전화 031-955-7000 팩스 031-955-7010
www.youlhwadang.co.kr yhdp@youlhwadang.co.kr
등록번호 제10-74호 등록일자 1971년 7월 2일
편집 이수정 장한올 디자인 박소영
번역 박연수 제이슨 워드
인쇄 제책 (주)상지사피앤비

Kiki Smith—Free Fall
© 2022, Seoul Museum of Art, Korea
Published by Youlhwadang Publishers.
Paju Bookcity, Gwanginsa-gil 25, Paju-si, Gyeonggi-do, Korea
Tel +82-31-955-7000 Fax +82-31-955-7010
Edited by Yi Soojung, Jang Han-ol Designed by Bak Soyoung
Translated by Park Yonsoo, Jason Ward
Printed and binded by Sangjisa P&B

ISBN 978-89-301-0771-6 (03650)
Printed in Korea.

이 책은 서울시립미술관 서소문본관에서 2022년 12월 15일부터
2023년 3월 12일까지 열린 「키키 스미스—자유낙하」 전시와 연계하여
발행된 단행본입니다.

This book was published in conjunction with the exhibition
Kiki Smith—Free Fall held from December 15, 2022 to March 12, 2023,
at Seosomun Main Building of Seoul Museum of Art, Korea.

이 책은 장평순 님의 서울시립미술관 연구출판 발전 후원금의
일부 지원을 받았습니다.

This publication was partly supported by Chang Pyung-Soon as part of
Research and Publication Development Fund of Seoul Museum of Art.